Canon DSLR

The Digital Workflow series from Focal Press

The Digital Workflow series offers clear, highly illustrated, in-depth, practical guides to each part of the digital workflow process. They help photographers and digital image makers to work faster, work smarter, and create great images. The focus is on what the working photographer and digital image maker actually need to know to get the job done.

This series is answering readers' calls to create books that offer clear, no-nonsense advice, with lots of explanatory images, but don't stint on explaining *why* a certain approach is suggested. The authors in this series – all professional photographers and image makers – look at the context in which you are working – whether you are a wedding photographer shooting 1000s of jpegs a week or a fine artist working on a single Raw file.

The huge explosion in the amount of tools available to photographers and digital image makers – as new cameras and software arrives on the market – has made choosing and using equipment an exciting, but risk-filled venture. The Digital Workflow series helps you find a path through digital workflow, tailored just for you.

Series editor: Richard Earney

Richard Earney is an award-winning Graphic Designer for Print and Web Design and Coding. He is a beta tester for Adobe Photoshop, a consultant for Photoshop Lightroom, on the Apple Developers program and is an expert on Digital Workflow. He has been a keen photographer for over 30 years and is a Licentiate of the Royal Photographic Society. He can be found at http://www.method-photo.co.uk

Forthcoming titles in the series

Mac OSX for Photographers

File Management for Photographers

CANON DSLR

*The Ultimate
Photographer's Guide*

Christopher Grey

Amsterdam • Boston • Heidelberg • London • New York
Oxford • Paris • San Diego • San Francisco • Singapore
Sydney • Tokyo

Focal Press is an imprint of Elsevier

Focal Press is an imprint of Elsevier
Linacre House, Jordan Hill, Oxford OX2 8DP, UK
30 Corporate Drive, Suite 400, Burlington, MA 01803, USA

First published 2008

Notice
No responsibility is assumed by the publisher for any injury and/or damage to persons or property as a matter of products liability, negligence or otherwise, or from any use or operation of any methods, products, instructions or ideas contained in the material herein. Because of rapid advances in the medical sciences, in particular, independent verification of diagnoses and drug dosages should be made

British Library Cataloguing in Publication Data
Grey, Christopher
Canon DSLR: the ultimate photographer's guide. – (Digital photography workflow)
1. Canon digital cameras
I. Title
771.3'3

Library of Congress Number: 2007933397

ISBN: 978-0-240-52040-7

For information on all Focal Press publications visit our website at www.focalpress.com

Typeset by Charon Tec Ltd (A Macmillan Company), Chennai, India
www.charontec.com

Printed and bound in Canada

07 08 09 10 11 11 10 9 8 7 6 5 4 3 2 1

CONTENTS

Contents

INTRODUCTION

Welcome. The fact that you're reading this book means you've either just bought a Canon camera and want more information than the instruction book can give you (no surprise there) or that you're thinking of getting into the system and want to know more about it.

As a professional photographer with a couple of million frames under his belt, my decision to give up another manufacturer's system for Canon was not one that was undertaken lightly. Well, actually, it was. I tried Canon's D30 some years ago and knew I was holding my future in my hands. I put my name in the hopper for a D60, moved from there to the 1Ds, and have been progressing ever since.

I've never regretted that decision.

In my opinion, Canon made a quantum leap for photography, both mechanically but more importantly, philosophically, producing the best, most intuitive, and easiest to use equipment ever. That said, no digital equipment is "easy." Yes, you can make a nice image (pretty much right out of the box, but also right down the middle of the road) in Full Auto or Program, but what's the point if you don't understand the subtleties?

If you haven't done so already, you're about to make a major financial investment in your photographic future. Canon's gear is the best this planet has ever seen – that's my opinion, but it's the opinion of a professional who makes his living from photography, and also someone who's made a substantial investment in his equipment. I want, and need, the very best, and I demand a lot from it.

Let me help you get the most out of yours.

Christopher Grey

ACKNOWLEDGMENTS

Many, many people volunteered their time and talent to make this project a reality, and I wish to thank each and every one of them. I spent many hours interviewing a very selected group of photographers with amazing talents and a firm grasp on their business niche. These shooters were very forthcoming about their history, workflow, even the professional "secrets" that have contributed to their success. I thanked each of them personally, but this is the place to formally thank David Bicho, Rod Evans, Paul Gero, Paul Hartley, and Gerry Kopelow for being so open with me about their professional lives.

One nice benefit of a project like this is that I got to work with some extremely nice people who were willing to put up with me checking my notes and making abrupt changes in the middle of the shoot or making numerous wardrobe changes to accommodate the shoot schedule. The list is long, but each should know that their contribution was worth every minute of their time. A big Thank You to Miki Adachi, Kimberly Anderson (makeup artist), Denise Armstead, Tristy Auger, Sandra Avelli (makeup artist), Lola Bel Aire, Tiffiny Carlson, Mike Dorfman, Stephanie Fellner, Bill Foster, Marc Foster, Gerry Girouard, Tammy Goldsworthy, Molly Grace, Elizabeth Grey, Jennifer Haldeman, Grace Harrod, Arika Inugami, Jennifer Lauren, Jessica Madson, Hayley Malone, Devonair Mathis, Kurt Melancon, Zoran Mojsilov, Julie Nielson, Jeremy Norred, Ingrid Nurse, Juris Plesums, Jennifer Rocha, Sahata, Katie, Lilly, Joe and Nora Thomey, Alissa Tousignant, Reuben Van Hemert, Liliane Vangay, Pistol Vegas, Keith Williams, and Justin Zitzer. I couldn't have done this without you.

Canon extended its cooperation for this project, for which I thank Joe DeLora and Brian Matsumoto for their personal help. Beyond that, I wish to give my deepest thanks to Elizabeth Pratt, a Canon Professional Market Representative who was also my Technical Editor for this book. If you've ever had the pleasure of meeting Elizabeth, you've met not only a warm and charming woman, you've met one of the most knowledgeable Canon reps ever. To my delight, she's become a great friend, and I couldn't have done this without her, either.

A final note from the Pit of Doom: Thank you, Susan!

The Basics

Aperture and Depth of Field

See also Shutter Speed, Reciprocity.

When we refer to the "aperture" of a lens, we are speaking on an iris, similar to that in the pupil of an eye, that opens or closes, allowing light to enter and strike the optic nerve, sending impulses to the brain. A lens aperture works much the same, except it will allow as much light to enter as we tell it to allow. While our brains can automatically compensate for light or dark (a human with good vision is capable of seeing light as dim as a trillionth of a watt), should we tell the aperture to allow too much light for the ISO we've set the chip to record, the result will be an overexposure that the camera cannot compensate for.

A camera's aperture is composed of thin metal blades that, when the shutter is actuated (and at any f-stop other than its widest), move together in less than a blink of an eye to form a circle corresponding to the chosen f-stop. After the chosen shutter speed has expired, and the shutter has been closed, they move back to their zero position to wait for the next actuation.

Unlike older irises, which were assembled by hand, Canon's are created and assembled robotically, in a super-clean, in-house environment, assuring a quality of design, construction, and control.

Throughout this book, you'll see references to "opening up" or "stopping down" your lens. When a lens is opened up, the iris is enlarged, allowing more light to strike the sensor. But, as with so many mysteries of life, things work in reverse; opening up a lens means changing its value to a smaller number. Lenses are rated at their maximum, or fastest, f-stop, thus a lens with a maximum aperture of f1.2 is faster (will gather more light at its maximum aperture) than a lens with a maximum aperture of f2.8. When we shoot "wide open" it means we're shooting at the lens' maximum aperture.

When we stop down a lens, the result is that less light will strike the sensor, because we change the f-stop to a smaller number. f22, for example, allows less light to reach the sensor than f16 because the circle is smaller.

Mathematically, when the aperture is "opened up" one full stop, the amount of light reaching the chip is doubled. For example, changing the aperture from f11 to f8 will double the amount of light falling on the chip and result in a one stop overexposure, assuming that f11 would provide a correct exposure.

When the aperture is "stopped down" one full stop the amount of light reaching the chip is cut in half. For example, changing the aperture from f11 to f16, assuming that f11 would provide a correct exposure, will result in an image underexposed by one stop (FIGS 1.1–1.3).

FIG 1.1 1/200 second, f8. Image is 1 stop overexposed

FIG 1.2 1/200 second, f11. Image is correctly exposed

FIG 1.3 1/200 second, f16. Image is 1 stop underexposed

The area in front of and in back of the point of focus that appears sharp to our eyes is the image's depth of field. Stopping down the lens will increase this area of apparent sharp focus while opening up the lens will diminish it. The closer you are to your subject, and with an opened aperture, the less depth of field. This is useful to isolate a subject against an otherwise cluttered or distracting background (FIGS 1.4 and 1.5).

FIG 1.4 At f22 the background is too confusing to make sense out of this close up, while a slight breeze was enough to blur the subject

FIG 1.5 At f2.8, the shutter speed is high enough to freeze any movement, and the background is so soft that the subject stands out nicely

Shutter Speed

See also Aperture, Depth of Field, and Reciprocity.

The amount of time a shutter remains open to allow light to strike the camera's sensor is the camera's "shutter speed." A shorter time duration (aka "faster") means more action can be stopped, or frozen. Conversely, slower shutter speeds (a.k.a. "longer") allows action to blur. Under many circumstances, longer shutter speeds will necessitate smaller apertures, increasing depth of field (FIGS 1.6 and 1.7).

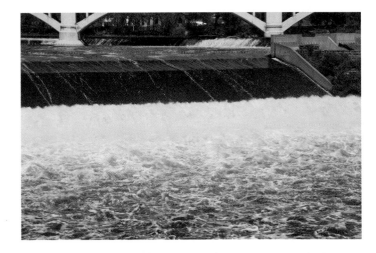

FIG 1.6 A very fast shutter speed of 1/1000th second (at f6.3) was fast enough to freeze the rapidly moving water

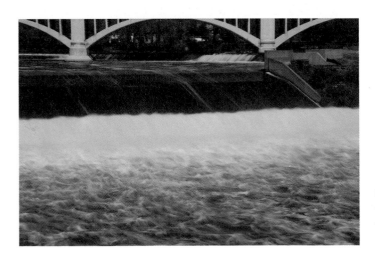

FIG 1.7 With the help of neutral density filters, a shutter speed of 6/10th second (at f22) was slow enough to gracefully blur the roiling water

When a shutter speed actuation is made slower (by the shutter's equivalent of a full stop), the amount of time that light plays on the chip is doubled. Changing the shutter speed in such a manner without correspondingly adjusting the aperture will result in an image overexposed by one stop.

When a shutter speed actuation is made faster (by the shutter's equivalent of a full stop), the amount of time that light plays on the chip is halved. Changing the shutter speed in this manner without a corresponding change in f-stop will yield an image underexposed by one stop (FIGS 1.8–1.10).

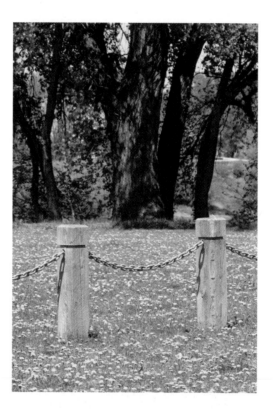

FIG 1.8 One stop overexposed

Canon cameras offer a range of shutter speeds from 30 seconds to 1/4000th of a second (on the Rebel) to a maximum of 1/8000 (on other models). All cameras have provision for Bulb exposures, where the shutter stays open as long as it's depressed. Custom Function (C.Fn) 6 (on most cameras) permits you to choose intermittent shutter speed increments in ½ stops (camera default is ⅓ stop increments).

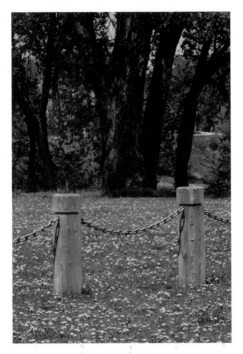

FIG 1.9 Correct exposure

FIG 1.10 One stop underexposed

Reciprocity

Reciprocity is the rule that states that if, beginning with the correct shutter/aperture combination to yield a perfect exposure, the shutter speed is adjusted in one direction (faster, for example) and the aperture is adjusted *correspondingly* in the opposite direction (opened up, for this example), the exposure will be the same.

Let's say a correct exposure for an image is 1/125 at f8. Charting all equivalent shutter speed/f-stop combinations would look like this:

1/15	1/30	1/60	1/125	1/250	1/500	1/1000
f22	f16	f11	f8	f5.6	f4	f2.8

Each combination would yield the same correct exposure. What would change would be the amount of blur in a moving subject (or moving photographer) as the shutter speeds got longer, or the amount of depth of field in the image as the aperture became progressively smaller.

Note that this is a constant rule only when the light source itself is constant. Sunlight and most available light is "constant" in that it doesn't change over the course of the exposure. Fluorescent lights are not considered "constant" because they flicker on and off 60 times per second. Studio strobes and on camera flash units are not constant sources of light because they fire and expire somewhere between the time the shutter actually opens and closes, so the amount of light they produce may be figured into the equation (like fill flash) and used to advantage to either supplement existing light or overpower it.

Back in the days of film, most of us were trained to think in terms of whole stops and half-stops. In other words, I might have told my assistant to "get me 11 and a half" if I wanted a little more light. Canon's EF Series of lenses, designed for the EOS camera family, easily work in thirds of stops, much more accurate for the touchy digital environment. Similarly, digital cameras have added additional shutter speeds to reflect the additional aperture settings. An expanded version of the reciprocity scale looks like this:

Shutter speed	1/15	1/20	1/25	1/30	1/40	1/50	1/60	1/80	1/100	
Aperture	f22	f20	f18	f16	f14	f13	f11	f10	f9	
Shutter speed	1/125	1/160	1/200	1/250	1/320	1/400	1/500	1/640	1/800	1/1000
Aperture	f8	f7.1	f6.3	f5.6	f5	f4.5	f4	f3.5	f3.2	f2.8

Should you decide to set your camera to work in half-stop increments, here's how the reciprocity scale would work for the same

1/125 at f8 exposure:

Shutter speed	1/15	1/20	1/30	1/45	1/60	1/90	1/125	1/180	1/250	1/350	1/500	1/750	1/1000
Aperture	f22	f19	f16	f13	f11	f9.5	f8	f6.7	f5.6	f4.5	f4	f3.5	f2.8

These are not complete scales, of course. There are lenses with a maximum aperture greater than f2.8 and there are lenses that stop down below f22, but the principle remains the same and can easily be charted for whatever lenses you may own.

Notice, as you look through these images, how depth of field increases as apertures get smaller (FIGS 1.11–1.17).

FIG 1.11 1/800, f2.8

FIG 1.12 1/400, f4

FIG 1.13 1/200, f5.6

FIG 1.14 1/100, f8

FIG 1.15 1/50, f11

FIG 1.16 1/25, f16

FIG 1.17 1/13, f22

Resolution and Compression

The reproduction quality of any image is ultimately tied to the number of pixels that comprise that image. Pixels, shorthand for "picture elements," are present in the millions in all of Canon's cameras, even their amateur snapshot cameras, as it takes a million pixels to equal 1 megapixel. Thus, a 16 megapixel sensor contains 16 million picture elements, and each element, electrically charged to receive and process information from the light that strikes it, becomes 1/16,000,000th of the final image. The number of pixels that make up an image is the resolution of the image.

Logic would dictate that, the more pixels in an image, the more information (and the higher degree of enlargement) in that image. That's true, but only to a degree.

Image quality is also dependent on the size of the chip that receives the image. A 10 megapixel CMOS sensor in a Rebel, for example, is smaller in physical size than a 10 megapixel sensor in a 1D Mark III. Larger sensors mean larger pixels, which equates to better light gathering capability and cleaner images, so even though the Rebel has the same number of pixels, images from the larger sensor will appear to be sharper, with less noise and more latitude for enlargement (FIG 1.18).

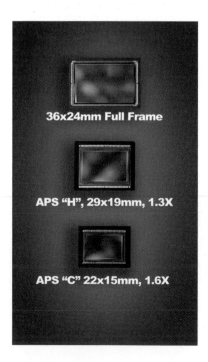

FIG 1.18 Comparative sizes and conversion factors of CMOS sensors

After chip size and resolution, the degree of image compression factors into the quality of the final reproduction. When you look at the resolution settings in the menu of a Canon prosumer camera or Digital Rebel, you will see Large (L), Medium (M), and Small (S) jpeg, plus RAW by itself and a RAW combination that will take a RAW file plus a Large, Medium, or Small jpeg at the same time. The 1D Mark III even has a Small RAW (sRAW) choice.

The Large jpeg setting will use all of the pixels on the sensor to create the image, while the Medium setting uses fewer pixels and the Small jpeg choice creates an even lower resolution image. You also have a choice of how that jpeg file is compressed. Compression doesn't affect the number of pixels used to make up the image, but how that information is remembered and stored.

Here's one way to visualize what jpeg compression does. Let's say we've chosen to shoot Large resolution jpegs. When an image is compressed into a jpeg, the processor looks at pixels and their neighbors. If a neighboring pixel is only slightly different than the inspected pixel, the neighbor is remembered by the processor as the same color. If the degree of compression is low, pixels that may be only slightly different than their neighbors are remembered by the processor as being different and the result is a Large file. If the degree of compression is high, as many pixels as possible are lumped together as the same color, tossing out some detailed information in the name of saving space. The result of high compression is a file that takes up less room on your hard drive or your memory card but may not have the same smooth colors and gradations as a less compressed file. The resolution (or number of pixels) of the file is still the same whether you choose a Large jpeg with low compression or with high compression.

You see, the jpeg file format, as convenient as it is, is what's known as a "lossy" format. The subtle color variation that was there before compression between some of the pixels is gone forever. The same thing happens when the image is recompressed in a program like Photoshop. After a certain number of compressions/decompressions, the image develops "artifacts," areas of color that look chunky because the pixels are not transitioning color or tone correctly. Artifacts are most likely to form around areas of sharp focus against a plain background, such as this chain against a bright sky. Once they form there's nothing that can be done about them, but they're much less likely to be visible in Large files with low compression (FIGS 1.19 and 1.20).

Does this mean that jpegs are a bad format? Not at all. Jpegs are a fine format, suitable for almost everything, provided you understand their operation and limitations. Working with jpegs can be a viable part of your workflow, actually saving you lots of time.

FIG 1.19 This Small file, high compression jpeg was only opened once

FIG 1.20 This Small file, high compression jpeg required more than a dozen cycles before artifacts became problematic

Storage cards are cheap. If you're shooting something important, like a vacation, be sure to have enough cards to cover the trip. If you take a laptop with you, and your machine is capable of burning CDs or DVDs, it's good insurance to burn your files to duplicate discs. Save one with your luggage and mail the other to your home or office. If your laptop, camera, or luggage is stolen or lost you'll still have your pictures.

In other words, don't re-format your storage cards until you're sure your images are safely backed up.

Yeah, I know. Paranoia is my middle name.

Personally, I believe you should always shoot at a level higher than you'll need. If you are just going to shoot snapshots, with maybe an occasional 8 × 10, I'd recommend you shoot Large (Normal). The number of images you can fit onto a card is double that of Large (High) files yet will yield high quality prints. With an 8 megapixel camera, that works out to over 500 shots on a 1 gigabyte card.

Pros should always shoot Large (High) or RAW to get the most out the files.

On the other hand, should you want the versatility of RAW but need a quick reference for an image catalog, you might want to shoot RAW + Small (Normal). It will be easy to use the Small jpegs in Canon's Image Browser or other programs such as iView Media or iPhoto. Use the catalog of jpegs for reference, then process the images you like from the RAW files. If you're worried about losing important data to artifacts (you shouldn't be) process those images as Tiffs, a lossless format.

The important thing to understand is how compression affects your picture quality. As always, I suggest you test your equipment to determine what makes you happy. Large or not so large, Canon's CMOS sensor technology allows for exceptionally clean data.

Quick Start

Okay, so you've got your new camera and lens, and you're champing at the bit to take a picture. Now, I'm the last guy on Earth who'll tell you not to read the instruction manual; today's cameras have so many sophisticated controls and systems that you'll actually be doing yourself a disfavor if you decide to rely only on what you know about film camera operation. Still, I remember my own excitement when I opened the box of my first Canon DSLR, the D60, and how anxious I was to "lock and load" so I won't yell at you if you just can't wait.

So, for those of you who just can't wait, here are ten simple steps to get your first pictures:

1. Insert the battery. Canon batteries are shipped with a slight charge, which may be enough to get you going, but you should charge the battery to a full charge first. Battery style and type varies between some models, and you need to consult your manual for the proper procedure to maintain the battery in peak performance. Some batteries, like the NP-E3 nickel metal hydride (NiMH), should be charged, refreshed, and recharged several times before actual camera use. This procedure, known as "shaping" or "forming," imprints a kind of behavior pattern on the battery, allowing it to perform as it was designed and at its best.

 When you insert a battery into an EOS-1 camera body, you'll feel a slight resistance as you push the battery into the chamber and use the thumb-turn lock to latch it into place. Canon EOS-1 pro bodies have been sealed against mild inclement weather and dust. The resistance you feel is the rubber gasket seal that protects the battery compartment from the elements (FIG 1.21).

FIG 1.21

Battery Life and Health

Rechargeable batteries will deteriorate over time. After periods of continuous use, they are unable to deliver a full charge, which means that the maximum number of images you may have been used to will decline. For the consumer and prosumer cameras, the batteries are small and relatively inexpensive. Replacing a battery doesn't mean you have to recycle the old one, it just means you have a backup. If you're a casual shooter, it may be years before you notice the loss of power, and you may never have to replace the battery before you replace the camera.

Pro shooters, especially those who work on location and away from AC power should buy at least one backup battery immediately. Many of the cameras at the high end of Canon's camera list, the machines use NiMH batteries, which are also prone to loss of power due to overuse. NiMH chargers come with a "Refresh" button that should be used before the camera is put into use and periodically thereafter. Selecting Refresh will drain the battery to zero charge before charging back to 100%, which guarantees the battery will perform its very best (FIG 1.22).

Canon's newest battery, the LP-E4 (lithium-ion) type, is an improvement found on the Mark III. Weighing about a half pound less than its NP-E3 (NiMH) counterpart, it delivers roughly twice the shooting power without the same need for the "shaping" or "forming" that NiMH batteries require for best performance. It's a significant benefit, and signals continued changes as Canon rotates improvements through its product line.

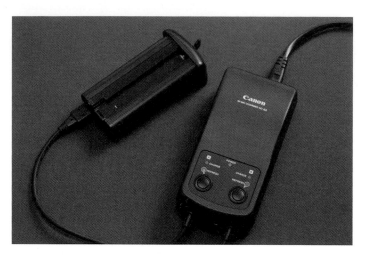

FIG 1.22

2. Attach the lens. Align the large red dot on the lens with the red dot on the lens mount of the camera body. Insert the lens and turn clockwise until the lens locks into place (about 1/8th of a full turn). If you have an EF-S lens, specifically designed for the recent digital cameras with the APS-C size sensor, you will align the white square on the lens with the white square on the lens mount (FIGS 1.23 and 1.24).

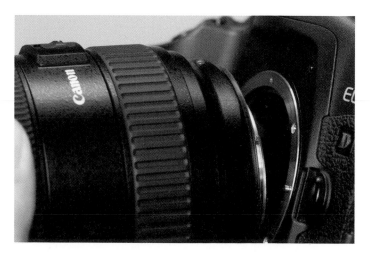

FIG 1.23

FIG 1.24

3. Set the Focus Mode switch on the lens to AF (Auto Focus) (FIG 1.25).
4. Insert a Compact Flash (CF) or Secure Digital (SD) card. Most Canon cameras only accept the CF card format, although a few will accept one of each. In that case, each card can be used separately or set up for one card to write Raw files while the other writes jpegs (FIG 1.26).
5. Turn the camera's power switch on (FIG 1.27).
6. Take a moment and Format your CF or SD card(s). Formatting prepares the card for use in the camera, and you'll risk image loss or corruption if you just pop it in and start shooting. See "Common Ground" on page 65 for more information.

FIG 1.25

FIG 1.26

FIG 1.27

After just a few days with your gear you'll realize that Canon's processors are the best in the business, and even those images made under Full Auto or Program will almost always be printable without additional work in image manipulation software like Photoshop. Once you realize this, you'll be able to resist the urge to "chimp" your shots, automatically looking at the LCD to check it after each shot. "Chimping" is a term, meant only in fun, for digital novices (and pros, too!) who look down at the LCD after each shot and then say "Oooh! Oooh!" as the screen lights up.

7. Set the Mode Dial to Full Auto (in the Basic Zone) or Program (in the Creative Zone). Doing so will allow the camera to automatically make all choices and decisions regarding focus point, exposure, and white balance.
8. Frame your image by moving into or out of the frame, or by using a zoom lens to get closer or further away. Depress the shutter halfway down to engage the AF mechanism (FIGS 1.28 and 1.29).
9. Depress the shutter button the rest of the way to take the picture.
10. Review the image on the camera's LCD screen. Although it's not accurate enough for critical assessment, the camera's LCD screen will tell you if you're "in the ballpark" regarding composition and exposure. The image has also been written to the CF or SD card, just waiting for you to download and print (FIG 1.30).

20

FIG 1.28

FIG 1.29

FIG 1.30

Workflow

Successful Workflow

There are monthly articles in almost every photography-related magazine, lectures given by experts in or near your fair city several times a year, and a never-ending stream of tips, ideas or just plain hearsay from store clerks and friends regarding just exactly what proper workflow is and how to accomplish it. For all the discussion, it's a very difficult subject to pin down because of one simple truth: workflow is a little different for everyone.

Beginning here, we'll take a hard look at workflow and how understanding the Canon system can lead you to make the right workflow choices to maximize your production time and minimize any necessary post-production. The idea is to get from Point A (the shoot) to Point B (completion and delivery) with a great product and the least expenditure of time.

Proper workflow begins at the camera, and there are some choices you need to make before you take your first picture.

Color Space: Adobe RGB vs. sRGB

Prior to beginning a job, it's necessary to think of the end result. Will the images be published on a mechanical press, like this book, or will they be printed through a desktop printer or by a commercial lab? The end result may dictate your choice of Color Space.

Adobe RGB (1998), is an industry standard and offers a very wide range of reproducible colors and shades, the "gamut" of that color space, and is similar to the reproduction range of film stock. When an image is prepared for mechanical reproduction, such as this book, each image is separated into its complimentary opposites; red becomes cyan, green becomes magenta, and blue becomes yellow. This reproduction color space, called CMYK (cyan, magenta, yellow, and "key" or black) represents the smallest gamut, allowing for the proper reproduction of roughly one-half of the colors present in a full-gamut RGB image. See "Common Ground" on page 65 for more information (FIG 2.1).

FIG 2.1 Here's another graph representing the comparative size of the three primary color spaces. Adobe RGB (1998) is the largest, followed by sRGB and CMYK

Adobe RGB represents that largest color gamut that is selectable for in-camera jpeg processing. However, DPP offers the option of processing the RAW file into "Wide Gamut RGB" (a larger color space than Adobe RGB) among others such as "Color Match RGB" and "Apple RGB." Some folks teach that when processing a RAW file in Adobe Camera RAW it should be processed into "ProPhoto RGB" since the RAW files color gamut actually exceeds Adobe RGB. This is overkill for the vast majority of photographers and, unless you understand, need, and have a practical reason for using one of them, my opinion is that these gamuts, while useful, are not necessary.

For this book, we'll deal only with the two most commonly used color spaces, Adobe RGB and sRGB.

It stands to reason that in order to get the maximum reproduction quality from an image that one would need to start with the color space that would present the largest selection of colors and shades, which is Adobe RGB. But, is that true?

The sRGB color space is smaller than its Adobe RGB counterpart, allowing for reproduction of approximately 4/5 of the maximum reproducible gamut. Many people incorrectly see RGB as a flawed color space, and

shoot everything, including weddings and portraits, as Adobe RGB imagery, assuming that more colors are better than fewer and that their pictures will always look better when made in Adobe RGB.

In actuality, the vast majority of devices for printing or viewing any image are native sRGB machines. With a few notable and very high-end exceptions, all commercial lab printers are sRGB, the Internet is sRGB, and so are computer monitors whether they are CRT or LCD devices (again, with few, very high-end, exceptions).

The sRGB color space is completely acceptable as a starting point for any image meant for printing by a lab or desktop machine. While some colors might change slightly to conform to the sRGB space, those changes are generally not noticed.

When you look at the Color Space options available on Canon gear you'll see that Canon gives you a choice of sRGB or Adobe RGB. Adobe RGB is a generic, encompassing, color space that's meant to be tweaked by image manipulation software such as Photoshop or by a pre-press service that will optimize the images for conversion to CMYK. Does this mean you can't shoot a portrait in Adobe RGB? Of course it doesn't, but it does mean that you should convert those images to the sRGB profile before sending them to your lab or to the Internet, extra steps that will add to your workflow.

Use the Adobe RGB Color Space when creating images for mechanical reproduction. Catalogs, magazines, and brochures are some examples of mechanically reproduced material that use images created as Adobe RGB and then converted to CMYK. Be aware that you will not be able to see the full range of RGB color on your computer monitor.

Use an appropriate sRGB Color Space when creating images that will be reproduced by a pro lab or 1-hour print shop, or for images you will print on a desktop printer. Also, sRGB is the preferred color space for the Internet — Adobe RGB images look flat when posted.

Shooting RAW

Another shooting option is to shoot RAW. Unlike the .jpg file format, in which the camera makes the processing decisions based on the parameters you set, a RAW file is the equivalent of a digital negative, and you decide, via Canon's Digital Photo Professional software (supplied with the camera with free updates available online) how you want the photo to look. You can correct the exposure over about a two stop range, up or down, adjusting for exposure errors, until you get a correct image. You can also change color temperature, make contrast and sharpness adjustments, even batch process a whole folder's worth of images. In a way, it's like shooting color transparency film, with its very tight tolerances, but having exposure latitude closer to color negative film.

The downside is that you can spend a *significant* amount of time processing these files. One or two at a time, of course, is minimal. It's when you shoot a major event, like a wedding with its requisite hundreds of shots, or a day's worth of graduate portraits, that you'll feel the time constraints of processing RAW files.

Personally, I have nothing against the RAW format. In fact, I think it's a digital gift. The problem I do have with it, and with those folks who

propose it as the only way to work, is that there are better ways to spend your time than sitting in front of your screen, opening, and tweaking files that should not need so much of your attention (FIGS 2.2 and 2.3).

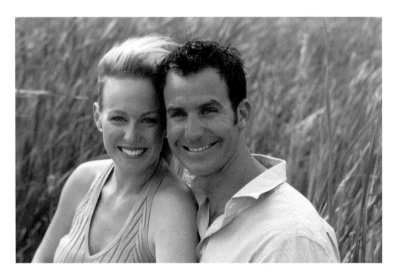

FIG 2.2 When exposure is tightly controlled, jpegs may be all you need to produce great work. This jpeg is just as the camera made it, and has not been adjusted

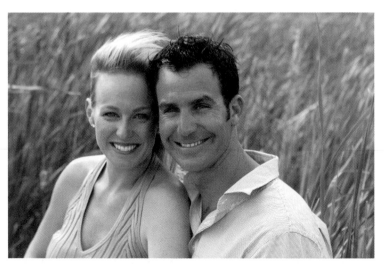

FIG 2.3 There are few discernible differences between the jpeg and this RAW file, both of which were opened "as is"

In terms of workflow (and this is only my opinion and based on my own clients and workflow), I think RAW should be used judiciously. If you are a photographer who may only shoot a minimal number of frames per day, a landscape or architectural photographer perhaps, then RAW is a great option for you, as it will allow you the greatest amount of control over your work.

For those of you who have a more production-intensive schedule, here is a solution that could save hours of post-production off of every day of your professional lives.

Canon allows you several compression ratios for your images (explained elsewhere) and also allows you to shoot RAW and .jpg at the same time. Now, RAW files do take up a fair amount of space on the storage cards, and you may have to buy more cards or download more frequently to shoot both formats, but if you want the convenience of shooting jpegs and the flexibility of RAW, shooting both RAW and high jpeg is the best bet.

On prosumer EOS bodies, and on the Rebel, find and select Quality from the Menu. Select RAW+L. You're good to go (FIG 2.4).

FIG 2.4

Current EOS-1 bodies, 1Ds Mark II, 1D Mark II N, use the Image Size Selection Button (the new Mark III uses the Function button), found on the bottom of the camera's back, along with the Quick Control Dial. The selection is indicated on the camera's rear LCD.

Note that on earlier models, such as the 1Ds, RAW+Jpeg had to be selected in the Menu, along with the desired jpeg quality, in order to obtain both formats. After the Menu selection, use the Quality button and the Quick Control Dial to find RAW. Both files will be created.

When your download is complete, open DPP and compare the two files side by side. If you've really messed up you use the RAW files, fix and process them, and create a file of perfect images. If the .jpg files are perfect (which should always be a goal), ignore the RAW files, make the proofs, and take the orders. Additional tweaking to get a perfect image will be minimal, and can be accomplished when client-selected files are made ready for printing (FIG 2.5).

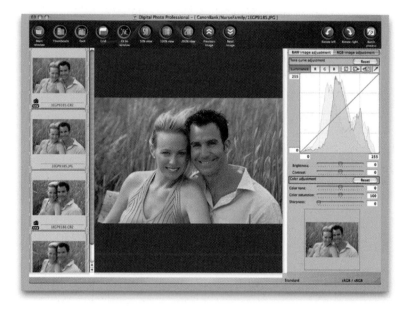

FIG 2.5 As this screengrab indicates, there is no reason to spend extra time processing RAW files

File Accessibility

The question of how to easily access and store files is frequently raised, and is another situation that should be studied by each photographer, then implemented according to individual needs.

Regardless of how you access your files, keeping your primary computer's hard drive full of files you might work on is not the best solution. Some say that computers function best when they are about half-full, and I have no logical argument against that. Using de-fragmenting software assures that the information that comprises your images is stored in as linear a position as possible, which means the search arm of your hard drive won't have to skip all over the drive's surface to reconstruct an image. Also, if you've got free space, you'll never have to worry about having enough room to download a big job.

The important thing to know, especially if you've never experienced it, is that all devices will fail, sooner or later. It's inevitable; a fact of life, and a problem that you must address if you want to keep your images for any reason.

My own workflow solution works like this: After a shoot, I'll download the files and immediately make a CD or DVD of those files (what can I say, I'm paranoid) which goes into a physical file reserved for original data.

I try to shoot as much work as possible in low compression (high quality) jpeg mode, to avoid additional time processing RAW files, and I routinely shoot those jpegs for commercial, stock, or portrait work. With the tight control that I exercise over my lighting and exposure, whether with my Canon's features or through hand-held light meters, my exposures are terrific (and my clients never complain).

If my shoot is deadlined and I will have the file on my machine for a short time, I'll keep it there and do whatever work I need to do on the files my client orders, saving my retouched images as separate files, designated by "v.2" after the camera-given or batch-renamed file name. Once the work is complete I'll burn another disc and file both discs together in an archive file. Once the second disc has been verified I can trash the file off the hard drive.

If my shoot is one I'll have to work on for a while, such as a large group of stock photographs, I'll make the first disc for insurance and keep the data on an external hard drive where I can work on it as time allows. Finished files are renamed to reflect the subject matter and are additionally copied to a special file I call "Saved Work #--," which I back up on another drive and which is burned to two separate DVDs when the file is large enough. These discs are cataloged so I have quick reference to what I've finished and which "Saved Work" disc it's on. Because this is important work, the second disc is kept in a safe place away from my office.

Being able to save more than one copy of an image is a tremendous step above film negatives. Copy negatives were never as good as originals, and if the originals were lost or damaged they could never be re-shot. Still, CD and DVD discs do fail sometimes, and the extra copy is an additional measure of insurance. Please be aware that there is great debate over the longevity of CDs and DVDs. The life expectancy of a standard CD or DVD is somewhat dicey unless it's kept in ideal conditions.

Some say that the Gold CDs and DVDs make all the difference. A quote from the Delkin Devices website regarding their "Archival Gold" CD would indicate: "CD-R's are known to deteriorate quickly due to Earth's common elements: ultraviolet light, heat, and humidity. Using N.I.S.T.'s (National Institute of Standards and Technology) accelerated aging process to test

the longevity of CD-R media, the Archival Gold CD-R's have been shown to safely store your images for more than 300 years."

If you feel your work warrants long-term storage, which is to say, longer life than that of a negative, you owe it to yourself to investigate storage methods and make the best decision for your work. "Diamonds Are Forever," Ian Fleming wrote. Most digital media, as it's currently defined, is not.

Want more info? Type this link into your browser to check out an optical media longevity study from the Library of Congress: http://www.itl.nist. gov/iad/894.05/docs/Public%20SP%20500263%20November%202005.pdf.

I wrote earlier that workflow is slightly different for everyone, and I think there are many important stories to tell. I've interviewed a few high-test Canon shooters and was given insight into their workflow habits, which I'd like to pass on to you. Read each interview to see how others do their jobs, then take what you like and apply it to your own situation.

Paul Gero

"It was surprisingly difficult for me to fully embrace digital. I had such a familiarity for film; there's nostalgia there, but there're some advantages, like dynamic range. I've always liked to think I'm willing to change, but making the total switch to digital was one of the toughest things I've ever done. Younger photographers, who come in without a history in film, well, I think it's easier for them because they have no nostalgia to overcome."

Paul Gero started shooting with film at age 12. He saw his first prints materialize in the developer tray and fell in love with the process. He learned what his equipment could do by shooting as much as he could afford, knowing that photography was his calling.

While attending college, it took Gero 3 years of persistent interviewing to land a job as an intern at the Chicago Tribune, going full time after just 6 months. He began his professional career as a photojournalist thoroughly immersed in the medium of film. "I tried to do everything 'right'," he says. "While the more seasoned guys would soup their film in hot chemistry, and be dry-to-dry in around six minutes, I'd be in the darkroom going the D-76 route, developing for the recommended period of time at the recommended temperature. I've always felt I was recording legacies, not mere assignments."

For a number of reasons, newspapers were on the rise in the 1980s, and, as Gero says, "I was livin' the dream, baby!" Indeed, while under the employ of the Tribune, Gero covered the second administration of Reagan, the conflict in Haiti, and Kennedy weddings.

Even though the majority of Tribune photographers shot a different brand, Gero felt totally at ease with his Canon T90s, working them hard every day, whether on call or shooting for pleasure.

After he left the Tribune, Gero spent the next 18 months as a contract shooter with Sygma, the photojournalism stock photography powerhouse, settling into a stint in Washington, DC. "I was basically working on my own," he said. "I missed the 'group collective' feel of a newspaper. I also realized that being on call 24/7 was no longer that appealing. I wanted my own life."

Gero accepted a job offer from the Arizona Republic, landing in Phoenix on a day that was so hot planes were actually grounded because of the heat danger to the tires, and spent the next several years on a wide variety of assignments. "It was the most fun I ever had," he recalled. "Among other things, I covered the start of both Charles Barkley's and Michael Jordan's pro basketball careers; it was a terrific place to be!"

Branching out, Gero began shooting weddings on the side, mostly for friends. Because it was *terra incognita* to him, Paul says his first efforts were "very posed, highly technical, but without much feeling."

During his parent's 50th anniversary party, Gero had the chance to compare their commissioned wedding album against a second album that had been shot by a friend of his mother's, who'd shot with a Leica in available light. "The shot's from the hired photographer were a lot like mine; technically excellent, no life. That's when it struck me that we don't shoot photos for now, we shoot them for the grandkids, for years from now. Wedding photography is the beginning of a family's visual history."

For Paul, shooting weddings brought back the euphoric feelings he'd had when he first started as a photojournalist. "I realized I'd been missing what I'd gotten into photography for, to see life as it happened naturally and to record those moments."

Paul shoots fine portraiture and quality architectural interiors, too, but weddings are what floats his boat. "I can't wait for 'em," he says. "It's such a loaded situation, good stuff's gotta happen!"

When it does, he's ready. Paul wears two 5D cameras at a time, one with a 24–70 zoom, the other with a 70–200 (or fast primes like the 35 mm f1.4 and the 85 mm f1.8), and shoots everything in RAW because he likes the flexibility for color temperature adjustments more than exposure. "I like to work in reverse, and let the ISO I need be dictated by the f-stop I want to use and the shutter speed I need to get it," he says. "Being exposure-consistent is much more critical than anything else; shooting RAW makes that easy" (FIGS 2.6–2.11).

FIG 2.6 This image was made at a private home in the San Fernando Valley, on the tennis courts. The lighting behind drew me to this angle and I positioned myself to place the subjects in front of the background. Using a 70–200 2.8 IS lens at 2.8 at 1/8th of a second (handheld – this is the reason the IS is so fantastic) I used a bit of fill flash – a 550EX with a Stofen Omni-bounce aimed directly at the bride – to fill the foreground

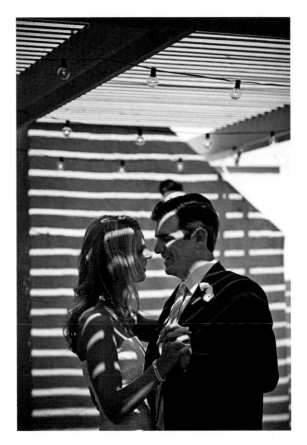

FIG 2.7 The couple dance in the shadows cast underneath the ramada at her home. Using a 70–200 IS at f2.8, 1/1000th of a second (90 mm) at 100 ISO, I was able to isolate them a bit. I converted the image to black and white in Photoshop and darkened the corners to bring the eye back to the couple

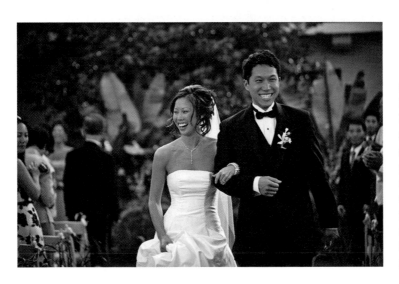

FIG 2.8 In this recessional photograph, I used available light at 400 ISO with a 70–200 2.8 IS lens at 130 mm, 1/400th at f2.8 in manual exposure mode. I stay on the couple for as long as I can as they proceed down the aisle, and then switch to a second camera with a 24–70 mm lens when they get closer to me. Working with two cameras such as I do is very typical of newspaper photographers and I bring that style of working to my wedding photography

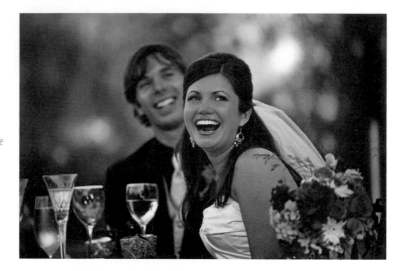

FIG 2.9 During the speeches, I kept a close watch on the couple using a 70–200 2.8 lens (1/320th at f2.8, 200 ISO, 200 mm). This is a tricky scene because you have to watch your metering carefully. The bright values in the background can cause many meters to underexpose the foreground so you have to be aware that may happen

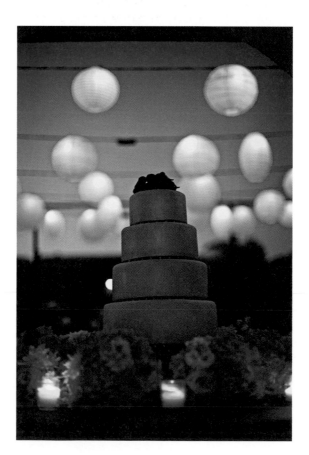

FIG 2.10 I kept watching the cake throughout the afternoon and evening, periodically stopping by to photograph it. But I suspected that the optimum time would be about 20–30 minutes after sunset, so I made sure to come back when the sky was dark blue, and the lanterns lit. It paid off. This image was made with a 50 mm f1.4 lens at 1/30th at f1.6 at 400 ISO, handheld

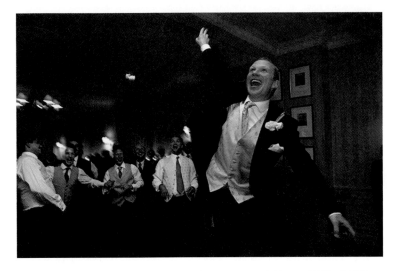

FIG 2.11 Phil tosses the garter at his wedding in London. Using a 16–35 f2.8 lens at 400 ISO and 1/15th at f2.8 with a Canon D60 camera, I knew I had basically one shot at this image (because of the speed of the camera). The slow shutter speed helped render the available light in the scene and the slightly movement and blur during the shot helps give the image some vibrancy

Note: This image was actually shot as a medium fine jpeg and the original file is approximately 8 megapixels when opened in photoshop, though I have taken it up to fit on a spread that is 20 × 15 and it looks amazing (rezzing up in 10% increments). The reason I shot as a medium fine jpeg is that at the time (2002) Compact Flash cards were still very expensive and I would often shoot in jpeg mode to conserve card space. Now, card costs are dramatically lower, RAW processing software incredibly good, and computer processing speeds are much faster.

He also shoots the majority of his frames in Auto White Balance. "Back when I shot color transparency film, exposure was very tight, yet I never let the lack of a critical light meter reading stop me from making an image. I've always been a 'seat of my pants' shooter, and, to be honest, I hate making Custom White Balance adjustments when I'm moving from situation to situation. I'd rather wait until I edit to gang up the similars and fix them all at one time, which is another advantage to shooting RAW."

Editing presents its own problems, since Gero will shoot up to 3500 frames at a wedding, which makes his back-end work quite extensive. "I make four backups before I edit anything," he says. "I have a rack of three Lexar Professional CompactFlash Readers which can download simultaneously through Photo Mechanic, a software program that was originally developed for newspaper photographers. Everything is loaded into a working hard drive as well as a backup hard drive. Then, before I do anything else, I'll burn duplicate DVDs of all the files." After the edit is

complete, he processes the chosen images in Photoshop Bridge. Catalogs of available images are made with IView Media Pro.

"As I envision my workflow," he says, "there is no one piece of current software that I can use for everything. I need one program to download, one to process, and one to catalog."

For lighting on location, Paul is a true minimalist. "If I didn't have to use flash, I wouldn't," he says. "I prefer to keep a low profile." He goes on, "I'm just trying to maintain a documentary look, and I don't want to announce my presence in a room by setting up multiple lights and making white balance adjustments."

For a guy who primarily uses one Canon 580EX on-camera flash, Gero is still able to create an impressively wide range of looks by bouncing or tilting the flash. Unless the flash is bounced off a ceiling or wall, it's most often fitted with a StoFen Omni Bounce, with many effects achieved by varying the camera's ISO speed and the output power of the flash. He knows the newer sensors produce less noise at higher speeds than their predecessors, and he exploits that benefit whenever possible. Most of his shots are made at f2.8 or faster, allowing him to retain about 35% of the scene's ambient light. "I like a splash of tungsten for depth and warmth," he says, noting that he will frequently bounce light off a wall rather than a ceiling but that he always considers the angle of the bounce. "Whatever light I choose has to flatter my subject or it's useless."

When using flash, Paul sets the camera's drive for One-Shot AF, which emits an infrared beam to lock focus. He'll use the AI Servo function

FIG. 2.12 Paul Gero at work, teaching his popular wedding photography class at ShootSmarter University, Aurora, IL

whenever there is enough light, to track focus between shots, although not when he's using flash.

Custom Function 4.1, back-button focus, is "My bread and butter, because I can tap for focus, lock it, and recompose on the fly either in AI Servo or One Shot AF."

In addition to being an extremely busy wedding photographer, the author of a terrific book, *Digital Wedding Photography*, Paul Gero is also a sought-after workshop instructor (just Google him to see what he's up to). Should you have the chance to catch his "One Light Wonder" class, you'll get first-hand instruction on how to make your Canon on-camera flash sing like an Italian soprano (http://www.paulfgero.com) (FIG 2.12).

The Cameras

Digital Rebel XTi

The Digital Rebel XTi is a great, entry level DSLR, for anyone who is curious about the benefits of working with an SLR, anyone who wishes to make the jump from a non-SLR, such as a Canon Powershot, or anyone looking for the ultimate snapshot machine. This is the finest consumer-end camera Canon makes, probably the best made by any manufacturer, but it *is* the first in the lineup and should be considered a basic tool (FIG 3.1).

The XTi features both Basic and Creative Zones on the Mode Dial, a built-in, pop up, flash and a 10.1 megapixel CMOS sensor. Even with the 1.6 conversion factor of the smaller sensor, it's quite sharp, and with clean and accurate color that's easy to judge (although not critically) on its 1.8 inch LCD monitor.

One major physical difference between the XTi and other Canon DSLRs is the lack of a Quick Control Dial on the XTi. Instead, the Rebel uses four Cross-Keys which toggle between selected images but also control ISO, White Balance selection, Metering Modes (there is no Spot meter mode on the Rebel), and the One Shot, AI Focus and AI Servo Auto Focus (AF) Modes (FIG 3.2).

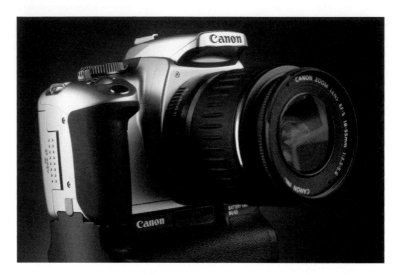

FIG 3.1

I really enjoy shooting this camera, and I have to say that I'm more impressed with it than I thought I would be. As a professional, I'm used to high-end gear and all the performance that comes with it. Even so, this lightweight DSLR is a wonderful machine for the money, especially when shooting RAW, Large jpeg, or both at the same time. I like to have this camera nearby, for everyday family or friend events, just because it's so easy to use and so predictably brilliant (FIGS 3.3–3.5).

Take this as only my advice, but I think that if you're embarking on a professional career, or a film-based pro looking to get into digital photography, the Rebel may not be a camera for you simply because it looks like a consumer machine. I know I might sound arrogant, but I'm talking image here, and image, the look that you present to your clients as you work a job, is as important to your success as the pictures you produce for them to buy. In straight-talking other words, buy equipment that accents your professional image, not gear that a bride's uncle is likely to bring to the event (or that your client may own).

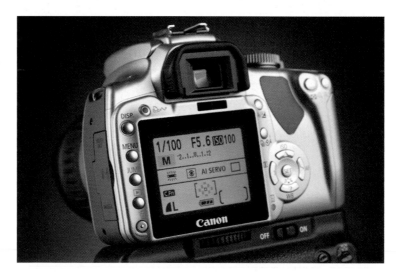

FIG 3.2

Even with its designation as a consumer camera, make no mistake about this machine's EOS title. You will get the benefit of simultaneous RAW and jpeg file capture, Picture Styles, electronically controlled shutter speeds from 30–1/4000 second, and an ISO range of 100–1600. Additionally, you can use any of the EF or EF-S lenses on this machine.

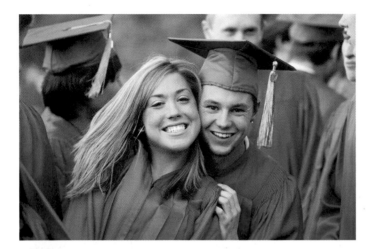

FIG 3.3

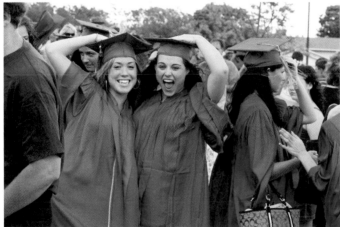

FIG 3.4

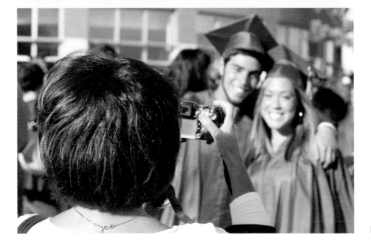

FIG 3.5

EOS 30D

With its nice mix of consumer and professional features, the EOS 30D, the first of Canon's two prosumer models, is worthy of any photographer's gadget bag. Canon has never rested on its laurels, and refines, tweaks, and modifies each new addition to its catalog (FIG 3.6).

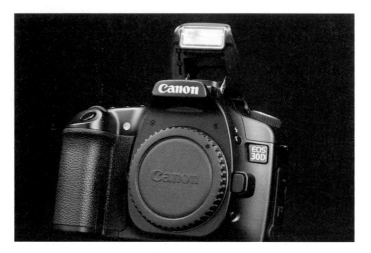

FIG 3.6

The 30D features an 8.2 megapixel CMOS sensor, the Digic II processor (faster than its predecessor), and access to the full line of EF and EF-S lenses. This "Digital Trinity" carries through every EOS camera, assuring you of continuity when you change models or add a second camera.

The built-in pop up flash and Mode Dial (with both Basic and Creative Modes) are the most prominent carryovers from the consumer Rebel, but beyond those the 30D is a very sophisticated machine. Canon added the 3.5% Spot to the light meter menu, along with a 9 point AF mechanism. The five Picture Styles are also included, as is simultaneous RAW and jpeg image capture.

The shutter, rated for 100,000 actuations, will fire in bursts of 3 or 5 frames per second (FIGS 3.7–3.9).

An addition to the 30D is the Multi-Controller, located above and to the left of the Quick Control Dial. The Multi-Controller is an eight key device that you can use to select an AF point, change white balance or scroll around a magnified image, checking focus and lighting on the brilliant 2.5 inch LCD. It's a very useful tool (FIG 3.10).

FIG 3.7

FIG 3.8

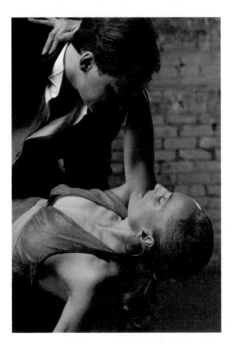

FIG 3.9

FIG 3.10

Many emerging professional photographers opt to start at this end of the scale, and usually for financial reasons. If this describes you, rest assured that your money was well spent, as this is the finest camera you can buy for the price.

EOS 5D

The EOS 5D is one of my favorite cameras of the entire line (FIG 3.11).

FIG 3.11

It costs a bit more than the 30D, but if you can afford it, I think this is the camera to start with. First of all, this unit features a full frame, 24 × 36mm, 12.8 megapixel CMOS sensor, which means no conversion factor. Your lenses will give you exactly what they were designed for.

As this prosumer model is one step below the professional cameras, you can expect to see less of the consumer influence. For example, the pop up flash is gone, and the Basic Zone has been eliminated from the Mode Dial. The Creative Zone remains, of course, with one wonderful addition, the Camera Setting selection (FIG 3.12).

Paul Gero (interviewed elsewhere in this book) said that after shooting film and prime (non-zoom) lenses for so many years, he developed an instinct for how far from his subject he would need to be to get the shot, and that the instinct extended to every lens in his bag.

It wasn't until after he switched to digital that he began to seriously work with zoom lenses, although he still uses his favorite primes. One thing he's never been willing to give up is the full frame sensor, which is why he works his wedding magic with two 5Ds at a time, each with a different lens

FIG 3.12

Canon's made it possible for you to record your favorite shooting settings and get back to them just by turning the Mode Dial to the "C".

It's easy. After you get the AF mode, Metering, ISO, white balance (and many more items), where you want them, activate the Menu and find Register Camera Settings in the Tools submenu. Press the Set button and a new screen will appear. Rotate the Quick Control Dial to OK, and press the Set button again. That's it.

In addition to shooting settings, you can register many Menu settings at the same time, 16 of them, in fact, plus any active Custom Functions. If you're a studio shooter with a preferred setup of, say, ISO 400, 6500 K Color Temperature, top center single AF Point, sRGB color space and Standard Picture Style, you can go out and shoot any other combination you wish, but get your preferred settings back anytime. I know you can easily see the usefulness of this feature (FIG 3.13).

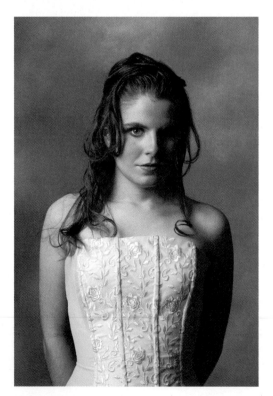

FIG 3.13

The best part? Even if you're set to C, you can make changes to any of the covered settings. If you find you like the new selection better, just register it as you did before, through the Menu.

EOS 1D Mark II N, 1Ds Mark II

It's quite obvious that the 1D Mark II N has been replaced by the Mark III. Yet, the Mark II N is an exceptional machine, and one that held the frame-rate record until the introduction of the Mark III. At the time of this writing, the Mark II N is a very popular machine, is still listed in Canon's product line, and deserves at least a few lines in this book (FIG 3.14).

FIG 3.14

Photojournalists find the 8.5 frame per second rate (up to 48 full resolution jpegs in one continuous burst) enormously useful when covering, well, anything that moves. It's also the camera of choice for many wedding and event photographers, who carry a Mark II N to capture subtleties of expression, and with more frames to choose from, than any other camera could catch. For those moments that don't require the full 8.5 frames per second burst, photographers have second choice, a 3 frames per second rate. This machine also sports an 8.2 megapixel CMOS sensor and the Digic II processor, which explains the exceptional image quality and processing speed (FIGS 3.15–3.17).

As the first in the professional EOS-1 line, the Mark II N's magnesium alloy body is weather sealed, to allow working in mildly inclement weather or under dusty conditions. With a shutter that's designed for approximately 200,000 actuations before service (it's only a guideline, Canons of every model have performed flawlessly well beyond the manufacturer's expectations) it's a terrific machine. The 2.5 inch LCD doesn't hurt, either (FIG 3.18).

FIG 3.15 Although these frames appear to be the same, a fast burst rate assures a great deal of subtlety

FIG 3.16 Although these frames appear to be the same, a fast burst rate assures a great deal of subtlety

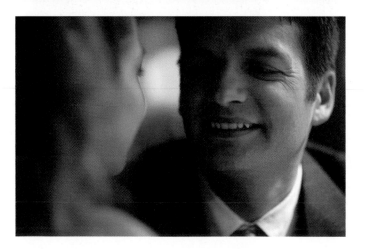

FIG 3.17 Although these frames appear to be the same, a fast burst rate assures a great deal of subtlety

FIG 3.18

The Mark II N's big brother, the 1Ds Mark II features a very impressive full frame, 16.7 megapixel CMOS sensor, large enough to threaten the realm of medium format digital cameras, but with versatility that only comes with a full line of lenses and accessories.

This is the camera for commercial shooters who desire easy, intuitive operation and impressive high quality, wrapped in an attractive and durable package. This is also the camera for Canon portrait photographers who want the largest file possible, for the most enlargement opportunities (FIG 3.19).

Just because a particular model is discontinued doesn't make it worthless.

There are many shooters out there who need, or always want to have, the newest gear. Consequently, whenever Canon introduces a new model, the online auction sites, list sites (such as Craigslists.com), and camera stores see many cameras put up for sale. If you can't afford a new machine, take advantage of new model introduction and spend time looking for used gear. Do your homework and investigate carefully, as these are mostly "as is" sales, but you may be able to acquire exactly what you want at a really sweet price. Be patient. The best deals usually come several months after a new model has been introduced.

FIG 3.19

The Incredible Canon 1D Mark III

For months before the official announcement of what the public had dubbed the Mark III, rumors flew through Internet photography sites at unbelievable speed. Whenever anyone even thought they had a clue, the photography world lined up to read about it (FIG 3.20).

FIG 3.20

Canon did, indeed, introduce the 1D Mark III. What Canon had so cleverly hidden from the rumor mill (and who could blame them?) was that they were not just introducing another model, they had actually reinvented the concept of a digital SLR and what it should do for the person who holds it. Since introducing its first DSLR, the EOS DCS 3, a Canon/Kodak hybrid released in 1995, Canon has noted every complaint, bitch, rant, compliment, praise and suggestion, waiting for the time when technology could produce the greatest camera of its kind.

Does this mean that photographic technology has reached the end of the road? Of course not. Technology moves by leaps and bounds, traditionally doubling in speed and benefits every 18 months (Moore's Law), so you can expect that Canon is already working on goodies that will blow your doors off again, and in the very near future. But, as far as the Mark III is concerned, Canon has produced a machine that does more, and does it faster, than any other camera out there (at the time of this writing).

To do this camera justice, and to provide practical advice for every feature, would require an entire book by itself, and, unfortunately, time and space will not allow me to do that. So let's take a look at some of my favorite features of the Mark III, and how you might apply them to your work.

You'll notice, as soon as you power up the machine, that the LCD indicates automatic sensor cleaning is taking place. Originally introduced on the Rebel XTi, this short burst of ultrasonic vibration cleans the sensor of small dust particles. While it's possible to acquire a chunk of something on the sensor that the cleaner can't remove, almost all of the dust problems we've learned to live with have been eliminated (FIG 3.21).

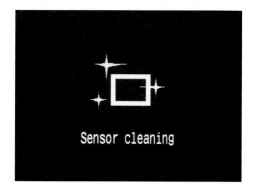

FIG 3.21

If you want to shoot tethered but don't like wires (I know I don't), the addition of a WFT-E2A dedicated Wireless File Transmitter lets you send images via three choices of wireless transfer methods, PTP, HTTP, and FTP, to a computer over a LAN. With FTP, studio photographers can send frames to the studio's lounge area (keeping unnecessary personnel out of the shooting area); event photographers, working with an assistant, can transfer files to be chosen for immediate printing.

Those of you who've worked social events know the bottom-line value of having prints ready for purchase within minutes of making the image.

The Wireless File Transmitter mounts on the camera's side and can also immediately upload to a website, using the HTTP version of the WFT-E2A. When using it, an assistant (in the next room or on another continent) could remotely browse the camera's memory card via any standard web browser and transfer only desirable files. This is a secure operation, by the way, as it requires knowledge of the camera's IP address as well as a password.

The PTP function can also be used to control the camera remotely! You can change settings, focus, and shoot from your computer using EOS Utility, free software that comes with the camera.

Let's move on to the Big Buzz.

It's true! The Mark III will shoot bursts of images at 10 frames per second onto its new 10.1 megabyte sensor and, depending on the write speed of the flashcard or SD card you're using, it will maintain that burst rate until the card is full. Canon promises 110 frames, but tests with a very fast card like the SanDisk Extreme III indicate the camera will write more than 120 continuous frames in a single burst before the buffer fills and forces the camera to take a breath. This sequence represents a full second of the shoot; notice how smoothly the action flows from frame to frame, so close to real-time animation (FIGS 3.22–3.31).

Recently, SanDisk announced its new Extreme IV cards, with the fastest write speed on the planet (at least for now) of 40 megabytes per second. I haven't seen any data from Canon as yet, but at such a speed you should be able to get well in excess of 120 frames in one burst.

For sports photographers, a burst rate of 10 frames per second is a blessing that means the peak of action will not be missed; an entire gymnastics exercise, many from start to finish, can be covered in one burst. For wedding and event photographers, it means fewer missed opportunities. Imagine being able to isolate the one split second that defines an intimate moment, along with frames immediately in front of and behind that image.

FIG 3.22

FIG 3.23

FIG 3.24

FIG 3.25

FIG 3.26

FIG 3.27

FIG 3.28

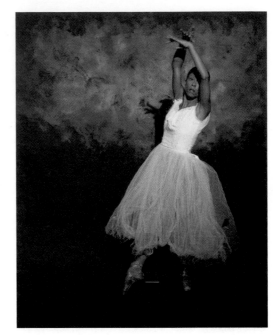

FIG 3.29

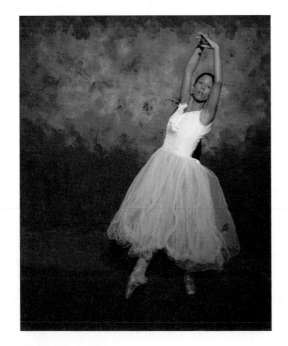

FIG 3.30

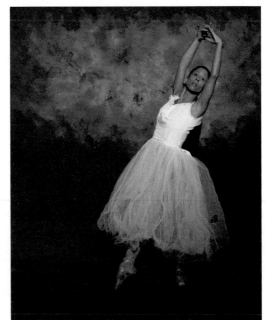

FIG 3.31

Unlike the 30D and 5D, traditional cameras of wedding and event photographers, the Mark III is weather sealed, so should you have to follow a bride and groom out the church into a spring rain, you can do so without fear of ruining your camera (check the manual for full details). It's a safe bet that friends of the couple will not hold their umbrellas over you.

Speaking of wedding photographs, the Mark III addressed the problem of blown out highlights in high contrast situations by extending the dynamic range, the number of tones that can be correctly produced, through a Custom Function, C.FnII:3, Highlight Tone Priority (FIG 3.32).

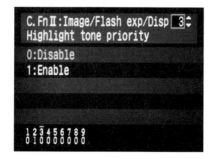

FIG 3.32

When you use it the lowest available ISO will be 200. The ISO designation on the display will change to read 2oo, indicating that Highlight Tone Priority is in use. Event photographers, who do not always have the luxury of testing exposure prior to shooting the "money" shot, have had many problems balancing the bleached and blued whites of a wedding dress against the light-absorbing blacks of tuxedoed groomsmen. Highlight Tone Priority very effectively addresses this problem, as well as the problem of white-on-white tones. Obviously, this Function can be useful for any subject matter that would be improved by an expanded dynamic range (FIG 3.33).

Pixels, and the borders around them, have been redesigned to be much more efficient. The borders, incredibly tiny photodiodes that separate pixels, now deliver the light more efficiently to the chip, lessening noise and allowing for an extended ISO range. The camera defaults to an ISO range of 100–3200. In the digital realm, ISO 1600 was previously noisy, because, up to now, signal amplification at each pixel site presented noise control issues. The ID Mark III carries the next generation of Canon's on-chip noise removal circuit, and the redesigned chip and new noise circuit, working together, are responsible for the amazing reduction in noise. Using an additional Custom Function, C.FnI:3, will extend the ISO range to 50 at the low end and an amazing 6400 on the high end.

FIG 3.33

Canon's instruction manual says that images made at ISO 6400 are "acceptable". I say they are astounding, especially when using C.FnII:2, High ISO Speed Noise Reduction, to suppress noise! Like most of you who read the hype, I was immediately intrigued by Canon's claim, and had to try it myself. I bounced an incandescent spotlight into a large umbrella and shot a series of portraits with the 85 mm f1.2 lens. I set the Mark III to Aperture Priority (at f1.2) so the camera would see the scene exactly the same way, regardless of the change in ISO. You can judge for yourself, but the results absolutely knocked me over, especially when looking at a 30 × 40 enlargement of the ISO 6400 image! (FIGS 3.34–3.41)

The previous set you looked at were all jpegs, straight out of the camera and without any adjustments. When the series was shot, I made the images in both RAW and jpeg, which gave me the opportunity, through DPP, to go to the original RAW file and change it to a Monochrome. Again,

FIG 3.34 ISO 50

FIG 3.35 ISO 100

FIG 3.36 ISO 200

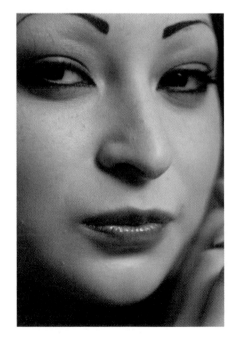

FIG 3.37 ISO 400

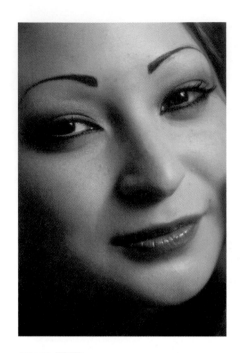

FIG 3.38 ISO 800

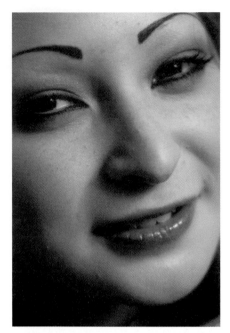

FIG 3.39 ISO 1600

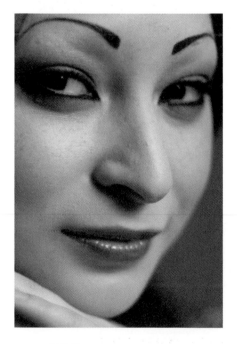

FIG 3.40 ISO 3200

FIG 3.41 ISO 6400

without any exposure or density changes (although I did some minor skin retouching after the fact), I processed the file as it was shot and, again, I was blown away. The result reminded me of Tri-X film processed in a very controllable developer like Rodinal; tight grain, great tonal range, and terrific skin tones. If you like black and white and want a look for your imagery that your competition can't touch (unless they read this book, of course), this could be it (FIGS 3.42 and 3.43).

FIG 3.42 FIG 3.43

When Canon redesigned the camera's back to accommodate the larger, 3 inch LCD, they added a new feature, Live View. If you've ever had trouble framing a shot because of difficulty looking through the viewfinder, like you might have if your camera is positioned quite high, you'll immediately appreciate that Live View allows you to see through the lens. To activate it, turn it on in the Menu, and then deselect the Menu. When you're ready, just push the Set button (the Menu must not be engaged when you do this or you will make a Menu selection) and the mirror will lock up. The LCD will act like a ground glass, letting you see exactly what the lens is seeing.

This feature is helpful if you're not able to shoot tethered but have clients milling about, offering suggestions as to what they want to see. When

you're ready to shoot you can either push the Set button to drop the mirror or just push the shutter button, which will close Live View before taking the picture (FIG 3.45).

FIG 3.45

Painting with light is back! In the early days of photography, and when faced with a cavernous interior that couldn't be easily lit, photographers would set the shutter to Bulb, and lock it open while they creatively "painted" the area with one light, wafting it like a brush across the planes of the image. The results were often spectacular. With the advent of smaller lights, many photographic artists chose to paint smaller subjects with flashlights, hand-held strobes, or custom lights. The inherent noise problems with earlier digital cameras made light painting very difficult, as the exposures were too long to create clean images.

This image was made with a (approximately) 3-minute exposure at ISO 100 by moving a small flashlight across the field of view. Although this is a long exposure, in digital terms, the Mark III produced an image that's entirely free of noticeable noise at 100% magnification (FIG 3.44).

FIG 3.44

Pre-visualizing a crop, in-camera, can be a source of frustration, especially if you'd like to shoot square. You could get a custom screen from Canon or other source, but they can be pricey. Canon addressed this problem in the Mark III via C.FnIV:14, Add Aspect Ratio Information. When you select a preset aspect ratio, bars appear in the Playback image on the LCD, indicating immediately whether you're framing correctly. If you use Live View, the bars appear on the LCD as you look through the lens, for more immediate adjustments and, although they won't appear in a finished image, of course, the bars will be seen, and can be moved around (or ignored), when the image is opened in DPP (FIGS 3.46 and 3.47).

FIG 3.46 The image as seen

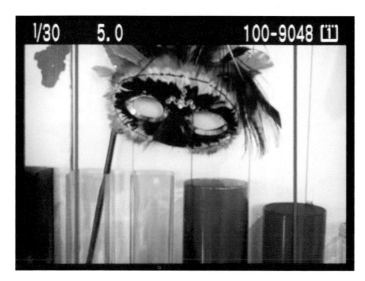

FIG 3.47 As seen on the LCD

There are 57 Custom Functions for the Mark III. To make it easier for you to quickly find what you need, Canon separated them into four groups and placed each relevant Custom Function in the correct folder within the redesigned Menu. As you can imagine, logical placement of these Functions will make your life a lot easier (FIG 3.48).

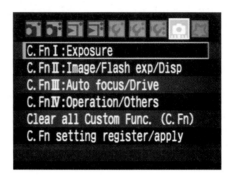

FIG 3.48

Also new to the Menu, the My Menu window displays Functions that you choose to add to the menu such as registered Custom White Balances, Dust Delete Data, a quick jump to Highlight Tone Priority, the invaluable Battery Info window, another quick jump to Format, and your registered personal Menu Settings. Just knowing that I could access this information so quickly rapidly increased my confidence level in the short time I had to work with the machine (FIG 3.49).

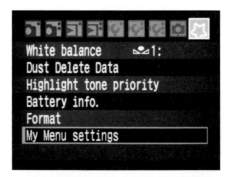

FIG 3.49

From the 19 high-precision, cross-type AF points to the precise Battery Info window (FIGS 3.50 and 3.51), the Mark III should be considered the first of a new breed of camera and a new approach to digital photography.

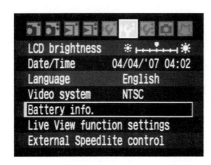

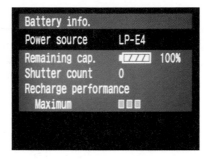

FIG 3.50

FIG 3.51

You could also consider the Mark III a "crossover" camera, with features that appeal to photographers of most every discipline, and you can bet that every new Canon being designed today will incorporate features and technologies introduced by the Mark III.

Common Ground

Wise and Thoughtful Features

All Canon cameras share some common features, giving the system a cohesiveness that any great camera line must have, especially when it's the leader of the pack. Although some of the controls may look different, or be placed in other locations, anyone who's enjoyed one EOS machine can become totally familiar with another EOS model in just a few minutes.

Power Switch

All prosumer and professional Canon cameras have a two-stepped power switch (the Rebel does not). To power the camera up, raise the toggle to either the first or second position. On prosumer EOS bodies, the first position is a general "on" switch with the Quick Control Dial disabled. The second on position will allow you to make exposure setting adjustments. Because the Quick Control Dial is so close to where you may have your thumb when shooting, it's possible to nudge the dial inadvertently. When shooting in Program, Aperture Priority or Shutter Priority, this adjusts your exposure compensation. In Manual, this dial controls aperture. With the dial turned on, it would be possible to throw off the exposure without realizing it, so it's a good idea to keep the power switch in the first position until you want to make adjustments (FIG 4.1).

FIG 4.1

On most EOS-1 bodies, the second power switch only powers the audible signal. On the EOS-1 bodies prior to the 1D Mark III, there is an additional switch, the Quick Control Dial Switch, located in 11 o'clock position just above and to the left of the Quick Control Dial. You may make exposure and vertical focus point adjustments only when this switch is active, however even when turned off, the Quick Control Dial will work for scrolling through the menu or moving around within an enlarged image you are reviewing (FIG 4.2).

FIG 4.2

The Main Dial

The Main Dial is located just behind the shutter button on the camera-right side. You will use this wheel to change Focus Points, make Exposure Compensation adjustments, change ISO, and to control many more functions (FIG 4.3).

FIG 4.3

EOS-1 bodies have an extra Main Dial (with its own on/off switch), along with an additional FEL button and shutter release, located under the camera's right side grip. Called the Vertical Grip Dial, this extra dial allows the photographer to control everything while holding the camera in a vertical position. If you've never had a camera with this feature it may take a little getting used to, but once you do you'll wonder how you ever got by without it (FIG 4.4).

Quick Control Dial

Found on the back of every EOS prosumer model and EOS-1 camera, the Quick Control Dial works in conjunction with a great many of the camera's settings (the Rebel uses a set of Cross-Keys). You will use it to dial through the many Menu items, select AF (Auto Focus) points, make exposure adjustments, or just to check images on the LCD screen.

The Quick Control Dial is also used to change focus points. On the 1Ds Mark II, for example, the *only* way to move your focus point up and down (without employing a Custom Function) is to have the QC dial turned on (FIG 4.5).

FIG 4.4

FIG 4.5

Please note that, on EOS prosumer bodies, you will not be able to use the Quick Control Dial to make exposure changes unless the power switch is set to the second position (FIG 4.6).

FIG 4.6

Shutter Release Button

When holding the camera as if to take a picture, the Shutter Button will be easy to reach with your right index finger (FIG 4.7).

FIG 4.7

The Shutter Button is a two-stepped switch. Push it halfway down and it will activate and set auto focus (AF) and auto exposure metering

(AE) for every Zone except Manual. In Manual Mode, you can use the Quick Control Dial and the Main Control Dial to move shutter speed and aperture until the Exposure Level Indicator is centered or otherwise where you want it to be. If you're using a lens with Image Stabilization, it is also activated by a half-press of the shutter button.

With prosumer EOS bodies, the Exposure Level Indicator is found on the bottom of the viewfinder; with EOS-1 bodies it's found on the right side of the viewfinder.

After pressing the Shutter Button halfway, it will remain active for a few seconds, after which you'll have to press it again to reactivate it.

Pressing the Shutter Button all the way will take the picture.

Should you be checking the Menu or reviewing images, you can return to shooting almost immediately just by pushing the Shutter Button to the halfway position.

Menu

A source of wonder for some photographers, and a source of confusion for others, the Menu can look daunting. Don't let it bother you. My suggestion is to open it, dive in, and play with it. You won't wreck the camera, and if you mess something up and don't know how to fix it, you can always return to Canon's default settings and start from scratch.

Each camera model's Menu is divided by topic and each topic is delineated by an icon. As Canon's models move up the scale, from consumer to prosumer to professional, the number of menu items naturally increases, although the icons are consistent (FIG 4.8).

The number of Menu options varies from model to model, from 17 on the current Rebel XTi to 57 on the new Mark III, but here are some that are common to all models, with explanations of what they do and some practical advice on how to make them work for you.

Quality

Canon cameras provide a number of options for image type from RAW, with the most data and flexibility of all file types that the camera's sensor can provide, to Large (L), Medium (M), and Small (S) jpegs. Each file size will provide high quality images. The difference is in the degree of enlargement a given file will withstand before artifacts and pixelization become noticeable.

Large jpegs deliver a full size file, so if you have a 10 megapixel sensor you will see a 30 mb file (10 mb for each channel of red, green, and blue) when it's opened in software like Photoshop.

Shooting Items

Playback Items

Camera Setup

Custom/Personal Functions

FIG 4.8

Medium jpegs will produce files about one-half the size, or about 15 mb for a 10 megapixel sensor. Basically, the camera ignores about half the data. This reduction in resolution will not be noticeable if the print size does not exceed the capabilities of the file.

Small jpegs will be roughly one-fourth the size of a full file, in this case about 7.5 mb. While you have less opportunity for enlargement, the lower resolution of the file will not be appreciably noticed as long as you understand, and work within, its limitations.

Based on the job at hand, it will be up to you to determine the most efficient resolution choice for your work. High-ticket jobs like commercial, advertising, portraiture, or weddings will generally demand RAW or Large jpeg files. Depending on your camera's sensor size and resolution, images meant for snapshot prints, even 5 × 7s, will look great when shot as Medium jpegs; Small is fine for web use, possibly even for 3 × 5s or 4 × 6s.

Canon cameras offer the opportunity to shoot both RAW and jpeg files at the same time. All models allow at least RAW + Large (aka High) jpeg and RAW + Small jpeg. Newer models also provide RAW + Medium as well as slightly more compressed versions of Large and Small jpegs. With the addition of the new, 2.5 megapixel Small RAW (sRAW) file available on the Mark III, the total number of quality options is a staggering 14 different ways to save your files (FIG 4.9).

Whether you're going to make large prints yourself or send the files off to a lab, it's probably best to not resize them beyond what you can do when converting a Raw file. Photoshop's interpolation software, while adequate, is only a small portion of the entire program and shouldn't be expected to do an A+ job.

Labs use RIP software, programs designed specifically to interpolate imagery, that are much more accurate than what's generally available to us. True, we can purchase RIP software from third-party manufacturers, which we should if our equipment is going to do the work, but it's expensive. I think the expense is justified if the burden is on us, otherwise, let the lab resize them (be sure to ask your lab how they will interpolate your image, of course).

FIG 4.9

Auto Exposure Bracketing

If you primarily work in jpeg, Auto Exposure Bracketing (AEB) is a great little tool, easy to implement, that will help you get even more out of your images. There are many instances in a photographer's career when "just a little more" or "just a little less" would have made the difference between a great image and an outstanding one, but there was no opportunity to download to a calibrated computer to judge the final image. And, although one could certainly shoot RAW and adjust an image

in manipulation software later, that does require more work. Even though it might take only a few minutes, time is money.

When you engage this feature, the camera will set itself to shoot a bracketed series of three exposures, in one-third stop increments, up to three full f-stops under and over the target exposure. This feature works in every Creative Zone mode except Bulb and is perfect for adding a bit of subtlety to your work.

With EOS-1 bodies, push the Mode and AF buttons at the same time. The top LCD panel will change from its usual inclusive display to a minimalist view showing only Exposure Compensation, 0.0, and an icon that represents a bracketed exposure (FIG 4.10).

FIG 4.10

Use the Quick Control Dial to select the amount of difference between exposures (FIG 4.11).

FIG 4.11 This LCD indicates a two-stop spread between the three exposures

The AEB feature is just as easy to use with prosumer EOS bodies. Just find the item in the Menu, select it, and use the Quick Control Dial to set the amount of exposure bracket you wish. Push the shutter three times to record the exposure bracket (FIGS 4.12 and 4.13).

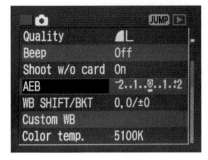

FIG 4.12

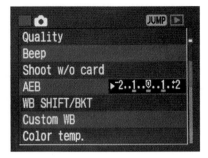

FIG 4.13

Once your picture is composed, click the shutter three times. The first exposure will be what you've determined to be "on the mark," the next will be the underexposed frame, followed by the frame that's brighter than the mark (FIGS 4.14–4.16).

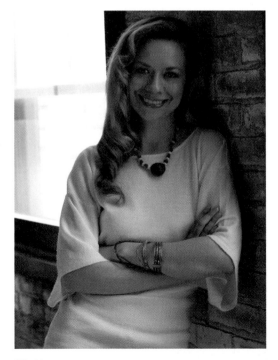

FIG 4.14

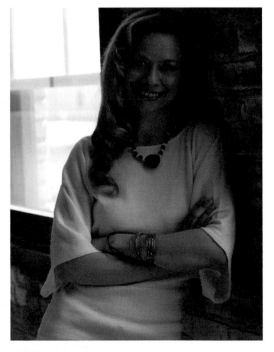

FIG 4.15

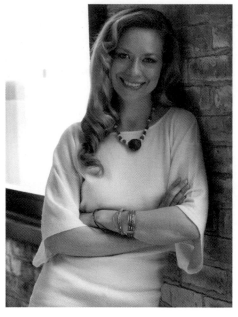

FIG 4.16

Shooting Tip

Use your camera's Drive function and set the motor drive to either the high or low setting. Just depress the shutter button and fire away. The camera will not shoot more than three frames.

Most cameras will allow as many additional series as you wish, and AEB will remain active until you either dial the exposure spread back to zero or turn the machine off. You can change the sequence of shots and whether or not AEB stays active after a series by engaging a Custom Function. Refer to your manual to determine which Custom Function allows this on your camera.

White Balance

From the Rebel to the Mark III, all Canons have a menu of preset white balances. Meant to be used "on the fly" when walking into a scene or under rapidly changing conditions (such as dark clouds moving across sunny blue skies), they are based on predetermined color temperature numbers and will, in a general way, neutralize colors found in the situations they were built for.

Canon has placed eight of these white balance presets into each of its cameras. Let's see how each will interpret the white balance of a typical daylight scene.

AWB (Auto White Balance) will look at any scene as it's being shot and attempt to neutralize the color it sees from 3000–7000 K. It's largely successful, but can be skewed (see Custom White Balance below).

Daylight uses Canon's default color temperature of 5200 K; Shade works at 7000 K; Cloudy at 6000 K; Tungsten at 3200 K; White Fluorescent is set to 4000 K (there are huge color temperature variations in fluorescent lights); Flash at 6000 K; and Custom White Balance, which can neutralize light with a color temperature anywhere between 2000 and 10,000 K. **Photos of bike in snow** (FIGS 4.17–4.23).

FIG 4.17 Daylight

FIG 4.18 Shade

Custom White Balance

One of the most valuable of all the Menu items, using Custom White Balance (Custom WB or CWB) will permit you to neutralize whatever light you're working under, changing the colors of that light, whatever they may have been, to clean, non-biased colors.

FIG 4.19 Cloudy

FIG 4.20 Tungsten

FIG 4.21 White Fluorescent

FIG 4.22 Flash

FIG 4.23 Custom White Balance

Light is not a constant color, except to our eyes and brain. Humans have the cerebral ability to white balance on the fly, interpreting whatever color we see to be neutral, based on our ability to see something we know to be a certain color (white, for instance) and balancing all other colors against that reference. The CWB function of the camera does exactly the same thing, except that the camera can leave us with a physical record, a print, of a situation that has been neutrally balanced.

There are a number of generic white balance settings already in play on every Canon DSLR (explained elsewhere), but they are not nearly as precise as a measured, custom, white balance.

To do this effectively you will need to meter and photograph a neutral gray or white card under the light conditions within the frame. If you're

Although Auto White Balance will do an acceptable job, it is possible that dominant colors in the frame can skew it to produce an off-color image. It's the most important argument for using CWB whenever possible (**FIGS 4.24 and 4.25**).

FIG 4.24 Auto White Balance sees the red background more than the subject and attempts to neutralize the two blocks of color, which it cannot do

working under studio strobes, you will need to use a calibrated flash meter to accurately measure the strength of the light. Either way, it's important to purchase a neutral target. Typewriter paper, tablecloths, bridal gowns, or other objects contain chemicals or bluing agents that make them *look* neutral, but they will not white balance properly because of that chemistry. A commercially available 18% gray target will produce the most accurate white balance.

Check your instruction manual to know how much of the frame you will have to fill to get a correct measurement. I think you should err on the

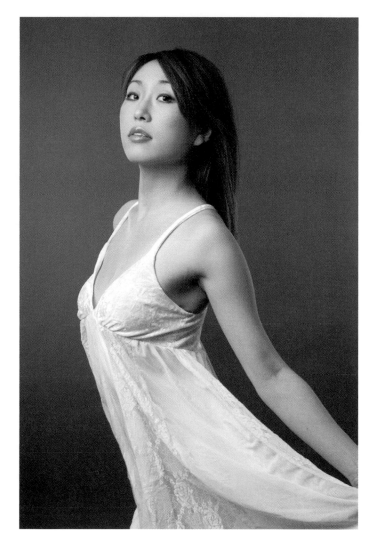

FIG 4.25 *CWB doesn't care what colors are in the scene, only the color temperature of the light that falls into it*

side of caution and fill as much of the frame as you can. It's not necessary for the image to be in focus, although a target like this BalanceSmarter (www.BalanceSmarter.com) with its printed lines, is helpful because you won't have to disable AF to make the shot (FIG 4.26).

In the Shooting menu choose Custom WB (FIG 4.27).

You will be asked to select an image, but the camera always defaults selection to the last image made. If you're happy with that image, press Select (or Set, depending on your model) (FIG 4.28).

FIG 4.26

FIG 4.27

FIG 4.28

On current EOS bodies, if your White Balance icon is not set to Custom, you will be told to set it accordingly. Push the WB/AF button and scroll to the CWB icon. Custom White Balance has been set.

EOS-1 bodies will ask you if you want to "Use this white tone?"

Use the Select button and the Quick Control Dial to choose "OK" (FIG 4.29).

Push the WB (White Balance) button and use the Quick Control Dial to select the CWB icon (FIG 4.30).

FIG 4.29

FIG 4.30

It won't matter if the picture you make of the gray or white card has an off-color cast. Telling the camera that you want it to neutralize that tone will effectively change the color balance of any additional image. You can prove it by shooting another image of the target, but with the data from the first image used for Custom White Balance. The new shot will show a color neutral target (**FIGS 4.31 and 4.32**).

Telling the camera that you want to use this balance is effectively telling the camera to neutralize the color it sees after you select the CWB icon.

FIG 4.31 If you were to shoot some images under daylight, and then move into a fluorescent light environment, the shot you'd make of the daylight-balanced gray target would look off-color

FIG 4.32 A new image of the target shows that bad color has been neutralized

White Balance Shift/Bracket

Similar to Auto Exposure Bracketing, White Balance Shift/Bracket can produce from one to three color variations from a single exposure. It's an interesting feature because you don't need to shoot a bracket set, which means that if you routinely like your images a little warmer or cooler, or a little more yellow or green, you can set the screen where you wish. From the moment the feature is engaged, all of your images will exhibit the color change, regardless of which white balance mode you are in, including Custom White Balance.

To access this feature, open the Menu and select WB Shift/Bracket. Entering that screen will get you what is, essentially a color chart that you can navigate through to select either a Blue/Amber or Magenta/Green bias (FIG 4.33).

On the 30D, 5D and Mark III, you'll use either the Main Dial or the Quick Control Dial (the Rebel doesn't have a Quick Control Dial) to select the number of bracketed images. Use the Multi-Controller to position the bias where you want it (FIG 4.34).

FIG 4.33

FIG 4.34

Note that the 1Ds Mark II and 1D Mark II N access this feature differently. Just check the manual for directions.

Remember, if you don't want multiple exposures, leave BKT at ± 0 (FIGS 4.35–4.37).

FIG 4.35

FIG 4.36

FIG 4.37

Color Space/Color Matrix

Color Space determines the number of colors that will be recorded (the "gamut") when a picture is taken. Adobe RGB (1998) is a wide gamut, recording a very large range of colors. Photographers who photograph for mechanical reproduction on a press (books, catalogs, brochures) should use the Adobe RGB color space so that, when those colors are converted to the very small CMYK reproduction gamut the most information possible will be retained.

For almost all other uses, weddings, portraits, snapshots and the like, the smaller gamut sRGB is all you need. Some have decried the sRGB color space as inadequate, which I don't believe to be true for a number of reasons. For instance, all labs use sRGB printers almost exclusively. From the 1-hour photo kiosk at the mall to the large machines at your pro lab, the sRGB color space is what the machines prefer (only a very few printers, are able to make use of Adobe RGB color space). In fact, your lab may add charges to your bill should you provide them with RGB files that they will have to convert.

Additionally, the Internet is an sRGB environment and doesn't treat Adobe RGB images kindly. Putting an Adobe RGB image on the web will flatten some colors and make it look, well, bad.

Finally, your computer monitor, either CRT or LCD, is an sRGB device and, as such, is incapable of seeing all the colors in the Adobe RGB space. At the moment, there are very few monitors that even claim to be Adobe RGB compatible, fewer still that can live up to the claim (FIG 4.38).

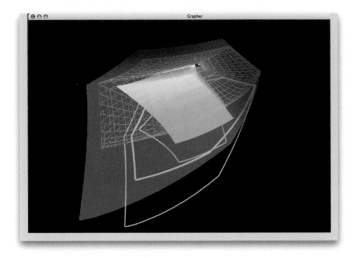

FIG 4.38 This three dimensional representation of three traditional color spaces clearly shows the size of the Adobe RGB space (the largest envelope of color), sRGB (the graphed space), and CMYK, representing mechanically reproduced color

EOS bodies offer your choice of Adobe RGB or sRGB but also offer a second system, Picture Styles (described elsewhere) to change the visual characteristics of the final image.

Early EOS-1 bodies offer five different designations, similar to Picture Styles but using older logarithms, found under Color Matrix. Four of the five are sRGB color spaces, engineered to render images that mimic a number of classic film emulsions. Newer EOS bodies, currently the Rebel XTi, 30D, 5D and 1D Mark III, offer the aforementioned Picture Styles.

Protect

With this feature, you can protect any image from normal erasure. This would be useful should you find yourself running out of card space in the middle of a shoot. All photographers tend to go overboard when shooting digital because there are no processing costs associated with

each image, and usually erase images during the post-shoot edit. When you use the Protect feature you can edit in the field, save your best images, and gain important memory space.

On the Rebel and the prosumer cameras, find Protect in the Playback portion of the Menu, then use the Set button to select it. Images stored on the memory card will appear on the LCD screen, beginning with the last image made. As you scroll through the images, push the Set button for each image you wish to protect. You'll see a small icon, a skeleton key, appear on the image, indicating that the image is locked (push the Set button a second time to unlock the image and void the protection) (FIG 4.39).

FIG 4.39

Protecting an image is faster with the EOS-1 cameras. On the back of the camera, at the top of the row of buttons on the left side (bottom center on the 1D Mark III), is the Protect/Sound Recording button. As you scroll through the images simply push this button when you see an image you wish to protect. It won't matter if you scroll through the images individually or in groups of four or nine, the skeleton key icon will appear on each image you select (FIG 4.40).

Erasing Images

On the bottom of "Button Row," found on the left side of any Rebel or prosumer camera's back, the noble trashcan patiently waits for you to use

FIG 4.40

it. Scroll through the images on the memory card. When you see one you don't want, just push the button. The rear LCD will display three boxes: Cancel, Erase, and All. Use the Quick Control Dial to erase just the selected image (Erase), or to erase every non-protected image on the card (All). You can change your mind by selecting Cancel, or just by pushing the shutter button halfway down (FIG 4.41).

FIG 4.41

Format

In the Menu of every Canon DSLR is a function always designated as Format. Selecting Format will do two things: (1) It will completely erase all data, including any protected images, from the CF (Compact Flash) card,

or the SD (Secure Data) card. (2) It will change a card that has been used in another camera for use in the camera you have in your hand (FIG 4.42).

FIG 4.42

Note that Formatting in camera simply deletes the file directory structure and allows that images on the card to be overwritten. In most cases, the images can still be rescued after an accidental format as long as the card is not overwritten.

Let's look at each in turn.

First, think of a clean CF or SD card as a straight line. When you take two (or more) consecutive pictures on a clean card the camera writes them in sequence, one after another, using as much space on the card as is necessary for a comfortable fit. When the straight line is exhausted, the card says, "Whoa, Cowboy!" (your display may say "CARD FULL"), and won't allow you to take any more pictures until you swap out the card for a fresh one.

Let's assume that, instead of swapping out the card, you choose to go back through the files and eliminate those that are clearly inferior by using the Erase function. Unlike a motored hard drive, which will put bits and pieces of a file wherever there is a little room, your camera's card can only write in a straight line, which means it will place smaller images into whatever larger slots are available or truncate (cut off) larger files which it cannot fit into an existing slot. Aside from files being truncated, a big enough problem by itself, placing smaller files into larger spaces means that some memory space, those little bits and pieces, will not be used. When that happens, there's no way to realize the full memory potential of the card, and you won't be able to get all the images you should.

In practical terms, what does this mean? Simply put, you should re-format each card between uses to maximize its potential. Although you can use the Erase function in the field when you find yourself without enough card space, just erasing individual images, even selecting Erase All, will ultimately hamper the performance of the card.

Reciprocity and ISO

In a stable environment, you can use ISO changes to get closer to a "perfect" image. For example, let's say you're shooting an event with an ambient light level that gives you 1/30th of a second at f2.8, with the camera set to ISO 100, and that combination is not enough to stop the action. Increasing the ISO to 200 (one stop in value) will permit a shutter speed of 1/60th of a second at f2.8. Doubling the ISO again, to 400, will allow a shutter speed of 1/125th of a second at f2.8 (**FIGS 4.45 and 4.46**).

Conversely, if you'd like more depth of field instead, changing the ISO to 200 will give you 1/30th of a second at f4; increasing to ISO 400 will give you f5.6 (**FIGS 4.47 and 4.48**). (See "Reciprocity" for a more in-depth explanation.)

ISO Speed

ISO is a number that indicates the chip's sensitivity to, and is based on formulas presented by the International Organization of Standards (who couldn't get their initials right, but at least did a good job figuring out exposure). Based on a set series of tests, an exposure under a controlled light source at a given shutter/aperture combination will yield a perfect exposure. When the ISO is increased, the same perfect exposure will be attained at a predictable (and constant) shutter/aperture combination. Generally speaking, setting your camera to a higher ISO will allow faster shutter speeds under dimmer light, while lower ISO means slower shutters to record the same exposure.

I say generally, because with any ISO, you can manipulate the shutter/aperture combination for creative effects (FIGS 4.43 and 4.44).

You can set your camera's sensor to record a wider range of ISO speeds than were ever available to film shooters, even those who manipulated

FIG 4.43 A 25th of a second is close to the hand-held shutter speed limit without an IS lens. At f2.8 and ISO 100 the scene was still a little too dark for a good representation

FIG 4.44 Boosting the ISO to 200 is the equivalent of opening the lens one more stop, but without the requisite loss of depth of field

FIG 4.45 The proper ISO 100 exposure was 1/60 second at f8, not quite fast enough to freeze motion in the flag

FIG 4.46 Boosting the ISO to 400 (2 stops) let me shoot the same f8, but now at 1/250 second

FIG 4.47 This marble statue, photographed under a table lamp, required 1/15 second at f2.8. There is almost no depth of field at that aperture

FIG 4.48 Increasing the ISO to 400 allowed f5.6 at 1/15th. Notice how much more "complete" the image appears

film stock by "pushing" or "holding" the exposure in processing, and with incredible precision. Just as you can adjust shutter and aperture values by thirds of stops, so can you adjust ISO.

All Canons begin their default ISO range at ISO 100, with most capping out at ISO 1600 (the Mark III default caps at ISO 3200 but is expandable to ISO 6400!). Except for the Rebel, the ISO on all Canon models may be expanded. Using the correct Custom Function will expand the ISO range to 3200 for most cameras.

ISO expansion works the other way, too, lowering the minimum ISO to 50. This is the solution for when your shot will look better with less depth of field or more blur. Please note that, although the rule of thumb is always to shoot at the lowest ISO possible for maximum image quality, using ISO 50 will actually decrease the dynamic range of the image. This is why Canon puts 50 outside of the normal range and accessible only via a Custom Function. The highest ISO setting, 3200 on most and 6400 on the Mark III is noisier than Canon generally considers acceptable. This is why these ISO settings are not included in the regular selections.

Highlight Alert

It's not totally accurate, but if you are close to overexposure you'll see small portions of your image blink in the LCD. Canon's overexposure threshold is relatively low, and any *minor* blinking areas should not be a huge source of alarm. When you see *major* portions of your displayed image blinking black to white you might want to reevaluate your exposure strategy. Test your own equipment to determine limits you find acceptable, then dial in appropriate Exposure Compensation or adjust your external light meter, if necessary.

Sensor Cleaning

It doesn't matter that you take great pains to mount and dismount lenses properly, or that your particular camera may have a weather seal, sooner or later you will get dust on the sensor, and of a size large enough to leave a shadow of itself on an image. When that happens, the sensor must be carefully cleaned or the spot will probably stay forever.

Most dust is unnoticeable, especially at apertures larger than f22 and against patterned backgrounds. Here's what to do to find out if your sensor is dirty.

First, set your camera's aperture to its maximum aperture (at least f22) and the shooting Mode to Aperture Priority. You'll want the smallest aperture to provide enough depth of field so even small spots will cast a discernible shadow.

Take a picture of any clean, white background, such as a sheet of typing paper. Because you're using the camera's meter on a pure white field, you may have to add Exposure Compensation to get a clean, but not overexposed, white. Make sure the background is evenly lit. It won't matter if the image is in focus or not.

Download your image and open it in DPP or Photoshop. Enlarge it to 100% or 200%, scroll through it to look for crud. My test indicated some small chunks of crud in the frame (FIG 4.49).

FIG 4.49

Canon recommends only one method of cleaning the sensor, rapidly squeezing fresh air from an air bladder onto the sensor while holding the camera upside down. Under no circumstances should you use canned air. While the air may be clean, the propellant itself may spray out and land on the sensor, drying immediately and seriously degrading image quality. Using non-recommended methods may, in fact, void the warranty.

In a clean, relatively dust-free environment, hold the camera upside down and remove the lens or body cap. If removing a lens, place a cap on the mount before proceeding. This will keep airborne dust from landing on the mount or the rear element of the lens. Continue to hold the camera upside down, so loose particles will fall to the floor. Blow any dust off the mirror and the interior assembly (FIG 4.50).

Find and select Sensor Cleaning in the Menu (FIG 4.51).

Your EOS-1 camera may want assurances that you'll do the procedure correctly. Assure it that you mean it no harm and select OK. Prosumer bodies will tell you what to do when you're done (FIGS 4.52 and 4.53).

With EOS-1 bodies, push the shutter button all the way down. Doing so will lock the mirror to the top of the viewfinder. With the prosumer bodies, the mirror will flip up and lock a second or two after you choose the Sensor Cleaning menu item.

Every sensor will eventually pick up some dust, even if you've treated your camera like a member of your own family (hmm, maybe that's a bad analogy), so don't call Canon to complain. It's rare to make this test and not find some dust. The reality is that the vast majority of it will never be seen on your images, even at f22, because image details will very effectively camouflage those tiny spots.

FIG 4.50

FIG 4.51

FIG 4.52 Pro EOS-1 screen

FIG 4.53 Prosumer EOS screen

Use the bladder to blow off the sensor, taking care not to touch the surface of the chip with the end of the bladder. Be sure to blow air onto the corners of the sensor as well as across the center. Dust likes to hide out in the corners (FIG 4.54).

When you're finished, and while still holding the camera upside down, replace the lens or body cap. Turn off the power, returning the mirror to its ready position (FIG 4.55).

FIG 4.55

FIG 4.56

FIG 4.54

As of this writing, both the Rebel XTi and the 1D Mark III feature automatic sensor cleaning which eliminates most of the need for manual sensor cleaning.

LCD Brightness

Canon allows you to adjust the brightness of the LCD screen to suit your environment. If you're working in a studio, for example, the brightest setting may be too bright to provide an adequate estimation of the image quality, and you may think it necessary to adjust the exposure. Working outside, you'll probably want to boost the level as high as possible. Checking an LCD image outdoors is difficult, especially in bright sun, so you'll want all the help you can get. Both EOS body styles use a slider to select brightness with this Function, although they don't have the same design (FIG 4.56).

Rod Evans

Walking into Rod Evans' studio reception room in Sioux Falls, South Dakota, is a bit like walking into an art gallery. Huge (4′ × 6′ inch and larger) prints are hung on sandblasted brick walls over plush sofas and chairs. Large windows, with carefully restored woodwork, illuminate the room with east and north light. Occupying the first floor corner of a building built in 1897 (which he purchased a number of years ago), Evans' studio is a well thought out mix of tasteful elegance and digital convenience.

The beautiful, massive, prints look a lot more like paintings than traditional photographs, and that's intentional. They represent the high end of Evans' considerable talent, and have been worked in Photoshop and Painter, sometimes painted by hand, until he's satisfied he's created an heirloom. Says Evans, "I believe the uniqueness you bring to your work is what people are looking for, so I think the more unique you can be with posing and design, and all the technical info you have will make you better as a creator. Whatever artistic vision you bring to the table will help you survive this market."

Rod Evans draws visual inspiration from one of the great masters of painting, John Singer Sargent. "I'm very passionate about his work," he says, "which gives me passion for my own. I think the more passion you have, as an artist in any media, can't help but make you better. I'm not trying to copy him, I'm trying to be inspired by his work and creativity."

"He had the same challenges that we, as photographers have; pleasing your client and pleasing yourself as an artist. There's a balance you have to create" (FIG 4.57).

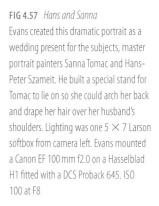

FIG 4.57 *Hans and Sanna*
Evans created this dramatic portrait as a wedding present for the subjects, master portrait painters Sanna Tomac and Hans-Peter Szameit. He built a special stand for Tomac to lie on so she could arch her back and drape her hair over her husband's shoulders. Lighting was one 5 × 7 Larson softbox from camera left. Evans mounted a Canon EF 100 mm f2.0 on a Hasselblad H1 fitted with a DCS Proback 645. ISO 100 at F8

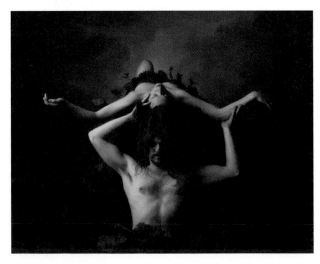

Evans' photography career started as a fluke. "I had a real job (as a sales trainer for Citibank), and someone asked me to shoot their wedding. I said yes, then realized what a huge mistake I'd made. I bought books, a camera, lights, because I knew a huge responsibility this was." He obviously did a good job. "One thing led to the next, and I booked a few more. Pretty soon I had more business than … well, I had to make a decision of one job over the other, and I was completely enamored with photography."

These days, Evans is strictly a portrait shooter, having left the wedding business behind years ago. "We've been fortunate in our market, a city of about 150,000 people which is growing rapidly," he says. "I'm able to work Tuesday to Friday, 9 to 5, and just shoot children and families. The children and family markets are very big right now, segments of the business that are actually growing" (FIG 4.58).

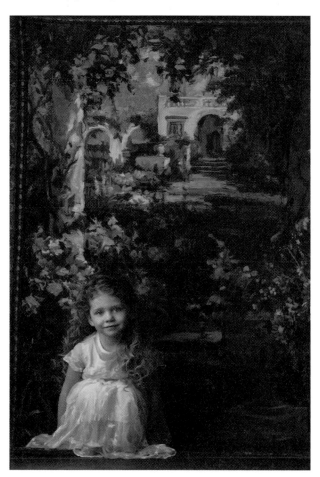

FIG 4.58 *Chloe*

To create a true work of art for this client's home, Evans departed from his tried and true formula of placing the subject 8–10 feet from the background and, instead, had her stand right in front of the tapestry. After some exposures, Chloe tired of standing and crouched down to rest. Evans shot, and knew he had the image he wanted. Because the file was large, Evans split it into nine segments and painted each one individually, primarily using Photoshop's Smudge tool. The incredible number of brush strokes in this image required over 60 hours of work, and was worth every minute of it. Lit by one 5 × 7 Larson softbox, 70–200 mm f2.8 at f11, ISO 100

Evans has always been a Canon shooter. "I had a number of Canon film cameras, including the 1N RS, a fantastic camera," he said. "My first Canon digital was a Kodak DCS 560 (a Canon/Kodak hybrid), one of the first 35 mm digital cameras, which I keep as a memento of my $33,000 foray into digital. Technology moves so fast; today, a camera with its features would cost $800.00."

These days Evans shoots with the venerable EOS-1Ds, although he doesn't use it in a conventional manner. "I like to shoot under incandescent light with the camera set for a Daylight white balance," he says. "It was a mistake I made some years ago, resulting in images with really orange light, but I liked it. Pictures I make this way have a degree of intimacy that I don't see when I shoot 'correctly'. It's amazing what comes out of the camera" (FIGS 4.59 and 4.60).

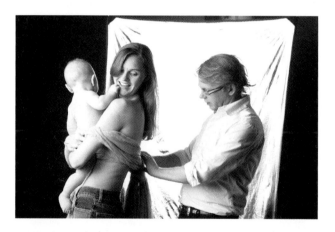

FIG 4.59 Rod Evans adjusts wardrobe for his client

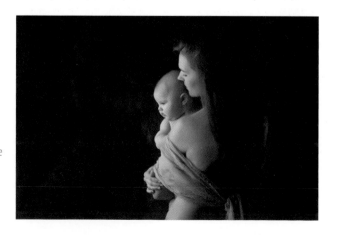

FIG 4.60 *Nicole and Hugh* The finished product. Evans used C.Fn4 (back button focus), Daylight white balance under tungsten light, "To give a feeling of warmth to the love that binds a mother and child." Canon 1Ds, 70–200 mm f2.8 at 1/60 second, ISO 250

He goes on. "There's an intimacy that happens when you don't use flash, even in the studio. Right now probably 85–90% of my portraiture is made without any flash, just higher ISO. When the flash goes off, people relax, but that's the moment I want. So by photographing them without a flash they're always relaxed" (FIG 4.61).

FIG 4.61 *Lily*
Evans perched this beautiful girl on the side of a large table in his gallery, against a large vase of dried flowers. The light was totally natural, north light from three 10' \times 10' windows, no additional reflectors or fill. Since the focus of the image was the girl's eyes, Evans enhanced them in Photoshop, adding blue and purple accents, and changing the catchlights. "I love vibrating color," he says. Canon 1Ds, 70-200mm f2.8 at f2.8, 1/60 at ISO 320.

Does he shoot RAW? "Absolutely," he says. "Is there any other choice?"

Evans processes his RAW files in Capture One. Unlike many other photographers, he edits in-camera first. A typical session with a mother and child, for example, would produce approximately 150 edited images. As he explains, "Obviously, I won't show them that many, only 30, maybe 40. More would be too overwhelming. There's a subtlety I'm looking for. I'm very confident in my ability, so I do a great deal of in-camera editing, checking focus, expression, composition, and getting rid of what I don't like, on the fly, so my final edit will be easier. It saves me a lot of time on the backend. Even though I'm an over-shooter, I'm also an in-camera editor."

Evans' somewhat unorthodox approach to shooting extends to his session philosophy as well. "I want things to go wrong," he says. "I want there to be a mistake. Technically, I understand things; I've studied them for years. I want something to go wrong that will challenge me artistically. For instance, if one of my lights doesn't function properly I won't freak out – I like that because it forces me to do something differently, and I have to adapt and do something new. I invite challenge."

After a somewhat low-tech session, his clients are often surprised by Evans' high-tech presentation. After being seated in what may be the most comfortable leather couch in the world, clients watch as their images seemingly materialize in front of them. "I'm using a rear projector against a screen, called Glassfire, that's suspended in the air on aircraft cable. So the client sits down and watches a presentation, with music, using a program called ProSelect. Think about it; clients know about computer monitors, plasma and flat-screen televisions. I want something the customer will look at and say, 'Wow! I've never seen this before' versus something that's just too familiar."

"The projector I'm using is very old, probably 10 years or more, and it's only 1200 lumens, but I don't need a lot of lumens to show images in a slightly lit room. The whole setup cost about $3000.00, a small price for the "Wow!" (FIG 4.62).

FIG 4.62 *Mr. Kobal*
To create a distinguished portrait of this director, Evans used a silver umbrella on his key light along with a silver reflector at camera right. It's Evans' attention to detail and eye for nuance that makes this portrait so insightful. He used his favorite lens, the 70–20 mm f2.8 at f8, ISO 100

Even though it's taken him years to build up his market, he's not afraid of competition, and freely offers advice to new photographers.

"First, if you're new, you need to learn everything you can learn about this business, so that you can freely create because you have the technical expertise and knowledge. That foundation is so incredibly important."

"Secondly, you have to find out who you are creatively and artistically, so you know what makes you different from your competition. What angle, what direction, what artistic vision, do you have. Find out what makes you excited, takes your breath away and stops you in your tracks. Study it, understand it, learn as much as you can about it, then apply it to your own work. As you learn you'll get even more excited and fascinated about that subject. Your enthusiasm will only grow."

See more of Rod's work at http://www.evansimages.com.

The Zones

Basic Zone

For certain prosumer cameras, like the 30D, Canon offers two options for creative controls. Dubbed the Basic Zone and the Creative Zone, they are meant to be utilized by photographers of varying skill levels to produce great photographs. The Basic Zone, for example, uses icons to indicate automated imaging modes while the Creative Zone requires a deeper knowledge of how things work in a camera.

None of the Basic Zone modes allow changes in white balance, exposure compensation, or exposure beyond what the camera's internal light meter says is correct. Instead, each mode is preset to what a photographer would typically choose for a specific type of image, like a portrait or a landscape. However, if the camera is not able to achieve this effect and still get a good exposure, it will simply attempt a well-exposed image.

The Basic Zone modes do allow for creative cheating. For instance, each mode will allow the lens to focus over its entire range, which means that you could focus on a close object even though you're in Landscape mode. The information that's most critical to your choice of mode is the relationship between the shutter speed and aperture that each mode provides by default.

Full Automatic

The first function, as you might guess, is Full Automatic. Although this function will achieve good results, the photographer allows the camera to make every decision regarding how the picture will be taken and it's not possible to use any function, custom or otherwise, to change the image (you are allowed to turn off the "beep"). If you're using your camera for basic snapshots, Full Auto may be all you need, but the results will be an average look at the scene you're photographing. You'll also be missing about 95% of your camera's capabilities! (FIG 5.1)

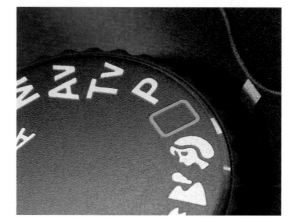

FIG 5.1

Even though Full Auto does not take advantage of the camera's technology, it beats trying to manually set up for a fleeting moment.

I heard a piece of advice (wish I could remember from whom) that actually makes a lot of sense: Always put the camera away with it set to Full Auto or Program. If you happen to come across a "fleeting moment" you'll be ready to go as fast as the camera can turn on and charge up. Certain family moments fall into this category as well as more impromptu activities, like witnessing a bank robbery.

If you have time after first recording the action you can reset the camera for more creative control.

One downside to Full Auto is that the flash may pop up and fire if the camera thinks there is not enough light for a good exposure.

One potential benefit of Full Auto is that the auto focus is set to AI Focus, enabling the camera to switch back and forth between One Shot mode (for stationary subjects) and AI Servo mode (to track moving subjects) based on whether it sees your subject as moving or standing still.

Portrait

The Portrait mode of your camera provides a quick and easy way to make images of your subject (you're not just limited to people) with a soft background because it automatically attempts to set the lens to its widest aperture, for the least amount of depth of field. Reciprocally,

the large aperture (greatest amount of light reaching the sensor) means the camera will choose the fastest shutter speed possible (shortest amount of time necessary to make a proper exposure) so any problems associated with camera shake are minimized or non-existent (FIG 5.2).

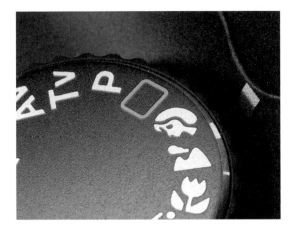

FIG 5.2

In Portrait mode, the camera defaults to a multiple exposure drive. Like a motor drive on a film camera, the camera will fire continuously as long as the shutter is depressed, until either the card or the buffer is full. It's often advantageous to shoot multiple frames of a subject because expressions can be subtle and nuanced. Portrait mode allows you to do that, if you wish.

The soft background one gets when shooting wide open can be accentuated by replacing the current lens with a longer telephoto. Also, the closer you are to the subject, or by using a longer focal length, the softer the background will be (FIGS 5.3–5.5).

Landscape

Landscape mode is meant for normal or wide perspective shots of distant horizons. Cameras set in this mode will default to an aperture somewhere in the middle of the lens' range, giving you some depth of field (it's not usually necessary to shoot landscapes for maximum depth of field) (FIG 5.6).

FIG 5.3 At 70 mm, the background does not intrude into the picture

FIG 5.4 At 100 mm, the background softens more and visually increases in size

FIG 5.5 At 200 mm, the background is extremely soft and delicate, and the subject exhibits a dimensionality unlike the other images. Note that I backed up with each focal length change to maintain the same composition.

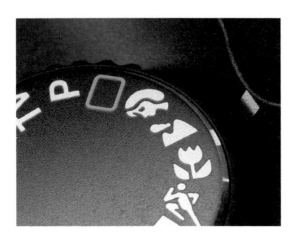

FIG 5.6

The light meter will default to its Evaluative setting, which means that the camera will meter the entire scene, but give emphasis to the area where the camera has chosen to focus. Should you decide you want to lock your focus and recompose, hold the shutter button halfway down, then re-frame and shoot. Landscape mode may be used for interiors, too (FIG 5.7).

FIG 5.7

Please note that exposure information will *not* lock or store in the camera's memory unless the shutter button remains half-pressed. Also, critical focus is almost never possible in any of the Basic Zone modes because the camera is always set to automatic focus point selection. The camera will choose what it wants to focus on; you don't get to select a focus point to use. Yes, you can focus/meter lock and recompose when in Landscape mode, but which focus point or points the camera decides to use is out of your control.

Close-up

When using the Close-up mode, you'll notice the camera will tend to choose an aperture that's not quite wide open, like it does in Portrait (FIG 5.8). The closer you are to your subject, the less depth of field you have, even in manual mode at small apertures. The camera wants to give you just a little depth of field to help showcase your subject with more than just pinpoint focus. At the same time, maintaining a fast shutter speed will help eliminate camera shake that's more obvious when shooting fine detail (FIG 5.9).

Should you find you enjoy close-up (macro) photography, and many people do, take a look at Canon's line of macro lenses. The EF 50 mm f2.5 Compact Macro is an inexpensive yet impressive lens to begin with, and will open up a whole new world for you (FIG 5.10).

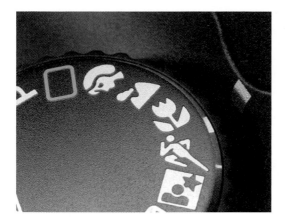

FIG 5.8

FIG 5.9

FIG 5.10

Sports

Got action? Whatever high-speed activity you're shooting, the Sports mode will do a great job of stopping it (FIG 5.11).

FIG 5.11

In this mode, the camera will attempt to give you a combination of fast shutter speed to stop action and, whenever possible, an aperture capable of more depth of field than Portrait or Close-up. Every lens works best at its middle apertures, and the camera will give you those f-stops unless the light level is too low. If that's the case, the camera will set progressively wider apertures, to compensate for the low light and to maintain faster shutter speeds. It's only after the camera has reached maximum aperture that it will allow shutter speeds to slow down. Slower shutter speeds, of course, will result in more blur in the image.

The best thing about using this mode is that the camera switches to AI Servo, which can intelligently track moving objects and keep them in focus from frame to frame, even if they're moving toward the camera. High speed multiple frame shooting is also activated.

To use it, it's first necessary to place the focusing points on the subject, although it doesn't need to be the center focus point as the camera will choose any focus point where there is the best detail and contrast, then hold the shutter button halfway down to activate the focus tracking. The camera will beep when focus is achieved. Push the shutter button all the way down to begin shooting, which you can continue to do until either the flashcard or the buffer is full. This set of snowboard images, shot with a zoom lens at 200 mm, took about 2 seconds to shoot and covered approximately 150', yet each image is in focus (FIGS 5.12–5.16).

Night Portrait

This mode will work best if you have your camera on a tripod, as the camera will automatically hold the shutter open long enough to register

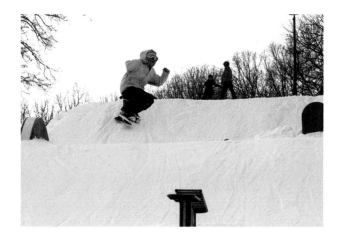

FIG 5.12

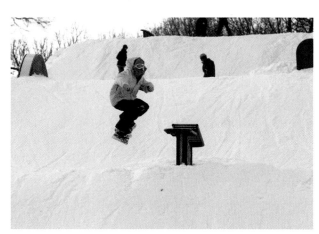

FIG 5.13

FIG 5.14

I wanted to use a sequence shot on snow to illustrate two points:

1. Remember that Basic modes do not allow any exposure compensation.

 It doesn't matter if you're dealing with a film or digital camera; every in-camera light meter can be fooled by a scene that's overly light or dark. The default meter mode, Evaluative, is designed to provide *averages* for whatever scene it looks at. When it sees a frame filled with light tones it tells the camera that it needs a lesser exposure than it actually does. The result is underexposure. If the meter read a frame that was mostly dark the result would be the opposite, overexposure, which would result in an overly bright image.

2. These images were shot as high resolution jpegs, not as Raw files. Still, the RGB Image Adjustment's Tone Curve Adjustment in DPP was more than enough to change the image from a failure to a success (FIGS 5.17 and 5.18).

FIG 5.15

FIG 5.16

FIG 5.17 As shot

FIG 5.18 After adjustment in DPP

background light behind your subject. It works in tandem with flash, either the built-in camera flash or an accessory unit, and the amount of time the shutter will stay open depends, not on the flash, but the brightness of the background light (FIG 5.19).

FIG 5.19 Night Portrait

Flash shots typically show a properly exposed subject but a very dark background because the flash loses intensity as it travels away from the subject. Night Portrait mode works equally well for inside portraits as well, for any subject, in fact, where you'd like some background detail.

It's a good idea to ask your subject to hold still after the flash fires and until you hear the shutter close (FIG 5.20).

FIG 5.20

Flash Off

This mode will disable the camera's command to fire the built-in flash or any accessory flash plugged into the flash shoe. The camera will attempt to give you a combination of shutter speed and aperture that will properly expose the frame but still provide some depth of field. Under lower light, the shutter must stay open longer and the possibility of camera shake exists. Based on the focal length of the lens you have on the camera, the shutter speed indicator light, visible inside the viewfinder along the bottom of the viewfinder window or on the exterior LCD panel, will blink to indicate potential camera shake (FIG 5.21).

FIG 5.21 Flash Off

This mode is particularly useful if you need to photograph a building interior and do not want the distraction or influence of a flash. Also, the Auto Focus function will default to AI Focus to enable the camera to switch back and forth between One Shot and AI Servo automatically. This mode is identical to Full Auto (the Green mode) with the exception that the flash will never pop up (FIG 5.22).

FIG 5.22

The Creative Zone

Within the prosumer line of cameras, the Creative Zone is separate set of functions that may be found on the other half of the Mode dial. On the EOS-1 bodies, the professional line, the Creative Zone is all you get. The Creative Zone offers a huge opportunity for aperture and shutter speed options as well as the use of many of the personal or fine-tuning options like Custom Functions or Exposure Compensation.

Program AE

Like its Basic Zone brother, Full Automatic, Program AE (Auto Exposure) is a general purpose shooting mode and will set shutter speed and aperture in exactly the same way. Still, it offers quite a number of options that Full Auto does not, but here a just a few of the most important (FIG 5.23).

FIG 5.23

You can change the White Balance from Auto White Balance to any of the presets or to a Custom White Balance (always a good idea). Even Color Temperature, a way to dial in a color temperature of choice, is available to you.

If your subjects are too light or dark, you may dial in some Exposure Compensation. This is often necessary when photographing a dark subject against a light background or vice versa.

The RAW file format is available when using Program AE.

All Picture Styles are available (if your camera supports them).

Tv Shutter Speed Priority AE

Tv (Time value), allows you to choose the shutter speed best suited to your creative needs while the camera chooses the correct reciprocal f-stop. This mode is a valuable tool when photographing moving objects because you can easily change the amount of motion blur in your final image, from none at all to as much as you want (FIG 5.24).

Note that if you see the aperture light blinking in the viewfinder or on the LCD display, you will not get a correct exposure (FIGS 5.25 and 5.26).

Shooting Tip

On many of its digital SLRs, Canon allows you to extend the ISO range, via a Custom Function, to a speed as low as ISO 50. This is still not slow enough to allow extraordinary blur of fast moving objects in bright daylight. You may need to purchase and use neutral density (ND) filters, available in a wide variety of densities, to get the amount of blur you want.

Specialty filters like ND are expensive. I always recommend buying filters larger than your largest lens diameter (to avoid potential vignetting issues if you stack two or three together) and using step-up or step-down rings so your one set of filters will fit all of your lenses.

I think it's a good idea to buy a variety of ND filters, perhaps a −2, −3, and −4 stop set. You can stack them together to get up to −9 stops. More than three filters in front of the lens and you'll run the risk of focus aberrations. Performing a Custom White Balance whenever you add ND is also a good idea.

FIG 5.24

FIG 5.25 Even at 70 miles per hour, 1/1000th second is not fast enough to stop all movement in the wheels, although the truck almost looks parked at first glance

FIG 5.26 Panning the camera at 1/8th second (with additional neutral density filtration) produces a beautiful blur and sense of great speed

Av Aperture Priority AE

If depth of field, or the lack of it, is more important than stopping motion you may wish to use the Av (Aperture value) mode. You may wish to shoot a number of close-up images, like portraits (which makes this similar to the Basic Portrait mode) or to the lens' hyperfocal distance. However you apply it, simply set the camera's aperture to the desired size and fire away. The camera will set the reciprocal shutter speed. Unless you see the shutter speed number blinking in either the viewfinder or on the LCD you will get a good exposure (FIG 5.27).

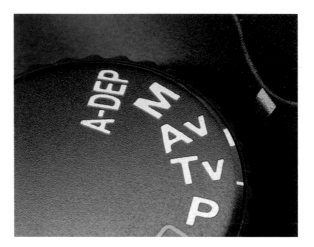

FIG 5.27

Since you can use any of the light meter and auto focus matrices with any Creative Zone mode I'd recommend that you experiment with each. After a little practice you'll have a good idea of what works best for your personal style.

Personally, Aperture Priority is my favorite mode if I'm just walking around, looking for things to photograph, and just want to snap away. I don't usually like great depth of field, so the faster shutter speeds I get with a large aperture, and Canon's rapid ultrasonic motors and image stabilizers, means I can shoot quickly and with confidence under a very wide variety of lighting conditions (FIGS 5.28–5.30).

Manual

Ah, Manual. Manual is probably my favorite mode in the Creative Zone, and for a number of reasons. First of all, using it forces me to think about what I'm doing and what I want to see when I'm done. If I'm on location

FIG 5.28

FIG 5.30

FIG 5.29

for a commercial client I know I can bend the camera to my will and deliver exactly what the art director wants to get. And, of course, working in Manual is indispensable in the studio, where everything must be tightly controlled to be successful (and where semi-automatic modes are almost impossible to work with) (FIG 5.31).

An accessory light meter may be necessary when working in Manual under available light although you can see light levels measured in the viewfinder, a somewhat tedious method. The camera does not set anything, so you'll have to make shutter and aperture adjustments manually. If your studio is equipped with electronic flash, you will need a separate light meter able to measure strobes as well as ambient light.

Some of the Canon line will strobe-sync to shutter speeds as fast as 1/250th of a second. This is often useful if you're balancing strobe light to bright ambient light, so you should be sure to read your camera's instruction manual to find the maximum shutter speed you can use to sync your studio, built-in, or accessory flash units. The faster it syncs, the

Digital imagery demands close tolerances, which means you need to test and possibly calibrate your light meter to your camera. Yes, there can be differences from camera to camera, light meter to light meter, and you'll need to be sure all of your equipment is speaking the same language.

Unlike film, digital files will not tolerate overexposure by more than 1/3 stop, the information is simply not there. Underexposure by more than 1/2 stop can be brought back with image manipulation software but never quite looks "normal."

My friend Will Crockett has devised a method for determining the accuracy of a light meter. It's called the Face-Mask Histogram, and instructions for how to use it can be found at http://www. ShootSmarter.com. ShootSmarter.com is a free site with tons of useful digital information. If you're not a member you'll be asked to sign up. Please do. It only takes a minute, you'll get free updates every month, and they never sell or give your name away. I write a monthly column for ShootSmarter.com, about lighting or other professional topics (and I teach at ShootSmarter University as well).

Once you know that your meter is reading "on the nose," you'll be able to control light with incredible precision. For this four light portrait, for example, the key light, the hair light (from camera right) and the background light were all powered to exactly the same f-stop. The accent light from camera left was powered to exactly 1/3 stop brighter than the others. The result is beautiful, if I do say so myself, all the more so because the light is so tightly controlled (FIG 5.32).

FIG 5.31

more options you have. See "High Speed Sync" in "Flash" for an interesting way to defeat this limitation.

A-DEP

There is more depth of field behind an object in focus as there is in front of that object. A-DEP (Automatic Depth of Field) AE uses nine focus points to determine where to place the primary point of focus to achieve maximum depth of field over a given area. A-DEP is especially useful for groups of people or objects set in staggered distances from the camera (FIG 5.33).

FIG 5.32

FIG 5.33

To use it, simply turn the dial to the A-DEP icon and compose your picture. A-DEP will analyze the data from the focus points and set an aperture adequate to get depth of field over the group along with its corresponding shutter speed. You can see the camera's selection in the information bar along the bottom of the viewfinder or in the LCD display on top of the body.

If you see a blinking shutter speed, either 30 or 8000, it means the subject is either too light or too dark. If the aperture number blinks, it means that proper depth of field could not be attained. Canon recommends either moving further away from the subjects or changing to a wider-angle (shorter focal length) lens. Also, A-DEP will not work if the lens is set to Manual Focus.

It's possible that, with low light subjects, the camera will set a shutter speed that requires a tripod to avoid camera shake (FIG 5.34).

FIG 5.34

David Bicho

A rising star in Stockholm, Swedish fashion photographer David Bicho didn't shoot a paying job until age 30, and then only marketing job for a Swedish governmental institution. "I spent all my awake time for a couple of years, just building my portfolio," he says. "They liked it! I got the job."

Bicho became interested in photography at an early age, as many of us do. "I went on a father-son trip to my father's home town of Lisbon, Portugal. I borrowed my mother's SLR to take some snapshots but was totally captivated by the creative possibilities just by looking through the viewfinder. I shot constantly through the whole trip."

Unfortunately, he wasn't as excited about the results. "After returning home to Sweden I had the negatives developed," he goes on. "I wasn't as fascinated by the results as I was when I took the pictures, but, I was bitten by capturing the world through a viewfinder."

When he was 15, Bicho took a course in television production and spent the next 10 years as a photographer and producer. "I loved the studios; lots of big lights, space, everything about it. Then the IT boom came. I totally reset my priorities, started working as a system developer and dropped everything else," he says. "Then, one day in 2004, I borrowed my mother's Ricoh XR-2, and I haven't stopped shooting since."

Bicho never envisioned an actual career in photography. "People began to see my work, and I got bigger and better clients," he says. "One day it struck me that it might be possible to make a living from this" (FIG 5.35).

FIG 5.35 *Blue*
David Bicho composited two photographs of the blue glass table top to get this somewhat disturbing image of his model, Margareta, seemingly pursued by malevolent hands. The first was made with the model under the table, lit by softboxes and a gridded parabolic reflector. Bicho wanted a cartoonish feel to the shot, so he used a 50 mm f1.4. "Normally, I'd think this lens too wide for this close perspective and, in fact, I did have a problem with the wide field of view and the relatively small table top," he said. "I had to flip the table quite a bit to hide the edge." EOS 5D, 50 mm f1.4 at f9. Makeup and wardrobe styling by Maria Tseva.

At the moment, Bicho still maintains a part-time job at a web bureau in Stockholm, just to be sure the family's bills are taken care of. "My photography is standing for the bigger part of the total family income, but I'm still investing a lot in gear and equipment," he says. "Measured in time, my photography is more than a full-time job."

In terms of fashion, Bicho is "fascinated by trends as phenomenon. In fashion photography there are fashion trends to follow but also esthetic and technical trends that are very inspiring." He goes on, "I love the fact that behind good fashion photography (to my taste) is a total control of details. I'm a control freak, so fashion suits me perfectly, but I also want to select makeup artists and wardrobe stylists who have something to contribute to the shoot. When I do this, everyone in the studio is also inspired."

David Bicho's equipment list is surprisingly minimal, given the look of his results. He shoots with a Canon 5D, with battery grip, and just a few lenses, the 35 mm f1.4L, 50 mm f1.4, 135 mm f2L primes and the 16–35 mm f2.8L and 70-200 f2.8L IS zooms. Along with three BX400 and two BX100 Elinchrom monolights, softbox and umbrella modifiers, Bicho is able to produce some compelling imagery (FIG 5.36).

FIG 5.36 *Sunset*
This image was made for a makeup artist's portfolio and Bicho wanted to create the look of a sunset on a vacation beach. He set up a flash with a small reflector directly behind a large diffusion panel. Because part of the flash is pointed directly at the camera, flare is formed, giving the impression of very bright light. A second light from above gently kisses her chin as it bounces off a reflector panel below. The underlight is typical of a beach reflection. Photographers live to deceive you. This image was created entirely in studio, of course. The hat, which is quite believable as a beach hat was actually made of thick felt. It's the shape and the model's pose that make it work. EOS 5D, 135 f2 at f14

And how does he deal with his images?

"I always shoot RAW," he says. "The only advantage in shooting jpeg is that I wouldn't have to change the memory card after a day's shooting. I see a RAW file as the beginning of an art work. The base material. I want as many possibilities for post-processing as possible. I am, of course, always striving to nail the shot in camera, but I couldn't live with the feeling that I'm locked into that tight (jpeg) corner."

He continues, "I'm a RAW file converter freak. I spent a lot of time testing all the RAW converters out there and I don't have any one favorite. Each one has its strengths, so I use them for different purposes."

"For example, Lightroom is my choice when a lot of images need to be fixed with no time for Photoshopping. The Hue/Saturation/Lightness tool is incredible, as is the Split Toning feature. If there's any drawback to LR it's that it doesn't support two monitors, but the fact that Lightroom will create and upload my web albums makes up for it. That feature is a life quality enhancer since I can go to sleep while it's working."

"When I shoot tethered I work with Capture One Pro. It's stable and renders RAW files beautifully. I also use Raw Shooter, the old RAW converter from Pixmantec that's been discontinued for some time. It was never made for Mac's OS X but runs wonderfully with the Windows emulator Parallels. Raw Shooter has a magic way of making colors look analog, and it makes great black and white conversions, too."

Archiving is a big issue for Bicho. He's tried virtually every application out there but hasn't found any one that suits his workflow, especially since he uses a number of RAW converters and different computers. As he puts it, "My archiving structure is a simple file structure with all RAW files in date order on a lot of hard drives. I also have a Project structure, based on client names, scattered over other hard drives. I would call my archive total chaos."

Bicho also shoots lifestyle stock photography. "I tried to join (a stock agency) with some personal fashion projects but was rejected because of 'poor lighting'. They sent me to a link that explained I couldn't light straight into the camera because this would cause flare. They were so cute and considerate."

Like every good photographer, Bicho continues to evolve. "There is so much to learn in so many different areas is one thing," he says. "But the absurd fact that one puts so much energy, time, and effort to control a hundredth of a second fascinates me" (FIGS 5.37–5.39).

To see more work, visit David's site, http://www.bicho.se .

FIG 5.37 *No legs at all*

Some people can't wait to shoot. Bicho made this image of his makeup artist, Hanna-Cecelia, while waiting for his hairstylist to finish with the "real" model. He lit the shot with a large beauty bowl from the right front and a softbox from behind and to the left. "Yes," he says. "I removed the legs in Photoshop." Canon EOS 5D, 85 mm f1.2 at f10

FIG 5.38 *Big Red Feathers*
"My beautiful model, Margareta, has perfect, flawless skin and unnaturally bright whites in her eyes, perfect proportions . . . it's like she's gone through Photoshop in real life." Bicho accented her features using a very feathered (angled away) softbox on the left and a black foamcore card on the right to deepen the shadows. An additional silver reflector was placed below the model's chest. Makeup by Maria Tseva, EOS 5D, 135 mm f2.0 at f10

FIG 5.39 *Without Trousers*
Working with a colleague, Martin Botvidsson, the two created this evocative image using only one light, a studio strobe with a 40 × 40 gridded softbox from above and an angled reflector card from below. EOS 5D, 50 mm f1.2 at f6.3

Focus, Exposure, and Style

Working With External Light Meters

Today's external digital light meters are miracles for photographers. All of the good ones are able to read in increments of 1/10 of an f-stop and, when they're properly calibrated to *your* equipment, will yield exposures that are impressively exact.

Canon's internal light meters are terrific, too, and you may never come up against a situation where they will not perform admirably. Still, for studio photographers working with either Canon Speedlites in manual mode, or larger studio strobes, in-camera meters just won't cut it – they simply aren't designed to measure non-constant light sources. Don't think you can use the camera's LCD as a light meter, either. It's just not accurate enough to give you more than a general idea of how close you are to perfection.

That said, external meters can be confusing. The extra numbers representing the decimal confuse many, and some largely ignore them. This can create exposure problems, especially with overexposure greater than 1/3 of a stop, so you must take those extra numbers seriously. For example, if you take a reading and you see something like this (FIG 6.1), it most definitely does not mean f11 alone. Rather, the meter is indicating your exposure is f11 plus 2/3 (7/10) of a stop more. To simply set the camera to f11 would mean an overexposure of 2/3 stop, too great to salvage with any software, unless you've shot RAW (which adds to your workflow time) (FIG 6.2).

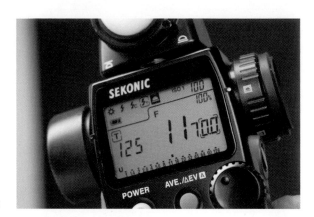

FIG 6.1

FIG 6.2 When an image is overexposed by more than 1/3 stop (f11) there is no way to bring highlight densities back to a "normal" range.

To make matters even more confusing, it's not the same old f8, f11, f16 on the camera anymore. There's a batch of new numbers in between those whole f-stops that are equally confusing. Those numbers, the numeric

counterparts to the decimals, are crucial to attaining correct exposure using an external meter, and the correct f-number for this exposure is f14 (FIG 6.3).

FIG 6.3 When properly exposed (the meter indicated f14) the image will show a correct range of tones and perfect highlight densities.

Here's a chart that will explain how what your meter says corresponds to how you should set your camera, as well as what those numbers mean in terms of exposure. Remember that you should power your strobes to either whole stops or stops at +3 or +7.

The Meter/Exposure/f-Stop Connection

If your light meter reads f	The effective exposure is f	The correct f-number on camera is
2.8	2.8	2.8
2.8.3	2.8 + 1/3	3.2
2.8.7	2.8 + 2/3	3.5
4.0	4.0	4.0
4.0.3	4.0 + 1/3	4.5

If your light meter reads f	The effective exposure is f	The correct f-number on camera is
4.0.7	4.0 + 2/3	5.0
5.6	5.6	5.6
5.6.3	5.6 + 1/3	6.3
5.6.7	5.6 + 2/3	7.1
8.0	8.0	8.0
8.03	8 + 1/3	9
8.0.7	8 + 2/3	10
11	11	11
11.3	11 + 1/3	13
11.7	11 + 2/3	14
16	16	16
16.3	16 + 1/3	18
16.7	16 + 2/3	20
22	22	22
22.3	22 + 1/3	25
22.7	22 + 2/3	29
32	32	32

For those of you who may wish to work in ½ stop increments, here's a chart that explains the concept in those terms.

If your light meter reads f	The effective exposure is f	The correct f-number on camera is
2.8	2.8	2.8
2.8.5	2.8 + 1/2	3.5
4	4	4
4.5	4 + 1/2	4.5
5.6	5.6	5.6
5.6.5	5.6 + 1/2	6.7
8	8	8
8.5	8 + 1/2	9.5

If your light meter reads f	The effective exposure is f	The correct f-number on camera is
11	11	11
11.5	11 + 1/2	13
16	16	16
16.5	16 + 1/2	19
22	22	22

Picture Styles

One of the first big gripes about digital was that it didn't look like film. True enough, and for a number of reasons. Even early digital cameras could produce images that were neutral in tone while film manufacturers were creating emulsions that looked anything but neutral. Kodak's Portra color negative film, for example, was soft and not overly saturated, while Fuji's Velvia transparency stock was more red-rich and very saturated.

Another frustration was digital's inability to easily make high quality black and white images and prints that looked like their darkroom-generated counterparts.

With the release of the 20D, Canon introduced a new control, Processing Parameters. Three preset selections which controlled saturation, contrast, sharpness, and color tone (a shift between yellow and red) allowed the photographer to create photographs with different looks, as well as black and white images. Additional presets were available which could be programmed a photographer's particular taste or situation. Note that with Parameters, each file was always processed with the same basic neutral algorithm, which could be modified by adding or subtracting contrast, saturation, sharpness, or color tone.

Canon upgraded the function by creating a series of unique algorithms, introduced with the 5D and 30D models, and calling them Picture Styles. In addition to each algorithm producing a different look, the upgrade allows variations within each Picture Style, called Detailed Settings. These settings allow for changes in Sharpness, Contrast, Saturation, and Color Tone for each of the Styles, giving photographers even more image control.

There are six native Picture Styles: Standard, Portrait, Landscape, Neutral, Faithful, and Monochrome. I would strongly encourage you to test these extensively, so they might be used to complement your work.

Standard

For general work, Standard is hard to beat (FIG 6.4). Colors are true but slightly exaggerated, with a crisp quality imparted by a built-in sharpness increase. Since I like a little punch in my imagery this is my favorite, everyday, Picture Style (FIGS 6.5 and 6.6).

Portrait

The Portrait algorithm was built for skin tones, producing a look similar to fine color negative film (FIG 6.7). Final prints are not quite as sharp as other Styles (fine portraiture should never be too sharp), and skin tones can be modified by changing the Color Tone feature (FIGS 6.8 and 6.9).

FIG 6.4

FIG 6.5

FIG 6.6

FIG 6.7

FIG 6.8

FIG 6.9

Landscape

Outdoor photographers will appreciate the increased blue and green recognition of the Landscape Style (FIG 6.10). While this Style is not recommended for general portraiture it can certainly be used to produce some interesting effects (FIGS 6.11 and 6.12).

FIG 6.10

FIG 6.11

FIG 6.12

Neutral

Designed to produce color that is not exaggerated in any way. Files produced in the Neutral setting will generally need to undergo some post-processing adjustments (FIG 6.13). By the way, if you are working with a pre-Picture Styles camera, all of your images are produced using the Neutral algorithm, unless Parameters are applied (FIGS 6.14 and 6.15).

FIG 6.13

FIG 6.14

FIG 6.15

Faithful

Faithful is based strictly on math and not on the personal tastes of the engineers who design the processing algorithms (FIG 6.16). Its algorithm reflects color as interpreted colorimetrically, faithful to the numbers that define each particular color or shade of that color (FIGS 6.17 and 6.18).

FIG 6.16

Monochrome

Monochrome, another new algorithm, redefines Canon's traditional Black and White Parameter setting to create totally neutral RGB or sRGB images

FIG 6.17

FIG 6.18

that are full of visual information and rival those produced in a darkroom
(FIG 6.19).

User Defined

With this interface, Canon gives you the option of creating and registering three Picture Styles with your choice of Detailed Settings. For example, you could select the Portrait Picture Style, set the Sharpness to 3 and Contrast to +2, leaving the Color Tone alone. Once set in the camera, this would become User Defined setting 1, available to you anytime you wished to use it (FIG 6.22).

FIG 6.19

Monochrome images made under jpeg compression cannot be returned to their color state with any image processing software but images shot Raw can be converted to any Picture Style (FIGS 6.20 and 6.21).

As I mentioned earlier, Sharpness, Contrast, Saturation, and Color Tone are variable beyond the basic default settings of each of the Picture Styles. For this demonstration I selected the Neutral Picture Style and shot a variation at each end of the scale (FIGS 6.23–6.49).

FIG 6.20

FIG 6.21

FIG 6.22

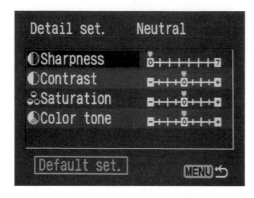

FIG 6.23 Zero Sharpness applied in camera

FIG 6.24

FIG 6.25

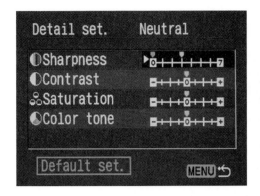

FIG 6.26 Same files with a Sharpness factor of +3

FIG 6.27

FIG 6.28

FIG 6.29 An applied Sharpness factor of +7

FIG 6.30

FIG 6.31

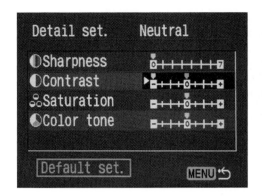

FIG 6.32 Neutral Picture Style with Contrast set to −4

FIG 6.33

FIG 6.34

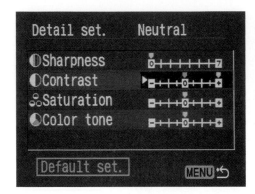

FIG 6.35 Neutral Picture Style with Contrast set to +4

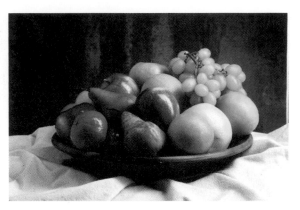

FIG 6.36

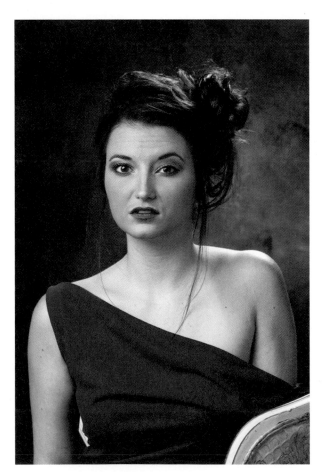

FIG 6.37

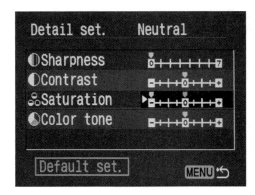

FIG 6.38 Color Saturation set, in camera, to −4

FIG 6.39

FIG 6.40

143

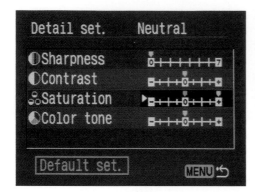

FIG 6.41 Color Saturation set, in camera, to +4

FIG 6.42

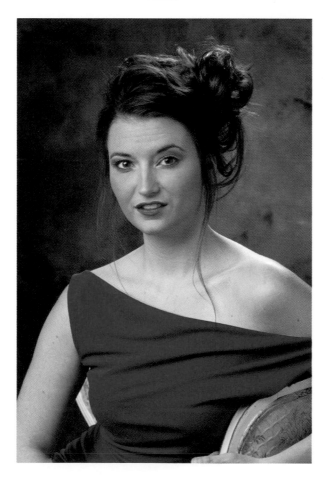

FIG 6.43

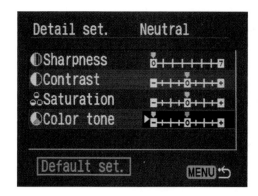

FIG 6.44 Moving the Color Tone slider to the left will skew colors toward red

FIG 6.45

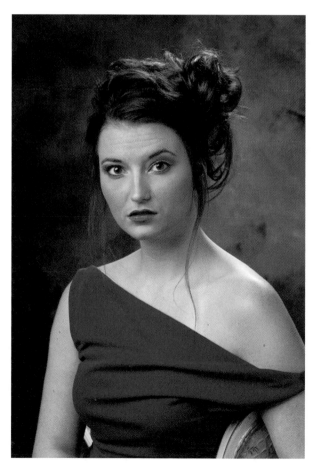

FIG 6.46

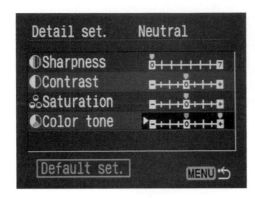

FIG 6.47 Moving the Color Tone slider to the right will skew colors toward yellow

FIG 6.48

FIG 6.49

I used a 30D for this demo, and the interface for this function varies slightly between body styles, so your set up screens may look different. Check your camera's manual to understand what's possible and how it's configured. I'd suggest you then run a test like I did to understand the differences and subtleties you can achieve with your equipment.

Want more? The Canon website has three more Picture Styles available for download: Nostalgia, Twilight, and Clear. You can download these Picture Styles to Digital Photo Professional to be applied to RAW files after shooting. Or you can connect your camera to your computer and add the selections to the camera menu. These new Picture Styles can be downloaded at http://www.cusa.canon.com/content/picturestyle/file/index.html.

Color Temperature

When a perfect white balance is not desired, Canon offers an interesting option. One of the White Balance modes is Color Temperature, designated in the white balance list (on the camera's LCD), by the letter K (for Kelvin). You will find this function on prosumer and professional cameras, but not on the Rebel.

We know, of course, that different types of light have differing color temperatures, measured in degrees Kelvin. Canon cameras, like those of other manufacturers, will take a photograph of a neutral item like a gray card or collapsible gray target and negate any odd color, rendering any subsequent images neutral in color. Sometimes that's just not good enough. Many photographers routinely alter color temperature to add to the mood of the images or to just to add some zip. Color Temperature is one more tool that you can use to set your work apart from that of other less informed or less creative shooters.

Canon uses 5200 K as its default daylight color temperature. When the camera is balanced for daylight, but you're shooting in color temperatures lower than 5200 K, your images will be rendered warmer, with more red and yellow; higher numbers will add more blue and cyan and look cooler. Custom White Balance will neutralize any tested light and add appropriate correction to bring the light to this temperature, but Color Temperature tells the camera that *whatever* light you're shooting in is a particular color temperature, from 2800 to 10,000 K, and will interpret any light to that selection.

It works like this: If you want a warmer look to your images, tell the camera that the light you're working with is cooler than it actually is. The camera will add warm color to counteract what it thinks is cool light, resulting in a warmer shot. The reverse is true if you want a cooler color; just tell the camera that the light is warmer than it actually is and the camera will add blue. The final image will have a cooler feel.

Prosumer and professional cameras access Color Temperature differently, but it's quite easy. Just check your instruction manual for the correct method for your camera.

The use of Color Temperature is practical for a number of circumstances.

Color influences and describes our emotions. If we're having a bad day we might say we're "blue", if we see something exciting we might describe it as "hot" (FIGS 6.50–6.54).

If you know your studio strobes are consistent in color output, setting a higher or lower color temperature will give your images a look that may become a brand "signature" for your work.

FIG 6.50 2800 K

FIG 6.51 4000 K

FIG 6.52 5200 K

FIG 6.53 7000 K

FIG 6.54 10,000 K

FIG 6.55

Sometimes just adding a slight correction will produce a look that's more consistent with how we think a subject should look. For this example I set the Color Temperature to 4800 K, slightly warmer than my strobes. Because the camera added blue, the slightly cooler result of the key light, coupled with the gelled accent lights, gives this image a genuine nightclub appearance (FIG 6.55).

By the way, if you're familiar with hand-held color meters, you can use Color Temperature to dial in a correct temperature, too.

Perfect Focus and Exposure

If you were to define the two most important and determining factors to the success of your imagery (aside from your personal creativity, of course), the ability to automatically place the critical point of focus would have to equal that of perfect exposure. Failure to accomplish either could be the kiss of death to what would have been a great idea.

Camera Metering

All Canon DSLRs are capable of metering exposure, via TTL (Through The Lens) full aperture metering, three or four different ways, each of which is accessed though the Metering Mode button. Note that none of the Rebels have spot metering, nor do any of the cameras that preceded the 30D: the 20D, 10D, D60 or D30. Whether you select Evaluative, Partial, Spot, or Center-Weighted Averaging, you'll get a very accurate exposure for any "average" scene. Note that while you will be able to see the information in the viewfinder, and set the camera accordingly, none of the metering functions will work automatically in Manual mode. All Basic Zones default to Evaluative Metering.

Understanding, in visual terms, what each mode might do for you is crucial to your development as a digital photographer. After all, what's the use of buying this beautiful technology if you never use anything but Program or Full Auto?

Evaluative Metering is the most general purpose metering system, and is the default mode for all of the Basic Zone settings. It is a very sophisticated system based on 35 zones of varying selectivity, with the most important zones located around the active focus point. It will do a great job 90% of the time, but is most useful when you understand that, although it can be fooled, there are ways to outsmart it.

When the AF (Auto Focus) Point selector is set to Automatic selection, and the camera is allowed to look at the scene and determine where focus should be set (usually by the closest objects in the scene), the aperture will be set based on the influence of those objects (FIGS 6.56 and 6.57).

Perhaps a more practical way to use Evaluative Metering would be to set the AF Point selector to an area more in keeping with your compositional goals. If your primary points of interest is on the bottom, selecting one of the lower AF Points would allow you to lock focus and exposure for that object at the same time by placing the AF Point on your subject and pressing the shutter release halfway down. Once focus

FIG 6.56 A dark center surrounded by bright edges is perfect for the Evaluative meter because it will read and average both, resulting in a perfect exposure.

FIG 6.57

FIG 6.58 When the Evaluative meter point is centered, the darker portion of this image will be read

FIG 6.59 Placing the AE point on the subject and holding the shutter allows for easy recomposition

and metering have been set, continue to depress the shutter release and recompose the image if necessary. You may fire when ready (FIGS 6.58 and 6.59).

If your scene features a subject darker than the background you may get successful results by selecting Partial Metering. The area measured by the meter is about 9% of the total frame, in the center. Essentially an oversize spot meter, Partial Metering can be utilized when a dark subject needs to be balanced against a brighter one or vice versa.

If you wish to change the composition of the image after metering for the important information, you will have to engage the AE (Auto Exposure) Lock before moving the camera because the Partial Metering does

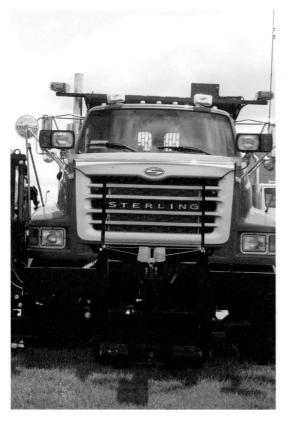

FIG 6.60

FIG 6.61

not correlate with focus points for exposure evaluation. Be aware that Focus Points are not actually used for metering (in any metering mode) although their selection will indicate to the metering system where to place its importance (FIGS 6.60 and 6.61).

To meter an even tighter area, many Canon cameras can use Spot Metering. Using about 3% of the frame, dead center, this function allows for critical exposure evaluation when shooting a difficult subject, a white object on a dark background, perhaps, or vice versa. Proper use of the Spot function can mean the difference between the success or failure of some images which may be so bright or dark as to overly influence the meter (FIGS 6.62 and 6.63).

FIG 6.62

FIG 6.63 Over or under exposure can result from the improper position of the Spot meter. In this case the meter read her dress, not her face

EOS-1 style bodies give the user the opportunity to link their spot meter to one of 11 chosen focusing point (19 on the Mark III) via a Custom Function for precise spot metering even with an off-center subject. Consult your camera's instruction manual to find the correct C.Fn if you wish to use this feature (FIGS 6.64 and 6.65).

FIG 6.64 The Spot meter was linked to the center focus point

FIG 6.65 The Spot meter was linked to the left focus point

The fourth method is the Center-Weighted Averaging Meter, which takes the majority of its reading from approximately 25% of the frame, from the center, then averages that portion against what it reads from the rest of the frame. This function is valuable when you are photographing an object or group that is more important than the surroundings but not significantly brighter or darker than those surroundings (FIGS 6.66 and 6.67).

FIG 6.66

FIG 6.67

When you look at a potential photo op, the first thing you see is usually the most important element. You've trained your eye to see the important details and to tell you how to compose the image. Let's see how Canon can help you capture that vision, beginning with some of the options you have for focusing (and I want to qualify "some of the options" because, while we'll look at specific controls and Custom Functions, you can create personalized control combinations that you can tailor to your special shooting needs).

Please note that Custom Functions may not carry the same reference number between cameras. Refer to your camera's instruction manual for specifics.

Automatic Focus Point Selection

Auto Focus

Manufacturers have created and implemented many versions of AF over the years, but none have been as successful as Canon, mostly because, unlike other companies, Canon designs their entire system in house. Refined during the 35 mm EOS era, Canon has incorporated new algorithms and new chip technology to realize an AF system of unparalleled performance.

Working in conjunction with the super fast Digic processor, Image Stabilization (in some lenses), Ultrasonic Motors and the latest in CMOS imaging sensor upgrades, Canon's AF mechanics are something for them to be proud of, and for you to exploit as just one more tool to make your professional life easier.

To be effective, any AF system must know where to look. Canon's system uses a combination of high-precision cross-type sensors along with a network of single-line assist sensors within the frame for a truly accurate focusing mechanism. Using Canon's AF technology and certain Custom Functions allow you to tailor your focusing habits to your camera, your application, and, ultimately, to the success of your images, at least as far as critical focus is concerned.

Different cameras make different uses of the cross-type and single-line sensors. The Rebel XTi, 20D, 30D, and 5D have one high-precision cross-type sensor and eight single-line sensors. The EOS-1D series bodies (up to, but not including, the Mark III) have 7 high-precision cross-type sensors and 38 single-line sensors. The new EOS-1D Mark III has 19 high-precision cross-type sensors and 26 invisible single-line "assist" sensors. The single-line assist sensors are not selectable on the 1D Mark III, but they are on all of the other cameras mentioned above.

Canon's AF technology permits the achievement of fine focus by allowing the camera to select the area it believes is dominant (it's usually correct), or critical focus by manually selecting the AF point you wish to use.

To default to automatic AF point selection, first press the AF button (FIG 6.68). Depending on your camera, you will use either the Main and Quick Control dials or the Multi-Controller to rotate through the selections until all of the AF points light up or, in the case of the EOS-1 style bodies, they form an ellipse. You can watch the rotation in the viewfinder or, on some cameras, on the camera's LCD. (You can't see the points on the LCD of the EOS-1 bodies.) When the AF points have been selected, aim the camera at your subject and hold the shutter button halfway down. In the viewfinder, you'll be able to see how your camera has evaluated the scene and where it has decided to focus (FIG 6.69).

FIG 6.68

FIG 6.69

Should you decide you don't like the AF points the camera chose, or if the area you wish to be sharp is outside the ellipse, you may move the camera to a better position, push the shutter button halfway to achieve focus, then recompose the image without releasing the shutter button (FIGS 6.70 and 6.71).

FIG 6.70

Some situations may require shot-to-shot focus in a particular area; perhaps a series of portraits in which the subject's face is too far off center to effectively utilize the entire focusing matrix. In this circumstance you can simply use the AF button to select a focus point that's appropriate to your composition.

Auto Focus Modes

In order to use any Auto Focus Mode the Focus Mode switch of the lens must be set to AF. You cannot switch between modes if the camera is set to Full Auto, although you can switch between One Shot, AI Servo, and AI Focus when in Program Mode. You can also change your focus points or use Automatic Focus Point selection (AFPS), which you cannot do when you're in Full Auto or using any Basic Zone.

FIG 6.71

Of the AF modes available on Canon gear, One-Shot AF is suitable for any subject standing still. With AFPS, the AF point which the camera uses to determine focus will flash briefly in the viewfinder, giving you an opportunity to judge whether or not the critical focus area was selected. A Focus Confirmation light will be displayed in the viewfinder.

If focus cannot be achieved, the Focus Confirmation light will blink rapidly. This can sometimes happen even if you're working within the focusing limits of the lens. Areas of flat or minimal detail, like a blank wall, or reflective surfaces like mirrors or windows may send the AF mechanism into what I like to call a "sub-electronic dilemma," racking the lens through a complete focusing cycle that finds nothing to lock onto.

With One-Shot AF and Evaluative Metering, and with Aperture Priority or Shutter Priority selected, the aperture or shutter speed are set at the same time that focus is achieved and will be locked as long as the shutter button is depressed halfway. This allows you to recompose the shot, if necessary, without changing the light meter reading, a useful tool if you'd like to zoom in on an important detail, meter it, then zoom out for the actual exposure (FIGS 6.72–6.74).

161

FIG 6.72 1. Compose

FIG 6.73 2. Meter

FIG 6.74 3. Recompose and shoot

AI Servo AF

By now, there's no question that Canon's Auto Focus is blazing fast and deadly accurate. It's always been one of Canon's better features, and as such is always under improvement. It seems that each new model works faster (and under progressively lower light levels, too). That's as it should be, of course, given not only the cost of the gear, but also what we expect of it. After all, if a manufacturer gives us such a feature we should feel obligated to try to defeat it.

Six months prior to this writing we acquired a new dog, a Golden Retriever puppy my daughter named Romeo because of his bedroom eyes. By the time this book is published I'm hoping Romeo will settle down, get a job, and pay me back for the chew job he did on my favorite loafers. In the meantime, he's become a very social animal and loves to play with his brethren at every opportunity.

At one of his weekly outings at an off-leash dog park, and armed with a Canon 70–200 mm f2.8L IS zoom, I was able to track him almost effortlessly as he played with a new buddy using the AI (for Artificial Intelligence) Servo AF mode. The AI Servo is designed for subjects that move unpredictably so they will stay in focus regardless of how they move within the frame. You might say it keeps track of the subject for you, a feature that was perfect for this demonstration, since the last things on earth to travel in a straight line are two dogs at play. They dodge and weave faster than the most skilled human boxer, and so quickly that the human eye cannot see the details of the game, only the blur of the fun. To make this test more difficult, I used Aperture Priority and set it at f2.8 to get the fastest shutter speed and the least depth of field.

After selecting AI Servo from the Auto Focus options button, start by holding the shutter button halfway down to get the first focus point on your subject, then simply continue to hold the shutter button in the same position, halfway down, for all the exposures in your series. If you let up on the shutter button, you will have to achieve a starting AF point before the AI Servo will kick in again. Note that neither focus confirmation lights nor beepers will be visible or audible in this mode (FIGS 6.75–6.79).

FIG 6.75

FIG 6.76

FIG 6.77

FIG 6.78

FIG 6.79

Canon has also built in what they call Predictive AF, a function within the AI Servo that allows the camera to analyze the movement of objects as they approach or retreat the camera at a constant rate. If you manually select an AF point, the camera will track the subject, predict, and confirm that focus point immediately before making the exposure. If your AF point selection is automatic, the camera will use the center AF point to begin but continue to track the subject as long as it is covered by at least one other AF point within the focusing ellipse. In this case, any active AF point will not light up. Trust it. It works (FIGS 6.80–6.85)

FIG 6.80

FIG 6.81

FIG 6.82

FIG 6.83

FIG 6.84

FIG 6.85

FIG 6.86

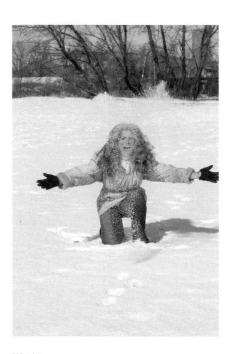

FIG 6.87

FIG 6.88

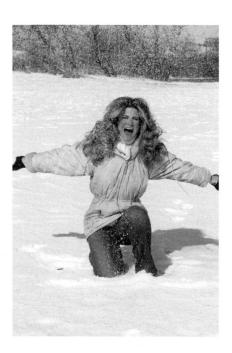

FIG 6.89

FIG 6.90

AI Focus

AI Focus is a nifty little feature that combines the best of One-Shot Focus and AI Servo.

When AI Focus is selected, you can shoot as you would with subjects that are not moving, or moving minimally, essentially One-Shot focusing. Should the subject begin to move with more energy, the camera will automatically shift into AI Servo mode, tracking and predicting the next point of focus. This feature works just as well if the photographer moves toward the subject.

Using AI Focus does not require you to hold the shutter button halfway down during the sequence, it will re-acquire focus frame-to-frame, much more rapidly than if you were using One-Shot Focus (FIGS 6.86–6.90).

At first glance, it would appear that AI Focus is the way to go. After all, an AF program that will track both moving and non-moving subjects should be pretty cool, right? If there is a problem with AI Focus it would be that the camera has to make some complicated decisions in an extremely short period of time. I'm here to tell you, at least for this technological moment, that doing so is a tough job. Personally, I've seen this function

169

succeed and fail, for a number of reasons, not the least of which was that both the subject and I were moving. AI Focus can sometimes mistake a slow-moving subject for a stationary one or, since it has a decision to make, it can miss a fast-moving subject.

Test this for yourself. I'm sure that, with just a little practice, you'll know a whole lot more about how Canon's AF system works.

REGISTERING AN AF POINT

EOS-1 bodies allow you to register specific AF points, via a Custom Function. Using the C.Fn in conjunction with the Assist button enables you to toggle between focusing options. You may wish to have all focus points active as Plan A but only one when Plan B is needed. This technique will switch focus points effortlessly and without removing your eye from the viewfinder.

Any AF mechanism can be fooled for a short time by a number of variables. As always, I suggest you try each feature to determine how it works best with your style of shooting.

I've noticed in lower light situations, such as when a subject is lit by a relatively dim softbox in a studio, and when using the shutter button to focus, it will take a bit longer for the lens to achieve focus. There is a Custom Function (C.Fn), "Shutter Button/AE Lock Button," that uses the AE Lock Button (also known as Thumb Focus, Rear Button Focus or FEL Focus) to act as the AF activator. EOS-1 bodies feature an additional FEL button on the Vertical Grip (FIG 6.91).

FIG 6.91

Wedding, sports photographers, and photojournalists love this feature, because they can focus, and change focus, using a thumb. When a thumb is used to make the exposure it means that focus can be achieved, held, or changed without waiting for the shutter button to find it. If focus is made in this manner, the actual exposure will be made faster than if the shutter button AF mechanism had to be activated before making the exposure. Also, when AI Servo is engaged, focus is continuous, as is the ability of the shutter button to shoot, which means you could change the plane of focus during a burst or suspend AI Servo while waiting for your subject to clear a visual obstacle, re-acquiring focus when you can and starting a new sequence.

It may take a little practice, but once your thumb and forefinger learn to work together you'll appreciate the fractions of seconds this technique adds to your timing skills.

As with most Custom Functions, there is more than one way to use it. Option 2 is terrific for sports photographers or anyone who may pre-focus on a spot and wait for the action to get there. Option 2 will start the AF function on the shutter button but let the photographer suspend that command by pressing the AE Lock (Rear Button) effectively locking focus on the predetermined point. I think you will find this option is most useful when exposure is set manually, as subjects entering the frame may skew the exposure value when either Av or Tv is set.

When Option 3 and Rear Button Focus is selected, and you're using Av or Tv for exposure, there is no AE Lock, so if you're following a moving subject through changing light conditions the camera will adjust automatically to the changing light (FIGS 6.92–6.96).

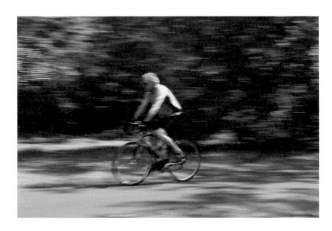

FIG 6.92

FIG 6.93

FIG 6.94

FIG 6.95

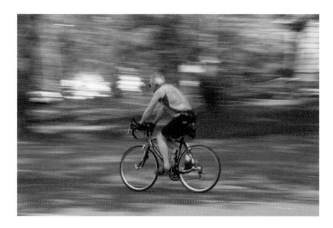

FIG 6.96

Manual Focus Point Selection (MFPS)

You may find it helpful to select a focus point manually. This is a useful function if you have many shots where the primary focus point will fall in a specific area, such as with a series of head and shoulder portraits. In such a case, you will not want the focus point to be influenced by body parts or props; you'll want to keep primary focus on the face. Whether you're shooting vertically or horizontally, you can select the proper focus point by pushing the AF button and selecting the correct focus point using the dials or (on some cameras) the Multi-Controller. As long as your primary focus area falls under this focus point your subject will be in focus (FIG 6.97).

FIG 6.97

EOS-1 pro cameras incorporate a number of Custom Functions that deal specifically with focusing issues, including my favorite, "AF Point Selection Method." This function allows me to reduce the number of focusing points and tie the Spot Meter and Flash Exposure Lock to any of those focus points. This is extremely useful if my primary point of interest is off-center and has a different exposure level than the rest of the image.

Almost all Custom Functions and Personal Functions will work together, which means that photographers can create sets of Functions that favor a particular shooting style or type of shoot. For example, events such as weddings or parties lean heavily on grab-shot photojournalism, with few pictures actually posed. Using the One-Shot AF Mode, with focus achieved by using the shutter button, a photographer might wish to create and apply some or all of the following Custom Functions. I refer to these Functions by title because the numbers may vary from camera to camera; check your instruction manual.

AF Point Selection Method, Option 2. Lets the Quick Control Dial take the job of the AF Point Selection Button, which may allow you to make focus point selections faster.

Number AF Points/Spot Metering, Option 3. This Function limits the number of AF points to 8 around the ellipse plus the center AF point. By limiting the number of AF points focus may be achieved a bit faster.

AF Point Activation Area, Option 1. If you are shooting in a situation with low contrast, this Function will expand the AF activation area, making it easier for the camera to find focus.

Once you have found a favorite set of Custom Functions, you can register and save that set for use anytime. Personal Function (00) will store up to three sets of Custom Functions, which means you can store your favorites for the different subject matter you may shoot on a regular basis without having to remember exactly what they are.

Paul Hartley

With his runner's physique, boyish looks and self-deprecating attitude, one would not necessarily think of Paul Hartley as a driving force in photography. The pun is intended, for Hartley's forte is the world of heavy trucks and long distance transportation and, as both a writer and location photographer of that world, he is rapidly becoming a master of his niche. His articles and photographs have appeared in almost every magazine devoted to the trade as well as the house organs and annual calendars of manufacturers such as Detroit Diesel, Kenworth, International, and Peterbilt. Additionally, Hartley's work regularly appears internationally in such magazines as Australia's *Truckin' Life*.

Although he always had an interest in photography, Hartley began his career, not surprisingly, as a trucker. At age 19 he was a "Beanbagger," a nickname applied to drivers who haul grain. At age 21 he bought his first truck and went interstate, and, at 23, an even bigger truck to make regular runs from the Midwest to the West Coast.

In 1978, while awaiting $6000 worth of repairs to his vehicle, Hartley called his bank and said, "Send money. I'm going camera shopping." He bought a new Canon A1 and a generic zoom lens. "I started my photography career right there," he said. "I photographed trucks, trailers, drivers, landscapes; anything that caught my eye. I wasn't all that good at it, you understand, but it was a great learning experience."

At first, Hartley says, "I had second thoughts about my Canon purchase. I liked my equipment, but I wasn't enthusiastic because I'd been reading about so many other photographers shooting a different brand. I felt I was missing out on something, but I didn't know what it was. At some point I realized that my feelings were a result of advertising, not of quality, and when Canon went digital I knew I was in the right place."

Sliding into a soft Southern accent (that belies his Minnesota roots and which seems to be reserved for truckers and commercial airline pilots), Hartley says, "I woke up one day and thought 'I'm gonna get me a college education. There's more to life than just hangin' on to a steering wheel.'"

Hartley enrolled in Journalism at Mankato (MN) State University. One of the requirements was a photography class taught by John Cross. "He was the best editorial photographer I've ever met," said Hartley. "He had a way of sizing up a composition as he prepared to shoot it, and never overlooked even minor changes of camera angle. Whether the scene demanded a bird's eye or mouse eye view, he would find the best

Paul Hartley's Travel Kit
You may have some trouble believing this!

This man travels heavy. When he's working with a 16 ton rig that may be on location for only a few hours Hartley knows he has to be ready for anything. While he's not opposed to hopping a flight when time demands it he usually prefers driving himself and all of his gear to the location. He's tapped himself into a vast network of fleets and schedules, articles and photographs, and art directors or art buyers, so when he knows in advance where he'll be he notifies as many of them as possible. Consequently, he's frequently asked to leave a day or two early or late, in order to complete another assignment within driving distance of his primary location.

If it's absolutely necessary to fly to a location, Hartley will pull what he feels will be the minimum gear to get the job done. Even then, Paul's idea of minimum always generates extra profits for the airline.

Standard gear

Camera Bag

EOS 1D Mark II

EOS 5D

EF 16-35 F2.8 USM

EF 24-70 F2.8 USM

EF 70-200 F2.8 USM

EF 300 F4 IS USM

Speedlite 550EX Flash

Speedlite 580EX Flash

Quantum Battery 1+ with charger Cables

Sekonic L-358 light meters (2)

Camera-battery chargers (2)

Spare camera batteries (for both bodies)

Spare 1- & 2-gig flash cards (4)

77 mm polarizing filter

Lens cleaning cloth

Operator manuals for cameras

Camera Support

Benbo 1 tripod w/Foba ball head

Hakuba HG-6240C carbon tripod w/Foba ball head

Bogen 3249 monopod w/Foba ball head

Small Tripod Bag

Manfrotto 3333 11-foot light stands (4)

Avenger 36" baby light stands (2)

Large Tripod Bag

Manfrotto 3353 6-foot light stands (2)

Avenger A635B 12-foot light stands (4)

Lightform Bag

Chimera Super Pro 57X72 softbox

Chimera Super Pro 36X48 softbox

Chimera Super Pro 24X32 softbox

Chimera Super Pro 16X22 softbox

Multiple reflective and shoot-through parabolics

Avenger D520B boom arm

Photoflex Litediscs (5, various sizes and colors)

Speed rings (4)

Main Toolbox

Various hand tools

Tape measure

point of view and exploit it. Everything he taught me has proved to be extremely valuable." Obviously true, as Hartley went on part-time staff at the *Mankato Free Press* and then onto staff positions at other newspapers, climbing the ladder until landing a staff writer position at *Overdrive* magazine.

"I'd always done the shooting for my stories," said Hartley. "Once I realized that the art director not only liked my work but found it technically competent I started to freelance on the side, contacting other publications and working as both writer and photographer. I was wearing more than one hat again, but, fortunately, I'm as passionate about my photography as I am about my writing."

Hartley carries two Canon DSLRs, a 5D and a 1D Mark II. He shoots the vast majority of the heavy equipment images with the 5D to take advantage of the larger file size. "Editors appreciate those extra pixels," he says. "Some of their product, like calendars, can be large, so bigger files are definitely better" (FIGS 6.98 and 6.99).

FIG 6.98 "This was one of the easiest shoots I've ever had," says Hartley. "It was 7:00pm with beautiful, warm light, the truck was spotless and the curve of the driveway was perfect." It's hard to believe that this truck, "often confused with a milk hauler," was actually carrying sewage, which it does 5 days a week. Hartley made the image with his 5D and 35–105 mm f2.8 zoom, set at 70 mm

"The Mark II is perfect for press events," he goes on. "I like to shoot in bursts of three to five shots, just to get a perfect expression. Sometimes I'll put my 70–200 mm telephoto on the Mark II and the 24–70 mm wide angle on the 5D, and carry both. I'm pretty much ready for anything" (FIGS 6.100 and 6.101).

"I only use flash if conditions demand it, and then only with second curtain sync, Custom Function 15, in case I want an interesting blur," he says. "I'll custom white balance to the room, of course, and I'll make

FIG 6.99 For a calendar shoot in Wheeling, West Virginia, Hartley had almost no time to get his shot. "The rig belonged to an owner-operator, not a fleet, and he had, as they say, a load for the road." Working with a small window of opportunity, Paul found an abandoned steel mill nearby, and had the driver move his truck into position. "I usually like low angles, but the Art Director said 'don't forget your Little Giant,' so I took that as a hint that maybe I'd been sending in too many low-angled shots," said Paul. "The Little Giant is a 10' foldable step ladder that I don't use often but am always happy to have with me." Hartley used his Canon 5D and 35–105 mm f2.8 zoom lens. "Fortunately for me, the sky that day offered some high thin overcast, which helped soften the light slightly. I wanted a somewhat bolder view, but not too whacked out, so I went with 40 mm of lens length"

FIG 6.100 "Shortly before this scene was photographed, I'd directed the driver to a different setting in a vacant lot. As he was driving toward that location, his right front wheel fell into a sinkhole, dropping the truck onto its bumper. The guy was wholeheartedly displeased in the project at that moment, but he cooled down after a while — especially after International promised to give him a new bumper and light bar. If you look carefully, you can see that the bumper is not quite straight." Hartley later repaired a number of broken lights in Photoshop. The dark, brooding, clouds and the angle of the raised "tipper" trailer make for a very interesting image, and the apparent mass of the truck was visually increased by using a 16–35 mm f2.8 lens

Spare batteries (AA and AAA)

Battery chargers (Quantum and Lumedyne)

Thin gloves (for shooting in cold weather)

FedEx envelopes and pre-printed air bills

Gel sheets (many flavors)

Power strip

"Cheater" plugs for two-prong electrical outlets

Gaffer tape

Duct tape

Strapping tape

Binoculars

Ear protection (handy at auto races)

Blank CDs and DVDs

Stroboframe

Manfrotto 2900 Super Clamp

Manfrotto Magic Arm

Manfrotto 482 mini tripod

Small Toolbox

Canon EF 25 extension tube

Canon EF 2X extension tube

Walkie-Talkies (6)

Lee filters and holder

Assorted connectors

Lumedyne 486 power pack w/3 025 batteries

Operator manuals for all equipment

Cleaning Toolbox

Various detergents and cleaners

Scrub brushes

Towels (paper and cloth)

100-foot garden hose

50-foot garden hose

Spray nozzles

Lights

Elinchrom EL-1000 (3)

Elinchrom Style RX 600 (1)

Elinchrom EL-500 (1)

Elinchrom EL-250 (3)

Elinchrom Ranger RX Speed AS kit

Quantum QFlash

Computer Equipment

17-inch Mac Powerbook

17-inch Apple Display

External keyboard

250-gig LaCie portable drives (2)

500-gig LaCie portable drive

Other

Yamaha EF3000ise generator (3000-watt)

10-foot Little Giant stepladder

4-foot stepladder

8 × 12-foot aluminum lighting frames with removable fabric panels (2)

20-lb sandbags (6)

Empty sandbags (1 case)

Mover's pads (6)

Handcarts (3)

Halogen work lamps (2)

20-ton hydraulic jack

Traffic cones (6)

Fluorescent orange safety vests (2)

FIG 6.101 The location looks European, but Hartley found this beautiful arch at the entrance to the grounds of a private school in Faribault, Minnesota. "I'd originally hoped to capture the coach in the classic three-quarters pose, but the windows provided a little too much reflection to suit my tastes, so we repositioned it behind the arch and shot it almost flat-on. Normally that angle doesn't work at all, but the addition of the arch made for a very pleasing photograph. "To frame the shot and compress the background, Hartley used his 70–200 mm f2.8 zoom "stretched out all the way"

certain to leave that shot on the card. If the color temperature changes, perhaps as the bulbs warm up, I'm able to neutralize any changes after the shots are downloaded."

Paul Hartley's production workflow is relatively simple and efficient. Since the vast majority of what he shoots is meant for publication his cameras default to the RGB color space, and he shoots everything RAW. He's found DPP, Canon's proprietary conversion software, to be especially valuable for batch conversions to the 16-bit Tiff files he prefers. "It takes up a lot of real estate, but it's worth the time," he says. "I just like the power, the control over the image, that I have at 16 bits. When I'm happy with the way my first image looks on my calibrated monitor, I'll apply the recipe and let the machine convert the batch to 8-bit, which is what my clients ultimately want."

"I've offered clients the RAW files," he continues. "Some art directors, in their own minds, are gods in the world of RAW conversion, but no one's ever taken me up on that. They just say 'you convert, I'll interpret' or, 'just send us a good picture.'"

"Once things look good to me, I'll burn to CD or DVD, package it for FedEx delivery and send it out the door and away it goes, along with my invoice. Color management of my RGB files is very important, and my gear is all calibrated to give me the most accurate color I can get, but my images are going to an art director who's probably using a monitor that's calibrated to a specific color space and need (author's note: such as a custom CMYK

space for publication on a specified paper. See 'Workflow' for more information). He or she is going to adjust my RGB files to suit those needs."

Hartley also licenses his images as stock photography (he shoots specifically for stock as well). In addition to archiving every job he shoots on CD or DVD, Hartley keeps a more easily accessible copy on portable LaCie hard drives that reside in his office or pack in his traveling gear, currently over a terabyte of storage, allowing his images to be available to him or to potential clients no matter where he might be. As you can imagine, it could be difficult to quickly find a particular image, and clients can be very picky, so Hartley devised an ingenious system that enables him to rapidly search his files by numbers rather than keywords.

It works like this: Let's say a client is looking for a Peterbilt truck hauling a flatbed trailer on a rural highway in the rain. A keyword search for "12.6.4.4.", Hartley's codes for Peterbilt, flatbed trailer, rural highway, and rain would locate several examples. An additional three or four digit file number would follow, indicating exactly which images would be submitted to the client.

Even though his professional roots are in trucking, Hartley finds many similarities between photography and his former life. "I think some people like trucking because of its unpredictability," he explains. "In a lot of ways it's just like photography. Personally, I thrive in an environment that's ever changing. I just want my voice to come through with every piece I create" (http://www.addmedia.com) (FIGS 6.102 and 6.103).

Heavy-duty extension cords (3 totaling 200 feet)

Multiple water pails

Cannondale mountain bike

FIG 6.102 Who says a photographer's life is a glamorous life? While on his way to an assignment in Texas, Paul drove into a blizzard in Missouri. Not to let that deter him, he pulled off the road to shoot some stock of trucks in bad weather. "I was standing on the roadway about two minutes when this I heard this plow scraping its way toward me. I crouched down and shot a number of frames. This one is the last, captured seconds before I was pelted with snow." As a matter of quality, Hartley prefers to shoot at ISO 100, but bumped the speed up to 200 because that allowed him to shoot at 1/250th of a second at f6.3 with his 24–70 zoom

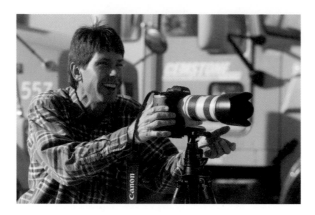

FIG 6.103 Paul Hartley on location at a cement company in Minnesota

The Glass

Lenses

So much glass, so little time.

Is it possible there is one photographer out there using a complete set of Canon lenses? I doubt it (although I have been wrong, on rare occasions). Lenses, to me, are like shirts, and while I have shirts for a wide range of social events, I don't own every shirt available, just those that fit my lifestyle.

Canon makes so many different lenses that it's possible for photographers of every skill level to purchase what's necessary to get their jobs done well while keeping an eye on cost vs. benefits. A studio photographer specializing in portraiture may desire a 400 mm f2.8 telephoto, for example, but the lens will not represent the most intelligent choice for portrait glass.

In the late 1980s, Canon began replacing its award winning FD Lens Series with even better glass, now designated as EF. This new Series incorporates next-generation design specs, and was developed with the entire camera line in mind. Each lens starts with an ideal, large diameter mount, which permits perfect communication between the camera and the lens' auto focus (AF) actuators and the electromagnetically driven precision diaphragm, to control the iris. Canon's Ultrasonic Motor (USM) was originally meant only for the L Series lenses but is now found on almost all of the EF Series.

Here's the real beauty of the EF Series: *Every* EF lens made since the debut of the EOS cameras in 1987 is fully operational on *any* EOS camera, film or digital. Canon recognizes and appreciates your investment!

Canon's EF L Series is the high ground for glass, with aspherical elements (to control distortion), a minimum of one fluorite element (to control secondary chromatic aberration), and UD (Ultra-low Dispersion) or Super-UD elements. Amazingly, Canon developed its own technology, right down to a successful method for creating artificial fluorite.

Shine a light into an L Series lens and you'll see a spectrum of colors. This is Canon's Super Spectra Coating, a system by which individual lens elements are coated with different substances to, among other things, reduce flare and ghosting (from internal reflections), assure consistent color balance, absorb ultraviolet and prevent white from shifting to yellow. "Wow!" is the only word that sums up what Canon has been able to do, and the lens' performance lives up to it.

Depending on which camera you have, you may have to deal with a "conversion factor," the difference between the focal length of the lens and how your camera's sensor sees that focal length.

Lenses are designed to effectively cover a full 36×36 mm circle, so full size CMOS sensors, as you'll currently find on the 5D and IDs Mark II (and earlier on the 1Ds) can take advantage of the full focal length of any compatible lens. All other Canons have smaller sensors, which require a conversion factor to determine a focal length as those cameras see it.

The Rebel XTi and the 30D have the smallest chip size of any of the DSLRs, and a conversion factor of 1.6. The 1D Mark II, Mark II N and Mark III have conversion factors of 1.3. When you multiply a focal length by the conversion factor, that number will give you the focal length of that lens *as your camera sees it*. Thus, a 100 mm lens on a 5D or 1Ds Mark II will have the angle of view of a 160 mm lens on a Rebel or a 30D, or a 130 mm lens on a 1D Mark II, Mark II N or Mark III (FIG 7.1).

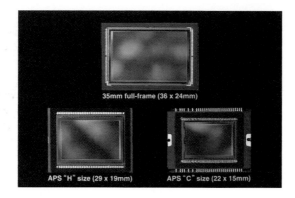

FIG 7.1

Note that a conversion factor only affects the angle of view of a lens, not its telephoto or wide-angle strength.

Canon currently manufactures an impressive number of lenses in its EF Series. I certainly don't have them all, and have never wished that I did, but I do have some favorites that I use relevant to what my assignments demand, and I'd like to share those selections with you.

EF 14 mm f2.8 L USM Aspherical

Because this lens uses an aspherical lens element, typical "fisheye" distortion is largely avoided, and it functions as an ultra wide-angle instead. And I do mean ultra. With an angle of coverage of 114°, it's the widest L lens in Canon's line up (as of this writing).

I've found this lens to be wonderful for landscapes and cityscapes; its ultra wide angle of view actually heightens the reality of a scene by visually pushing everything away and expanding perspective or by allowing a foreground object to be much more dominant than it was in real life (FIG 7.2).

Wide-angle lenses are more prone to "keystoning," an effect whereby vertical lines slant left and right, up or down, from center, and the ultra wide-angle lenses even more so. While keystoning can be avoided by placing the horizon of the image across the middle of the lens, the fact that it happens can be visually exploited as a way to direct the viewer's eye through the image or to an area of particular interest (FIG 7.3).

FIG 7.2

FIG 7.3

One thing that I've always enjoyed about the 14 mm is that the image is so wide it's possible to crop it to a long, narrow aspect ratio, which gives the impression of a panoramic image without stitching together individual images or when a tripod is not available to correctly line up those individual frames. Cropping also allows you to move the centered horizon up or down to a more compositionally friendly location (FIG 7.4).

FIG 7.4

EF 15 mm f2.8 Fisheye

This is one of the most fun lenses Canon has ever built. Aside from its impressive 180° angle of view (measured diagonally across a 24 × 36 mm, 35 mm size sensor), the inherent ability of this lens to distort

both foreground and background creates images that are uniquely interesting. A viewer simply *has* to look at them, if for no other reason than to try to figure them out (FIG 7.5).

FIG 7.5

Wide-angle lenses are capable of more depth of field than normal perspective or telephoto lenses. Thus, at small apertures, it's possible to get what appears to be sharp focus from the closest working distance (0.2 m/0.7 ft in this case) almost to infinity (FIG 7.6).

FIG 7.6

As with any lens, but certainly true of wide angles, distortion is minimized when the horizon is framed at the center (FIG 7.7).

85 mm f1.2

This lens is a photojournalist's dream. Super fast and dead-on sharp, its slight telephoto focal length adds charm to the images through a slightly foreshortened perspective. This is a perfect, grab-shot lens for

FIG 7.7

location work, and, even though its huge front element (72 mm) adds extra weight, is the lens of choice for many wedding and documentary photographers on the prowl for the perfect moment (FIG 7.8).

FIG 7.8

With a maximum aperture of f1.2, not only is this lens able to function under very low light levels, depth of field at f1.2 is virtually non-existent.

This lens makes it easy to isolate an in-focus subject within an out of focus field, both in the foreground and background (FIG 7.9).

FIG 7.9

Current trends in creative food photography lean toward small areas of sharp focus with rapid fall off to blur, a beautiful and evocative trick. The majority of contemporary cookbooks have been photographed this way, and I've even seen upscale restaurant menus shot with this style. Many of these images are made on sheet film, with the view camera's lens tilted in such a way as to limit depth of field, and many are manipulated in Photoshop (see my book, *Photoshop Effects for Portrait Photographers* for an easy way to do this). Although the look may not be quite the same, this lens makes that effect an easy one to achieve (FIG 7.10).

FIG 7.10

There's a buzzword floating around, *bokeh*, which refers to the quality of the out of focus areas in any image where such is deliberately introduced or used as a compositional element. I understand it came from the Japanese, *boke*, but I'd never heard it until recently and it isn't in my American dictionary. I just wanted to pass it along, so that if a member of the photographic *intelligencia* drops the word into polite conversation, as in "Hey! Nice bokeh!" you won't take it personally.

At 85 mm, this lens is terrific for portraits. The slight perspective compression that I spoke of earlier, coupled with a mid-range f-stop of 5.6 or 8 will hold focus over the planes of the face but begin falling off to a nice blur at the ears and shoulders (FIG 7.11).

FIG 7.11

50 mm f2.5 Compact Macro

Here's an entry-level macro lens that will perform beautifully as it opens up the world of close-up imagery for you. Capable of one half life-size magnification and 1:1 ratio with the Lifesize Converter EF, this inexpensive and lightweight little lens also functions as a lens of normal perspective that you could use for everyday snapshot photography.

This lens is best for inanimate objects, as you have to move in pretty close to get a tight image, a position some creatures feel uncomfortable with. Still, it can work well with people. Many medical and legal operations and investigators use this lens for everyday documentation of injuries or evidence (FIG 7.12).

190

FIG 7.12

Please note that the 50 mm f/2.5 Compact Macro is the only true flat field lens in Canon's lineup. If you do a lot of work on a copystand this is a lens you really need.

100 mm f2.8 macro

Like macro? Take a step-up and check out the 100 mm f2.8. Yes, it's substantially heavier than the 50 mm, but it's still inexpensive (for what it does) and also makes a great portrait lens. The Twin Light macro light system and the Ring Flash are built to fit this lens (see Flash).

This lens also delivers true 1:1 magnification, but the extra 50 mm this lens' focal length allows you to get in really close from further away, perfect if you like close-up images with a great deal of background blur. At smaller apertures, this lens will keep enough background detail so your subject matter will be tied to it.

By the way, this lens also features full-time manual focus, which means you can make fine adjustments at any time (very useful when doing macro work), while maintaining AF capabilities (FIG 7.13).

FIG 7.13

If macro photography becomes a driving force in your life, be sure to check out Canon's MP-E 65 mm f2.8 Macro Photo lens. This lens will set you back a few extra dollars, but with magnification up to 5× life size it might be something you'll have to have.

TS-E 90 mm f2.8 Tilt/Shift

Acting much like a view camera, Tilt/Shift (T/S) lenses correct image distortion and control depth of field by moving the axis of the lens. Canon makes three focal lengths of T/S lenses, 24, 45, and 90 mm and, although all are manual focus, each will do the same job, it's the applications that are different.

The 24 mm, for example, is extremely useful for architectural photographers, as the keystoning effect one typically sees when rooms or buildings are photographed can be controlled, with vertical lines drawn back into parallel with the edges of the image frame. Additionally, depth of field can be increased by properly tilting the lens into the frame.

A fair portion of my work is editorial and usually involves people. When I am called upon to photograph buildings I'm typically granted a certain amount of artistic license to interpret what I see. For that reason I prefer the 90 mm, as it can be used to photograph details in what the eye perceives as a normal perspective (FIG 7.14), as well as to alter details of other subjects by narrowing the point of focus (FIG 7.15).

FIG 7.14

FIG 7.15

EF 70–200 mm f2.8L USM

It's long, heavy and expensive, and it's my favorite lens of all time. The quality of this glass is second to none, and I've found it invaluable for just about every subject I like to photograph.

The old rule of thumb for hand-held telephotos was that the focal length of the lens was equivalent to the maximum shutter speed one should use to get a critically sharp image. So, if this lens was being used at its max focal length, a cautious photographer wouldn't use a shutter speed slower than 1/200th of a second because of potential camera shake. That's a seriously limiting rule, and one I like to break.

The 70–200 incorporates Canon's most advanced Image Stabilization technology, which lets me break that rule because it will anticipate (based on my movements), and compensate for, up to three shutter speeds' worth of camera movement.

Shooting Tip

Here's an effective and very inexpensive way to get a few more shutter speeds' use out of this or any other lens.

Any hardware store should have 1/4 × 20 "O" bolts in stock. Buy one and screw it into the tripod socket on the bottom of the lens (or the camera, if the lens doesn't have a socket).

From a pet supply store, buy a nylon dog leash, about a foot longer than your height. Clip the leash onto the bolt, then stand on it to put upward pressure against the lens. This extra stabilization will buy you at least two more shutter speeds (depending on your caffeine intake for the day) (FIGS 7.16–7.18).

FIG 7.16

FIG 7.17

FIG 7.18

I've found many uses for this lens. At a maximum aperture of f2.8, it's fast enough in the studio to shoot using only modeling lights or the ambient incandescent light around the seating area. This image started as a total grab shot, when during a break in a portrait shoot my couple began nuzzling each other. Since the thrust of the shoot was to show their

relationship it was only fitting that I take advantage of the situation. I cranked the ISO up to 1250 and, even though the camera's white balance was set for the studio strobes, the images I got on the fly were definitely worth the short time it took to get them (FIG 7.19).

FIG 7.19

As a portrait lens, this glass comes through every time. It's got a nice, snappy, contrast level, great color resolution, and is as sharp as I want it to be (I can change the degree of sharpness in Picture Styles, if I wish) (FIG 7.20).

For sports photography, the amazingly fast AF USM is very difficult to fool. I used Aperture Priority and an ISO of 200 in the bright sun of this early afternoon Costa Rican soccer game to be sure the shutter speed would be high enough to stop the action. The camera's aperture was set to f7.1, to maintain some depth of field (FIG 7.21).

Shooting Tip

I'm not a big fan of tripods or camera stands in the studio, as I prefer to be as mobile as possible. Taking the weight of this lens does tire out my arms, neck and shoulders after a while, even though I'm used to it. If I know I'll be using the 70–200 for an extended shoot, I will mount it on a tripod, but I'll loosen all three of the tripod head's axes just before I start shooting.

Image stabilization isn't needed when the lens is stationary, but the best compromise is to keep the head fluid and IS turned on. The lens will continue to compensate for minor movement and shake and you'll have the benefit of a weight-bearing platform that will save your muscles for another day.

Don't forget to tighten all three axes before you release the camera and walk away from the tripod.

FIG 7.20

FIG 7.21

EF 24–70 mm f2.8 USM

Another favorite, the 24–70 is an indispensable tool for wedding and event photographers or anyone who likes to rack from wide to normal

in split seconds. I know many photographers who carry two cameras, with the 70–200 on the second body, switching whenever the situation warrants a change in focal length. It takes getting used to, but once you do you're covered from wide angle to telephoto.

This is my favorite, everyday lens. I use it professionally, of course, as it does a terrific job on people and environmental images, two subjects I shoot regularly for clients, as well as many self-assignments for stock (FIGS 7.22 and 7.23).

At 70 mm, it's a useful portrait lens, although just barely. If you have to move in tight to get a good head and shoulder composition, for example, you may see distortion caused by the short subject-to-camera distance. Noses will look larger and ears will look smaller. I'm not saying you shouldn't use it, just be mindful of short focal length pitfalls for classic portraiture.

FIG 7.22

FIG 7.23

EF 400 mm f2.8L IS USM

Weighing almost 12 pounds (5.37 kg), this lens is a beast, and not one to just casually toss into your gadget bag for vacation photos at the beach, but it's so cool it's worth lugging around when photography is your living.

Sports and wildlife photographers love this lens. At f2.8 it gathers just about every photon out there, which makes it a terrific choice for games at night or gazelles at dawn. Those of us who shoot stock photography are always

looking for ways to separate our work from the rest of the pack, so a lens like this can actually justify its expense (hey, that's what I told my wife).

I've used this lens in a number of situations where glass of a shorter focal length would have produced a much more "normal" looking image. When I'm working with this lens, "normal" is the last thing I'm going to get, or want. This compressed scene began almost 600' away from me (FIG 7.24).

FIG 7.24

One of my photographic loves is heavy transport machinery; trucks, trains, and planes, anything with mass. This lens can compress so much perspective that massive objects look even bigger. I like that. Many photographers who shoot big stuff like to work with wide angle, as do I, sometimes, although I am extremely pleased with the look of strong telephoto (FIG 7.25).

For this particular series of stock shots, I wanted even stronger telephoto compression than I was getting with the 400. The easy solution was to use the Canon Extender EF 2× II, effectively doubling the focal length of the lens to 800 mm. It cost me two stops, so my available largest aperture was

FIG 7.25

f5.6, but Canon doesn't make an 800 mm. In the first of these two shots, made at least half a mile (1.75 km) from my location, notice how effectively Canon's Super Spectra Coating suppressed internal element reflections from the sun, not an easy task with such a bright source (FIGS 7.26 and 7.27).

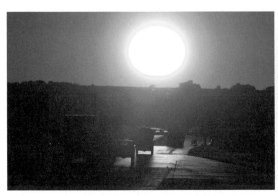

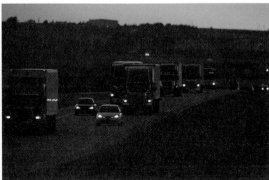

FIG 7.26

FIG 7.27

You can take a trip through a Canon lens catalog and surely find gear that will do whatever you wish it to do. As an avowed generalist, I'm lucky in that I can find something I like to shoot with just about any lens Canon makes. I realize that you may have different aspirations. I'm OK with that. I just want to assure you that whatever you need, Canon makes.

If you're looking for a starter "kit" of lenses that will creatively realize the vast majority of your ideas, let me suggest the following:

- EF 16–35 mm f2.8L II USM. I don't have one. The 14 mm Aspherical and 15 mm Fisheye do nice things for me (and may be for you), but this lens is an easy and relatively inexpensive way to get into ultra wide angle.
- As a lower cost alternative, the EF 17–40 mm f/4L USM is a terrific lens and about half the price of the 16–35 mm f2.8.
- EF 24–70 mm f2.8 USM. With its close focusing abilities, this lens is an excellent day-to-day lens and will do beautiful things for you.
- EF 70–200 mm f2.8L USM. I don't have a bad word to say about this lens – it's incredible, right out of the box.
- Canon has built several lenses that one could consider "sleepers" in that they're great pieces of glass for less money than you'd think you'd have to pay. Do yourself a favor and check them out.
- One of my favorites, the aforementioned 100 mm f2.8 macro absolutely falls into this category.
- The EF 85 mm f/1.8 is an awesome lens. I consider it a very viable alternative to the EF 85 mm f/1.2 for folks who can't spare the cash. This lens is generally around $340 instead of $1789 (at the time of this writing) for the 85 mm f/1.2! It's lighter, faster to focus (since it doesn't have the giant elements to move around) and is optically quite pleasing.

I also think that the EF 28 mm f/1.8 is a great value at around $400. It is quick to focus, nice and sharp at the edges and a great way to get into a fast lens at a low price. For the Digital Rebel/30D shooter, its effective focal length is 44.8, which could be a nice all-purpose lens (and pretty close to 50 mm with a full frame sensor).

EF-S Lenses

In 2003, beginning with the Digital Rebel, Canon debuted a new series of lenses, designated EF-S, with a new mount that was designed for cameras with the APS-C sensor and its 1.6 conversion factor. Although earlier models, specifically the D30, D60, and 10D, have APS-C sensors, these lenses will not fit those cameras because the lens mount is too deep. The Rebel, 20D and 30D sport mirror assemblies that move the mirror back as it moves up. If you could mount an EF-S lens on a 10D, for example, the

mirror would smack into the lens mount with the very first exposure. That would be bad (FIG 7.28).

FIG 7.28 EF-S lenses feature deeper mount that will only fit a select number of Canon cameras.

The lenses were designed to be lighter, smaller and less expensive, which they can be because the camera sensors are smaller and the circle of light is correspondingly small. There is nothing to be gained by a circle of light that's larger than the sensor, a fact Canon took into account.

There are currently five lenses in this series.

EF-S 17–55 mm f2.8 IS USM
This is the most expensive of the series, currently almost $1200.00. What makes it interesting is that is comprised of the requisite number of exotic elements (fluorite, aspherical elements, etc.) as to qualify it for L-Series inclusion. (It can't be a L lens because it doesn't fit all the cameras.)

For everything that it packs into its 4.4", 22.8 oz. weight (110.6 mm, 645 g), it's a great piece of glass. The conversion factor effectively makes it a 27–88 mm zoom.

EF-S 10–22 mm f3.5–4.5 USM
Ultra wide-angle coverage, aspherical elements to control distortion, and focus as close as 9.5 inch makes this lens a great choice for the Rebel, 20D or 30D. The conversion factor means you'd have a 16–35 mm, one of the most popular choices for wide-angle lenses. Full-time manual focus means you can tweak focus anytime, even when using AF.

EF-S 17–85 mm f4–5.6 IS USM
The equivalent of a 28–135 mm on a full frame camera, this lens also features Canon's Image Stabilization, allowing you to shoot under lower light conditions than you normally would be able to use.

This strikes me as a useful lens for event photographers who shoot with flash. I think the f5.6 maximum aperture (at 85 mm) would be limiting without flash, but the price is certainly attractive, currently about $515, and you're certainly not limited to just flash work (FIG 7.29).

FIG 7.29

EF-S 18–55 mm f3.5–5.6 USM

The standard "kit" lens that Canon lets you purchase for next to nothing when you buy a Rebel or 30D. Many photographers have indicated they feel the lens must be pretty bad or Canon wouldn't sell them so cheaply. They couldn't be further from the truth.

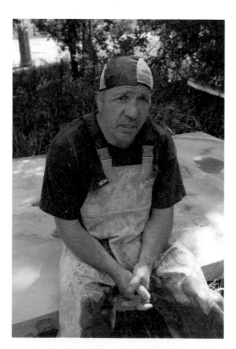

FIG 7.30

I had the opportunity to work with this lens for quite a while when writing this book and, aside from my typical reservations about f5.6 as a maximum aperture, I have to say that I was quite impressed with its performance. It focuses close and quickly, the zoom ring is smooth and it weighs almost nothing. It's actually quite a bargain! (FIG 7.30)

EF-S 60 mm f2.8 Macro USM

I love lenses like this. At 60 mm (angle of view equal to 96 mm) it's a lot like the 100 mm macro I wrote about earlier, so it functions like a short telephoto, makes a great portrait lens and delivers 1:1 macro. It's a sleeper, too. At $449.00 it's a great lens for the money (FIG 7.31).

FIG 7.31

A final word about EF-S lenses. If you think you'll move up to a camera with a larger sensor, you might want to stick with straight EF lenses. After all, they fit every DSLR in the line.

Flash

Watt? Me Worry?

Whether you'll use a built-in flash (found on the Rebel and 30D) or an accessory Speedlite, Canon has paid a great deal of attention to how that equipment interacts with their cameras. In the earlier days of Canon's digital photography, early Rebels, D30, D60, 10D, and 20D models, even the 1Ds, there were significant problems with E-TTL, Canon's through-the-lens flash metering system, that garnered less than rave reviews from many photographers. The problem was that the output power of the flash was tied to the final position of the focus point, so that if you focused, held the shutter halfway down and recomposed the image, the flash would fire based on where that focus point ended up. If the focus point came to rest on a white wall, for example, the exposure could be seriously skewed (although the wall would look great).

Canon's newer cameras, beginning with the EOS-1D Mark II, employ a newer flash metering algorithm called E-TTL II which provides more stable flash exposure than the previous E-TTL. The flash metering is still influenced by the location of the focus point at the time of exposure but not nearly as much so as with the older E-TTL bodies. E-TTL II will also take into account the focusing distance information that it gets from most, but not all, Canon lenses. While not perfect, it is certainly an improvement over E-TTL.

Shooting Tip

Should you be working with one of the early E-TTL cameras, getting good images is not impossible, it just requires that you pay close attention to where the focus point falls at the time of exposure or, if you choose to focus and recompose, that you add one more step with a feature called Flash Exposure Lock (FEL).

Using either the on-camera flash or an accessory Speedlite, find the most important part of the image, the portion you wish to focus on. Push the shutter button halfway to lock focus. Find the FEL (* on the prosumer bodies and near the shutter button on the EOS-1 cameras) button and push it. The FEL button will fire a small flash at the subject, and will record its strength and distance data when it's bounced back into the camera's memory.

Note that you cannot use back-button focus with FEL on consumer and prosumer bodies (FIG 8.1).

EOS-1 pro cameras have a dedicated FEL button, located just to the left of the shutter release. It's used exactly the same way, except that you can still use back-button focus (FIG 8.2).

You now have 6 seconds to recompose and shoot the image, with the FEL-targeted area nicely exposed. While this feature is helpful for earlier cameras, it's just as valuable as a tool for critical flash exposure on newer machines.

FIG 8.1

FIG 8.2

Built-In Flash

Working with the built-in on-camera flash is terrific for snapshots, although, in my opinion, it should not be used for paying jobs because its tube is small and produces a hard, specular source that accents skin shine and shows hard shadows. Pictures made with built-in flash will also look like everyone else's shots, so if you're a wedding photographer trying to establish a visual identity, using this feature might not be the best idea. The flash is placed close to the lens, and pops up vertically just above the lens axis. While this guarantees even light over its effective working area, the look of the images will actually be quite flat. Further, if you turn the camera to its vertical position, the resulting shadows will fall straight across that axis and look quite unattractive.

That said, the built-in flash can be very effective as fill flash, a little something to brighten up a shot without overpowering it.

Flash Exposure Compensation is a Function on any Canon with a built-in flash. Find it in the Menu of the Rebel, but on the 30D it is a button push that displays on the top LCD. It allows an increase or decrease in the flash output power relative to what the camera tells the flash it needs, a determination the camera will make based on the light at hand and the shooting Mode it's in. You are allowed up to two full stops of exposure compensation, over or under what the camera considers to be correct, when you use this Function.

We all know that outdoor exposures, even made under diffused daylight conditions, can show shadows that are not especially attractive even though the subject may be. If a face is lit from the side, for example, eyes tend to look lifeless because there is no catchlight, no hint of a light source, to give them a spark. This set of images was made in the Av Mode (FIG 8.3).

FIG 8.3 Ambient light only

Even if the camera doesn't automatically raise the flash (there may be so much light that the camera won't think it's necessary), push the flash button near the lens and pop it up manually (FIG 8.4).

Without making any Flash Exposure Compensation, the camera will use the built-in flash as a fill flash. Comparing a non-compensated image with one deliberately set to −1/3 stop would indicate that this is the camera's default fill flash position (FIGS 8.5 and 8.6).

With further compensation adjustments, at −2/3, −1, and −2 stops, you can easily see how Flash Exposure Compensation can improve your images when used as a supplemental light source. In each case, look

FIG 8.4

FIG 8.5 Fill flash, no adjustment

FIG 8.6 Fill — 1/3

at how much life the catchlights in the eyes add to the shots
(FIGS 8.7–8.9).

When working with built-in flash indoors, there are a couple of things for you to consider that will improve the quality of your images.

Virtually any setting that has light falling in it can be photographed. It's the quality of the light that determines the final beauty of the shot.

FIG 8.7 Fill — 2/3

FIG 8.8 Fill — 1 stop

FIG 8.9 Fill — 2 stops

This image, made in the Av Mode, takes advantage of the light coming into the room through this family's large front room window. It's a nice image, but looks a little flat because the source (the window) is so broad and the subject is not influenced by any direct light (FIG 8.10).

FIG 8.10 Ambient light only

Use a shooting Mode that will take ambient light into account. If you use Manual, be sure to set a shutter speed and aperture that will include enough ambient detail to show the background. A shutter speed that's too short or an aperture that's too small will not allow enough ambient light to register, resulting in dark backgrounds with minimal or no detail. Even though the exposure from the flash will be terrific, the lack of ambient detail will result in "tonal merger," a part of the image where dark areas of the subject like hair or clothing are so dark they become indistinguishable against the background. Photos made with tonal merger lack the three-dimensional quality that makes for a better shot (FIG 8.11).

FIG 8.11 Camera in Manual mode

You'll get better results working in a mode that supports ambient light exposures. On the Basic side of the dial, Portrait, even Night Portrait, will produce great results because the exposure will be made for both ambient and flash. On the Creative side, Av, Tv, even ADep (on the Rebel and 30D) will produce nicely lit, dimensional results that balance ambient light to the flash (FIG 8.12).

FIG 8.12

Accessory Flash

At the time of this writing, Canon's flagship accessory strobe is the 580EX-II Speedlite, a beautiful, slim, relatively lightweight product that can do wonderful things either by itself or linked with many additional units (I've heard of as many as 36!). Unlike the earlier 580EX, the EX-II adds "Auto" to its Mode list, along with E-TTL and Manual, a feature many photographers feel will bring the Speedlite line back into the race as a full-featured unit capable of delivering what the photographic community says it wants.

E-TTL Mode fires a small flash immediately before firing the main burst. The purpose is for the unit to get a read on the amount of light bouncing back from the measuring point and shorten or lengthen the second flash duration accordingly. Auto Mode fires one shot at essentially full power, reads the bounce, and turns the strobe off when the correct amount of light has hit the sensor. Many photographers feel Auto to be more accurate than E-TTL.

No matter how you cut it, any 580 is considered a small unit. While it's capable of a strong burst at full power it doesn't typically work that way in E-TTL, where recycle speed is important (FIG 8.13).

FIG 8.13

I'll go out on a limb here, at least a little bit, to say that there is no accessory flash out there that will deliver perfect shots, every time and

right out of the box unless you understand and use Manual mode. Back in the days when we shot weddings, events, and portraits on film we could mess up quite a bit with our "automatic" flash units, and our labs would bail us out by adjusting exposure at the enlarger. Those days are over. Today, if we mess up, we're on the hook to fix it and sometimes that's hard to do, even with Photoshop.

I've found a few tricks, over the years, to get more consistent results from my Canon flash in E-TTL. Naturally, I'll share. Some of these tricks have minimal basis in fact, they're only based on my experience, but they seem to work nicely and improve my shot-to-shot success ratio.

My most important tip is that E-TTL seems to work better with an ISO higher than 100. When I fire up my flash unit I'll set my camera's ISO to at least 400. I think this helps because the unit doesn't have to push out as much light as it does at my preferred ISO of 100, and can light the scene more efficiently.

The units have a built-in power adjustment that you can use to increase or decrease the output power relative to what the camera thinks it wants. This is just like the Flash Exposure Compensation Function dialed in on the camera with built-in flash, except that the adjustments are made on the flash unit itself. I've found that, working with the 30D and 5D, I like an overall increase of +1/3 on the strobe to give me more consistently perfect exposures although I can easily work with what the camera gives me if I forget to do that.

I've also found that zoom lenses are definitely the way to go when using accessory flash.

At 7 to 10 feet, the flash is working at its best. The distance from the subject is not so far that the flash has to work overtime but far enough so that the spread of light is even and consistent. My preferred lens in this circumstance is the 24–70 mm f2.8 zoom, because I can let the lens do the work of moving in or out of the frame.

It's also a good idea to use a maximum aperture of f5.6 (larger is better) whenever possible.

Even when you've got your E-TTL flash nailed, you're still dealing with a small, specular, light source. Better results are obtained when you use a third-party diffuser to broaden and soften the light source. There are many of these devices on the market, and I certainly haven't tried all of them, but there are some characteristics that each exhibit: Any of them will spread the light, creating a larger, softer, source, and each will cut the efficiency of the source, the power of the strobe's output, by at least one full stop.

The two that I use the most are the LumiQuest MidiBouncer (aka the Baseball Glove), www.lumiquest.com, which I attach with the provided Velcro strips, and my new favorite, the Ultimate Light Box System, a beautiful mini-softbox that's engineered to fit snugly right over the flash head and that can be easily modified for a softer or more specular light because it's a modular system. www.harbordigitaldesign.com (FIG 8.14).

FIG 8.14

If you want the most controllable results from your Speedlites, you must learn and note their power output in Manual mode. When you know what the true output is, and at what f-stop, a whole new world of controlled imagery is literally at your fingertips.

If you don't have an external flash meter, you will need to borrow or rent one to make this test, and you'll need to calibrate it to your camera first. Since there may be discrepancies between your camera and the meter, you'll need to photograph a gray target first. You'll also require the services of a friend to hold the meter as you fire the flash.

Make this test at ISO 100.

Set the EX flash unit to Manual, which will give you consistent shot-to-shot power (make sure the unit is fully recharged before firing). You will also

Shooting Tip

A look that I really like is when a flash fill is not noticeable but looks like it was part of the ambient. In other words, the fill is so soft as to be unrecognizable as fill flash, except, perhaps, in the catchlights in the eyes.

Try this with your favorite third-party modifier. From a working distance of not more than 10 feet, and with your modifier in place and your camera set to Av Mode, dial the E-TTL power to $-1^{1}/_{3}$ stops. Be sure to use an aperture that will not require a high power discharge from the flash unit. The result may be inconsistent and take too long to recycle. I think you'll find that the strobe fills in the shadows just enough to make the image truly believable and much prettier than it would have been without the fill. This image was made with the ULB (FIG 8.15).

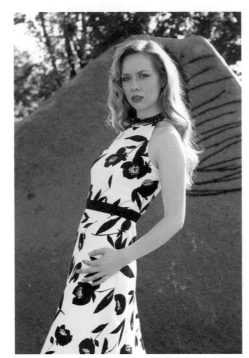

FIG 8.15

need to set the Zoom control to 50 mm for the test, and be sure to select 50 mm whenever you use this technique for an actual shoot or do another test at other focal lengths. Dialing a different zoom focal length will change the power output of the light (FIG 8.16).

FIG 8.16

Using full power, 1/1 as noted on the back of the unit, find the correct distance from the target (and as close to it as possible, so you can fill the frame with gray) that will give you a meter reading in a whole stop or whole stop plus 0.3 or 0.7 (see External Meters). Take a picture of the gray target.

Push the Display button on the camera, and dial in the image with the Histogram. A properly metered and exposed image will show the primary pixel spike dead center. A spike to the left indicates that your

meter is giving you underexposure, while a spike to the right indicates overexposure. Adjust your light meter (see the manual) so that the reading it gives you will produce a centered histogram (FIG 8.17).

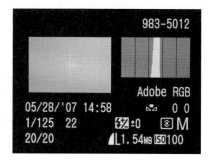

FIG 8.17

Use a tape measure and measure out one-foot increments, over a length of 20 feet. Starting at the 20' mark, and with your friend aiming the light meter at the camera from the other end, fire a full power flash at the meter. Note the f-stop the meter gives you. You may have to move a little closer, but the object is to get to the first available whole f-stop. Make note of that distance.

Move forward, test firing as you go and making note of where the whole f-stops are found. When you're done, you'll have a power map that will give you consistent results, shot after shot, over that 20' range.

You'll also have a map that can be used to extrapolate f-stops for every Manual power setting on the flash, from 1/1 to 1/64.

Every time you cut the power ratio in Manual, you'll drop the exposure value by one stop. So, if you're at 5' and getting f22 at full power, changing the ratio to 1/2 will give you f16, 1/4 will give you f11, and so on, all the way down to 1/64 which will give you a perfect f2.8. The 580 powers down to 1/128, for those of you with f2.0 capabilities (FIGS 8.18–8.20).

FIG 8.18 1/1 equals f22

FIG 8.19 1/8 equals f8

FIG 8.20 1/64 equals f2.8

This is a rock-solid technique that works in any indoor situation. Of course, once you know how much light your favorite modifier eats, you'll have a map for that, as well.

You can use flash outdoors, and in Manual, too, although there are some considerations that will affect the quality of your images.

When shooting outdoors, E-TTL and Auto will both take ambient light (sunlight) into account, more so than indoors when the flash is the dominant source. Manual does not. It can't make allowances for ambient light because its output is consistent, so you have to make allowances for it.

The effects of light are cumulative. Adding light to light creates brighter light, which must be dealt with at the camera by selecting a smaller aperture. For example, if you're outside in bright sun, and the sun is falling on the subject (with its usual bad shadows), you may want to fill those shadows as much as possible. Should you select the correct distance/power output to give you a flash strength of f16, you will have to add one stop less of exposure *at the camera* to f22, which will give you the perfect exposure you require (FIGS 8.21–8.23).

FIG 8.21 Exposure from sun is f16

FIG 8.22 Manual flash power equals f16. Image is one stop overexposed

FIG 8.23 Adding one stop at the camera, to f22, equals perfect exposure

When you use Manual flash as fill, you need to consider how much of the ambient light you wish to be dominant and then make the appropriate exposure adjustment. Note that some adjustments will not produce a whole f-stop or a perfect third. In those cases I've noted the closest f-stop that will yield an exposure good enough for proofs, without manipulation. This example uses f16 as its base, but the formula can be extrapolated against any ambient light level.

Assume the sun is a constant at f16.

Fill flash strength to ambient	Exposure adjustment	New aperture/result
−2 stops	+1/10 stop	f16 (image is 1/10 over)
−1 $^2/_3$ stops	+2/10 stop	f18 (image is 1/10 under)
−1 $^1/_3$ stops	+4/10 stop	f18 (image is 1/10 over)
−1 stop	+1/2 stop	f20 (image is 2/10 under)
−2/3 stop	+6/10 stop	f20 (image is 1/10 under)
−1/3 stop	+2/3 stop	f20 (perfect exposure)
Same as constant	+1 stop	f22 (perfect exposure)

Canon's Speedlites have many other features, all designed to help you make better pictures.

FEB (Flash Exposure Bracketing) let's you take three flash shots in a row at three different strengths. You can symmetrically vary the power in 1/3 stop increments up to a plus/minus of three whole stops. The camera will have to wait for the flash to recycle, of course, but if you jump the gun and fire the camera before the flash is ready you won't have to reset the bracket. The flash will hold the setting until a successful discharge can be made and, if you have dialed in a basic E-TTL exposure correction, the flash will add or

subtract that correction automatically. You will have to reselect FEB each time you wish to make a new bracket series (FIG 8.24).

FIG 8.24

Sometimes, working outside in bright sunlight can pose a significant challenge to photographers hoping to use fill flash along with large apertures. On a typical sunny day, ISO 100 would require 1/1600 second at f4, well beyond the camera's maximum flash sync speed.

Speedlites offer High-Speed Sync (FP Flash), which lets you use flash at any shutter speed, up to the maximum 1/8000 second. To access it, select the high-speed option from the back of the flash. An icon next to the E-TTL designation will appear in the LCD panel. Note that as shutter speeds increase in speed the working distance of the strobe decreases. There is a distance scale on the bottom of the LCD showing you the effective range, but only for an unmodified strobe. If you'd like to use a diffuser to soften the light, your best bet might be to use the camera in Av Mode and make adjustments via Flash Exposure Compensation (FIG 8.25).

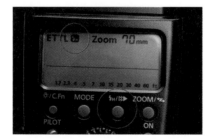

FIG 8.25

Of course, there are many other uses for High-Speed Sync (FIG 8.26).

Toggling the same button that controls High-Speed Sync will access Second-Curtain Sync, a cool tool that fires the flash at the end of the exposure rather than the outset. If you wish to intentionally create a motion blur, flash at the end of a long exposure will freeze time at the end of the blur. The images will have a more realistic look to them. For the

FIG 8.26

most realistic look, be sure all the lights have, or have been gelled to, the same color temperature.

FIG 8.27

Working with Second-Curtain Sync in the studio poses an interesting problem. Even though Canon cameras have a Custom Function called Shutter Curtain Sync, it only works with Canon Speedlites that do not have that feature built into them. It will only fire studio strobes (or non-Canon accessory flash units) at the start of the exposure.

Obviously, the thing to do is to use the Speedlite to fire the Slave function of the studio strobes. I realized quickly that I couldn't use the E-TTL mode, as it fires a pre-flash that was strong enough to activate the slave. The studio strobes went off before the shutter (the shots were a little dark). The solution was to set the Speedlite to Manual at its lowest power, 1/128, and turn it so it was aimed behind me, at the slave on the studio pack (FIG 8.27).

Multi Stroboscopic Flash

Multi Stroboscopic Flash is yet another option for the creative photographer. Using this Mode gets you a multiple, rapid burst of strobe fires that will freeze movement in multiple positions. Use the images for analysis, like a golf swing, or just for drama or fun.

This feature is just slightly more difficult to use than other Modes, but it's not that tough. You'll need to determine the correct exposure strength of *one* flash, in Manual mode, that falls on your subject. Use an external meter or photograph a gray card, adjusting either the flash to subject distance or the strength of the flash, until you get a perfect, centered, histogram. Make note of the correct power setting.

Now, press the Mode button until Multi is displayed on the LCD. Dial in the same power setting.

For moving subjects that will not significantly overlap, decide how many times the flash should fire, and use the Dial button to find the burst number (it will blink when selected) and the Dial to select the number of flashes that will comprise the burst. Note that finding a lower power setting at the start of the process will allow for more flashes now.

The Hz setting will determine the speed of the burst. Higher Hz numbers mean shorter times between flashes but will also require more power, which is another reason to use a lower power setting if possible (FIG 8.28).

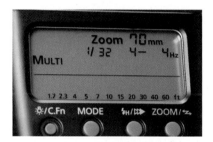

FIG 8.28

To find the correct shutter speed for your image, divide the number of flashes by the Hz rate. In this case the number of flashes is 4, as is the Hz rate (4/4 = 1). The shutter speed needs to be at least one full second long (FIG 8.29).

FIG 8.29

Speedlites in Studio or Location

Speedlites can talk to each other and, like humans, can set each other off.

You can connect a network of Speedlites together for a basic portrait light setup or to provide accent and background lights for a wedding or other such event. Although Speedlites are small, specular sources, they are, like all auxiliary lighting, tools to boost your creativity and realize your vision. It's simply a matter of how you work with them, and how you get them to do what you want.

The 550EX and 580 Speedlites have a switch on the bottom, just above the shoe mount, that will assign the role of Master or Slave, but the 580EX II Master/Slave selection happens in the Speedlite's Menu. The unit on the camera is always the Master, and with it, you can control every other Slave unit. Now, there are some caveats. Because the Slave units must "see" the camera unit, you are limited to a spread of 40°, left and right of the lens axis. You will also need to tilt or swing each flash so the infrared signal window (the red window on the front of the unit) is facing the Master. This 80° total is the limit of the infrared signal transmitted by the Master. Working with multiple Speedlites outside, according to Canon, gives you a maximum working outdoor distance of about 26', indoors, almost 50'. These are average results, and yours may vary, so test any setup before you put your money on it.

You can program Flash Exposure Compensation, High-Speed Sync, Stroboscopic Flash, or any other feature of the Speedlite (with the exception of Second-Curtain Sync) into the Master, but understand that the same settings will be applied to each of the slaves. For many images this is totally acceptable. Wedding and event photographers will often set several slaves on clamp mounts in multiple locations in a reception hall, to illuminate backgrounds or add hair lights to create depth and dimension to their images. Should you decide to make a change to the Master, such as adding or subtracting 1/3 stop of exposure value, the change will be made symmetrically to every Slave unit, although they can be ratioed separately against each other.

I'm not a fan of on-camera flash as a key (main) light, although I'll admit I've seen some beautiful shots made in that manner. I much prefer to have my key light off-camera, set to camera right or camera left, just to give my subject dimension by throwing a nice shadow. When I do have the Master on-camera, I prefer to use a modifier. The key light for this shot of R&B singer, Sahata, was modified with the Ultimate Light Box. The slaves, slightly behind and to the sides of her at camera right and camera left, were gelled with orange (FIG 8.30).

Shooting Tip

The little stand, the foot, that is provided with the 580EX II is best used when the strobe can be placed on a flat, level surface such as a floor or shelf. If you want to place the unit on a stand, and have the ability to change its angle, check out the R 4130 Umbrella Stand Adapter from Norman (www.photo-control.com). It's inexpensive and you can thread an umbrella through it, turning your Canon flash into a much broader, softer, source.

If you find yourself in a pinch and need to position another flash at an angle, just screw the foot onto your tripod and use its controls to angle the flash where you need it.

FIG 8.30

Canon allows you the option of prohibiting the Master unit from firing, even though it will still send out a signal flash to alert the other units. Being able to disable the Master is an extremely valuable feature because it frees you from the flat-light look that's so common to on-camera flash images made without modifiers.

We all like to break the rules, and the most important rule with wireless is that the units must see each other. One of my favorite lighting arrangements is to place a large softbox behind a sheet of white Plexiglas. I meter it by retracting the dome of the my external flash meter and placing it flat against the Plexi from the camera side, take the reading, then set the camera +2/3 over that reading. For example, if the meter read f11, I'd open the lens' aperture to f9. The result is an almost total silhouette (with just a little wrap-around light), against a clean, white background.

Recently, I had to set this up in an area where I could not use my studio flash. This presented a problem because the Plexiglas would not allow the infrared signal from the on-camera unit to pass through it to the Slave. While I could have slaved the rear unit to the Master, I didn't want any extra light to fall on my subject. The solution was to place the flash on a stand and aim it at a window to the side of the set. Since I could see the

Slave unit's reflection in the window, I knew the signal would be received (a mirror on a stand would work just as well). I connected the Master to the camera with a Canon Off-Camera Shoe Flash Cord 2, disabled the flash of the Master unit, and made this image (FIGS 8.31 and 8.32).

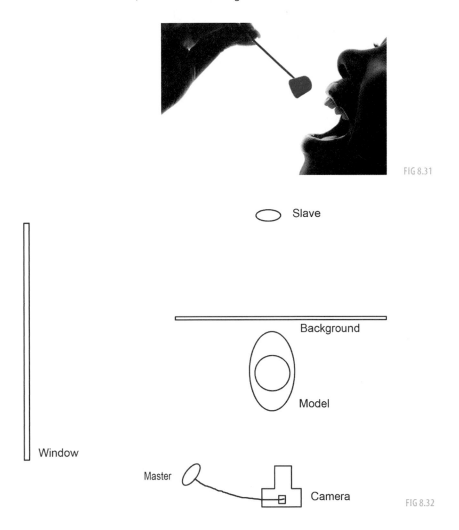

FIG 8.31

FIG 8.32

For studio or location, a nifty trick to increase the apparent size of the light is to place a translucent diffusion screen close to the subject and place the flash a few feet behind it. When the screen lights up from the flash it will act as a softbox and become a softer, broader source. It's best, in my opinion, to set the flash on Manual and meter with an external device. For this image the Master was disabled, with only the Slave firing. An additional bounce panel was placed at camera left (FIG 8.33).

FIG 8.33 Even a single Speedlite can produce exceptional images when properly modified.

Specialty Strobes

MACRO TWIN LITE

Canon makes two special accessory flashes, the Macro Twin Lite and the Ring Lite. Each is mounted on the lens and meant to be a close-to-the-lens source. While they are similar to the pop up flashes of the Rebel and 30D, the Twin Lite is a two light source that can be controlled while the Ring Lite is a continuous circle of light around the lens. Both have applications for anyone who wishes to expand his or her visual vocabulary.

Should you be one of the many shooters looking for an edge over your competition or just someone looking for a cool and unusual accessory, check out Canon's Macro Twin Lite MT-24EX (FIG 8.34).

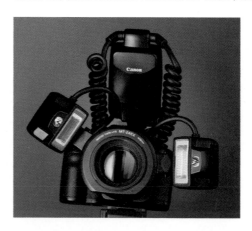

FIG 8.34

The first thing you'll notice, of course, are the dual strobe heads, designated A and B. Mounted on a ring that is, in turn, mounted on the lens barrel, both heads can be moved in tandem around the lens or moved independently by pushing a small release button to any other position. Additionally, each head swivels on its' own mount, allowing you to place head A at an angle of 45° to the lens while positioning head B at, perhaps, 75°. Being able to move the two heads separately allows a great deal of control. Think of one head as the key light, the most important of the two, and the other as fill light. You may wish to use a hard angle for the key and a lesser angle for the fill, which will produce a lighting scenario impossible to achieve with other macro flashes such as ring lights.

In E-TTL, each head can be ratioed against the other, allowing even more control of key (head A) to fill (head B), up to three stops in either direction. Note that, on the back of the unit, the ratio is marked as A:B (FIG 8.35). This cannot be changed, which is why the ratio scale runs from 8:1 (A being three stops brighter than B, and B is the correct f-stop according to E-TTL) to 1:8 (B now being three stops brighter than A, according to the E-TTL computations). Since the two lights are so close together, the actual difference will be a blend of the two lights although one will be truly brighter than the other (FIGS 8.36 and 8.37).

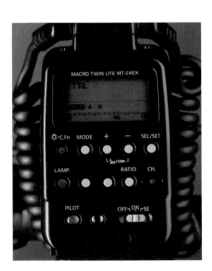

FIG 8.35

FIG 8.36 An 8:1 ratio.

FIG 8.37 An 1:8 ratio.

In Manual mode, the ratio of the two heads is symmetrical and cannot be modified although the actual power output of the unit can be changed. In other words, the strength of the two heads is the same regardless of the strength of the pulse of light they emit. The default full power output designation is 1/1. Push the Sel/Set button and the + and − keys to select 1/2, 1/4, 1/8, 1/16, 1/32, or 1/64; each number represents a reduction of power by one full f-stop (FIG 8.38).

Light Source: Light Source Ratios

Ratios are always determined against values of 2, with the key light noted as a constant, expressed as the numeral 1. The key light is always regarded as the correct exposure for the image area we wish to be perfect, with all other lights ratioed against it.

Each f-stop increase of light (changing the aperture to a smaller number, or, "opening up") doubles the amount of light reaching the chip while each f-stop decrease of light (changing the aperture to a larger number, or, "stopping down") cuts the amount of light reaching the chip in half.

When a secondary light is brighter than that of the key, the secondary value is expressed to the left of the numeral 1, indicating its stronger relationship to the correct exposure. Conversely, an exposure with a light powered less than that of the key is expressed to the right of the numeral 1.

Exposure ratios, either right or left of 1, are numerically expressed like this:

FIG 8.38

Exposure	Ratio
Correct	1
−0.5	1:1.5
−1	1:2
−1.5	1:3
−2	1:4
−2.5	1:6
−3	1:8

What does this mean in practical terms? This is valuable knowledge if you don't want to rely on E-TTL in a potentially "iffy" situation like a bright subject against a dark background. By testing your flash in Manual mode with a calibrated flash meter you will know *exactly* how much light it pumps out at a given distance and be able to set the camera's aperture accordingly. Perfect fill flash can be guaranteed, shot after shot, but it will take some work on your end to determine the limits of the gear and how those limits apply to your work.

Relatively strong for a macro light, with a guide number of 78 (in feet, 24 in meters), this innovative flash does a terrific job lighting a wide variety of subjects and works well in both E-TTL and Manual modes. In some situations, it's even strong enough to overpower the strength of the sun when a subject is fully backlit and close to the camera, a feature that allows you a great deal of versatility within the

realm of your work. Since I got mine, I've used it for a wide variety of images.

In the studio environment, the Canon Twin Lite makes a terrific key light for snappy, on the fly, headshots whether you use it with other Speedlites, using the built-in infrared triggering device, or simply to set off studio packs. My Twin Lite was set to a 1:4 ratio, with the upper flash being dominant. Notice how nicely the lower strobe fills in the small shadow under the chin (FIGS 8.39).

For a fill light that's less than the key:

Exposure	Ratio
Correct	1
+0.5	1.5:1
+1	2:1
+1.5	3:1
+2	4:1
+2.5	6:1
+3	8:1

You can easily extrapolate additional ratios and f-stop values from these numbers.

FIG 8.39

Foliage in deep shadow can be easily photographed in relief with the Twin Lite. This image, made in E-TTL at f5 in Manual mode and with a 100 mm Macro, shows just enough depth of field to give the viewer a strong impression of shape and form (FIG 8.40).

I was able to overpower the strength of the sun by setting my aperture to f32 and letting the E-TTL function of the Twin Lite throw more light at the subject than the ambient light would ever show. Be aware that proper eye protection is necessary when making images when full sunlight can shine directly into your focusing eye. An optic nerve is a terrible thing to waste (FIG 8.41).

FIG 8.40

FIG 8.41

I've worked with or watched a number of medical photographers who photograph their patients, and the vast majority have used ring lights. In my opinion, a Twin Lite will produce a better light for photographing injuries because the two lights can be separated and ratioed against each other, to show the dimensional planes of physical injuries (FIG 8.42).

FIG 8.42

"Incredibly rare, this small rubber bust of Jar-Jar Binks, George Lucas' most endearing Star Wars character, is, without question, the most desirable collectible of all time. No reserve!"

Should you be one of the many who sell goods via online auction services, an accessory such as the Twin Lite will give your goods so much life they might look, well, desirable (FIG 8.43).

FIG 8.43

RING LITE

Canon's Ring Light, MR-14EX, like the Twin Light, is built to fit onto the 58 mm front of the 100 mm Macro, but you can buy step-down and step-up rings so that the flashes can be mounted on lenses with filter diameters other than 58 mm. Because it can act like a continuous flashtube around the lens, it can produce a beautiful, virtually shadow-free light onto any subject. However, the strobe tube is not a single piece, rather two semi-circular tubes that can be proportioned against each other to create a key:fill ratio.

Even though it wraps around the lens, the light it throws is not shadow-free. Instead, a small shadow is formed, symmetrically, around the entire periphery of the subject. The width of this shadow is controlled by the distance of the subject to the background, which many photographers exploit as a compositional element. There are examples in virtually every fashion magazine, every month, of ring light photography (FIGS 8.44 and 8.45).

FIG 8.44

FIG 8.45

Canon's Ring Light, while certainly usable as a fashion light, is also extremely useful as a macro light. Insurance documentarians and collectors use it routinely, as it adequately represents the planes of important artifacts well enough to establish monetary value. The light is flat, but modeled enough so it sees cosmetic damage easily (FIG 8.46).

FIG 8.46

Most of Canon's Speedlites will work together as a wireless unit, which means you could set up a portrait shot using a Ring Light as the key, a Twin Light to accent the hair, and a head-modified, standard flash for the background, controlling all of them from a Master flash on camera that you've told not to fire.

There is so much more to Canon's Speedlite system than first meets the eye. Yes, the gear is more expensive than that from a third-party manufacturer, but the other stuff can't do as much or talk to the camera, like native equipment can. I'd suggest, that if you have doubts about what a Canon flash can do for you and your camera, you rent or borrow one for a weekend. Make sure you have the instruction manual. Play, and don't be afraid to mess up. Working with flash is not a trouble-free experience, but I know that when you're done you'll be a True Believer.

Gerry Kopelow's Gear

1D Mark II

5D (as backup)

14 mm

17–40 mm f4

24–105 mm

70–300 mm DO

85 mm f1.8

24 mm TSC

Polarizer big enough for all lenses

Lens shades

Modified Gitzo tripod

Gerry Kopelow

I caught up with Canada's Gerry Kopelow shortly before he was scheduled to leave for a hectic 10 days of teaching and lecturing in the States. A noted architectural photographer and author, Kopelow's insight and expertise is in great demand, especially by Canon, who often asks his help on the floor at events where architecture and photography come together. At 57, Kopelow is at the top of his game, and always willing to help those coming up the ranks.

Gerry began his career in eighth grade, with the help of a teacher who had an avid interest in photography. Within a few months "I guess I got good," he says. "I saw a call for submissions from the Still Photography Branch of the National Film Board of Canada (the government's public relations arm) and sent in some of my images, which were immediately accepted. I was 14 years old."

The National Film Board of Canada took a liking to young Kopelow and his style of photography. "They were great for me," he recalls. "For several years after that initial connection, I would take a train to the NFB Head Office in Ottawa during school holidays to sell them images." At $50.00 per image, and in his teens, Kopelow began making good money from his work.

He became a street photographer, in the style of Henri Cartier-Bresson, but "I peaked early," he says. "I married young, had children young, and couldn't make a living doing what I had been doing, so I started shooting commercial jobs."

It wasn't long after that when Kopelow's work caught the eyes of an architectural engineering firm seeking to produce a brochure about their projects. "I was asked to photograph one key building in each Provincial capital, ten buildings spread across Canada. It never occurred to me to question it, but they wanted me to shoot two buildings per day. I would fly into a city, be met by someone at the airport and driven to the location, shoot the picture and be driven back to the airport. It sounds awful, but it was a charmed project. Every situation was perfect, with great light and a point of view that I was quickly able to find. I remember thinking, 'This is easy. I should do more of this.'"

Kopelow used the finished brochure as a promotional piece, which got him hired by major architectural firms in his home city, Winnipeg as well as other cities across the country. Canada was going through a boom period and fine architectural photography was in demand by every competitive firm. Just when things were going well, the government closed a tax law loophole that encouraged investment and the entire architectural market, and Kopelow's source of revenue, dried up virtually overnight.

Kopelow went back to commercial shooting while the architectural market slowly rebounded. His work is largely architectural again.

When the digital revolution hit, Kopelow did not jump ship immediately. He continued to shoot with view cameras and medium format equipment, scanning his film on a high-end scanner in order to deliver the digital files his clients requested. He'd made a list of things he wanted in a digital camera and vowed to not purchase one until the list was met. His primary requirement was a full frame sensor, and the Canon 1Ds was the first camera to make the grade. "The first Raw file I made was superior to files coming off my scanner," he recalls. "I sold all my film camera and darkroom gear immediately."

These days Kopelow shoots a 1Ds Mark II, with a 5D for backup. "Canon is definitely superior," he notes, "and photography is way more fun. I can do better work – one order of magnitude better – that I could with my 4 × 5. Any future improvements will just make my life that much smoother."

Kopelow's shooting workflow changes with his clients. For example, he will often shoot tethered to his computer so his clients can see what he sees. "It's a fantastic tool because the clients become involved in fine-tuning the shot. When they can see the images they'll know when the shot is what they want. (Shooting tethered) slows the process but that doesn't bother me."

Even if clients can see the final composition on the tethered screen, they still have to rely on the photographer for the final vision. Kopelow shoots a very wide exposure bracket, nine or ten full f-stops, to get all the detail in every area. Unlike High Dynamic Range processing, which merges a number of exposures together by itself, Kopelow prefers a more basic method. "I've taught myself a number of creative ways to cut and paste. I'll start with a baseline pick, a shot with great midtones and detail, then build the image from there. HDR gives you great tonal range but not always fine detail, especially at severely over-exposed edges. If I'm working on the road, I can do the Photoshop work while I'm watching a movie in my hotel room. A typical image takes 45–60 minutes, and I build that into my cost."

For backup, Kopelow replaced the single drive that came in his Mac laptop with dual hard drives and RAID software that immediately places his shots on both drives. "I feel pretty safe on the road," he says.

It's a different story at home, where he built his own RAID array using Mac G4 logic boards bought on eBay and assembled in third-party towers, networked together. "The main drawback to digital is storage," he says, "but I have over ten terabytes of it. I don't use any optical storage, it's too

slow. I've duplicated all my Raw files, and I'm sure I'll have to deal with them someday . . ."

Kopelow travels as light as possible. "I feel obligated, as a pro, to carry some lighting with me, so I'll often bring a small Profoto kit. Otherwise, everything I bring fits in the overhead compartment on an aircraft." In addition to his lens selection (see below), Kopelow has a few special tricks. "The right-angle finder attachment is valuable, as I'm frequently backed up to a wall." Obviously handy in the workshop, he adds, "I mounted a tripod head on a vice grip, which works great if I need to mount a camera to a door or shelf, and I've customized my lens shades so I won't ever see any vignetting."

In between a busy schedule of shooting and speaking, Gerry Kopelow is also the author of several books on architectural photography and other subjects (FIGS 8.47–8.51). His latest, *Architectural Photography the Digital Way* has just been released by Princeton Architectural Press. See more of his work at http://www.GerryKopelow.com.

FIG 8.47 "Shooting digitally at night is much easier than shooting film," Kopelow says. "Colors are more predictable and accurate, and the illuminated LCD and histogram make finding the right exposure that much quicker." Kopelow used his 1Ds Mark II with a 17–40 mm Canon zoom to make this image for AB Architects of Vancouver

FIG 8.48 Kopelow used his Photoshop skills to blend several bracketed exposures of this sculpture inside the Museum of Anthropology at the University of British Columbia in Vancouver. His client was the architect, Arthur Erickson. 1Ds Mark II, 24–105 mm zoom (at 42 mm)

FIG 8.49 On assignment for Loewen Windows, used only available light to make this image of a beautiful San Diego, California, living room. "This is a good example of how an extreme range of exposure brackets can be combined in Photoshop to make a natural looking, extremely wide tonal range image." 1Ds Mark II, 17–40 mm zoom

FIG 8.50 It's always best to correct perspective in camera. For this detail image from the new National Archives of Canada, Kopelow used his 24 mm TSE lens. As he explains, "Image focus was manipulated for effect with the tilt function of the lens, perspective was controlled by dialing in sufficient vertical rise"

FIG 8.51 With the exception of one strobe, fitted with a medium strip-light softbox to open up shadows and illuminate the props, this balcony at the Landings of St. Lucia was available light. The time of day was carefully chosen for maximum sunlight details. Kopelow used his 24–105 mm zoom, at 45 mm, to make this image

Digital Photo Professional

Maximizing the Digital Negative

As I discuss in various parts of this book, there are many reasons one would shoot in RAW, the most important being the amount of control one has over the final processing of the image.

A RAW file is considered the digital equivalent to a film negative (thankfully without the requisite liquid chemistry) and can be affected by a variety of software controls to create a .tif or .jpg file delivering exactly what you want to present. It does take additional time to work a RAW file, which is something you need to consider if you're working with a large number of images, but the extra effort can be worth it if you need a superlative final product for an advertising, commercial, or fine art piece.

Canon addressed this issue by creating Digital Photo Professional (DPP), a proprietary program included free of charge with every DSLR in their lineup.

Many photographers wonder why they should work with DPP when other, more common programs like Adobe Camera RAW within Photoshop, can make an image conversion from RAW to Tiff or Jpeg, then place it on the desktop for more intense image manipulation. The answer is very simple and sublimely logical: Canon's RAW conversion software was built for Canon files only. Since Canon does not share its

architecture with other manufacturers, they can only create programs that generically do the job. Consequently, those other manufacturers, whose goal is to create generic translators that work with any RAW code, cannot incorporate the subtleties and nuances available to the engineers at Canon. Let me show you what I mean.

Both programs, Photoshop and DPP, can make a conversion from a RAW file without making any other changes beyond what the conversion software "sees" when the file is selected. Smart photographers, who take the time to calibrate their light meters to their camera equipment, use the correct White Balance settings or who take the time to test the automated settings (such as Av or Tv) and make any necessary exposure adjustments via Exposure Compensation, can produce files that are as close to perfect as possible. These files may require no further manipulation other than conversion from RAW to Tiff or Jpeg, which makes it important that the conversion software reflects those calibrations. Note that if you make adjustments to the image in the camera by changing the amount of sharpness or other such parameters, this information will not be seen by software other than DPP.

Consider these "straight" conversions, made without any exposure or color changes, just as the RAW file was captured by the camera and interpreted by the software (FIGS 9.1 and 9.2).

Of course, color and exposure can also be adjusted in other programs, but why would you want to take that extra time?

Another, very significant, benefit from working with Canon's DPP software is the reduction of noise in a processed image.

Noise is a natural by-product of signal amplification, how the camera defines ISO, a term that originally defined how sensitive film was to light. Camera manufacturers have programmed their sensors to mimic that same scale, so that, at ISO 100 an exposure of 1/100th of a second under bright sun at f16 on film (the Sweet Sixteen rule) will yield the same results with digital media. If a film photographer needed the same f-stop and shutter speed under less bright circumstances it was a simple matter to change to a film with a higher ISO, but that's not an option for digital photographers.

With film, higher ISO speed film meant a more pronounced grain structure, grain being the size of the individual light sensitive silver-based "chunks" adhered to the film base. Faster films generally meant larger grain.

Digital cameras compensate by amplifying the signal that reaches the sensor chip, and the result is quite dissimilar. The higher the camera's ISO,

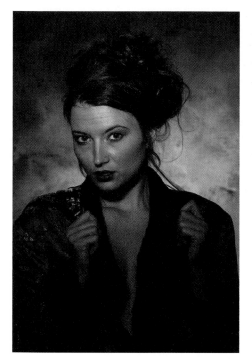

FIG 9.1 Conversion made in DPP

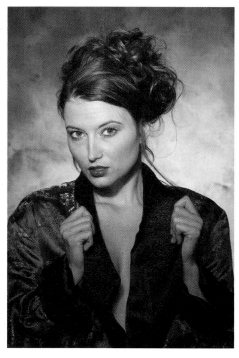

FIG 9.2 Conversion made in Photoshop CS3

the more noise it produces. The difference is that grain (or the deliberate use of it) had a certain charm that frequently added to the look of the image. Noise is an amplification of the RGB signal, which shows up as RGB artifacts and is not usually considered "charming" at all.

Because Canon's DPP software was built for its own chips it has built-in noise reduction, engineered only for itself, that generic RAW converters simply cannot target. Noise typically is most prominent in darker tones or shadows and should be noticeable even in small reproductions like these (FIGS 9.3 and 9.4).

DPP uses two windows for its operation. The Main window acts like a browser; you point it to the folder you wish to view, select it, and all of that folder's contents show up in rows of thumbnails (FIG 9.5).

Select one, some, or all of the images, then select Edit Image window from the button menu at the top. Doing so will call up a second window, the Edit window, and your selected images will appear in a vertical row on the left. The first image from the selected group will appear large in the main portion of the Edit Window. You'll note this image will look fuzzy for a few seconds, as DPP renders the file.

A RAW file itself is never changed, no matter how you change the screen image. When you see a RAW image on your screen you're looking at an image influenced only by the conditions under which it was shot and the manipulations that you make in the conversion software. When you like it, tell the machine to Convert and Save and a new file will be created as a Tiff or Jpeg (your choice). The original RAW file information can be revisited any time, and remains intact until removed or deleted.

FIG 9.3 DPP conversion at 100%

FIG 9.4 Photoshop CS3 conversion at 100%

FIG 9.5

Now that you're initially familiar with the two windows, let's back up for a moment. DPP magic can happen in either window, and I want to focus on the Main window before we proceed.

With the Main window open, click the Folders button (FIG 9.6) to hide the drive menu on the left and maximize the rows of thumbnails. Dragging on the expansion tab at the lower right corner will expand the screen even further, as long as you have room on your monitor (FIG 9.7).

Select All will highlight every image in the folder; Clear All will de-select them (FIG 9.8).

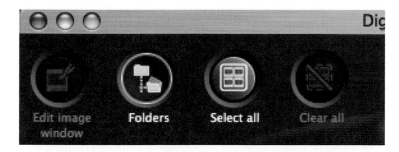

FIG 9.6

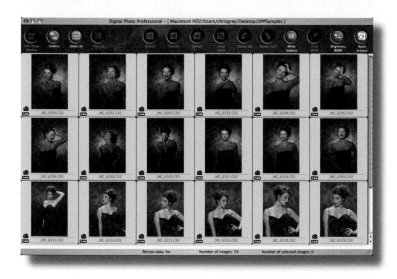

FIG 9.7

FIG 9.8

You can select each image individually and rank them in order of importance (first, second, third) by clicking the Check1, Check2, or Check3 buttons (FIG 9.9).

Obviously, the Clear Check button will clear any previously checked files (FIG 9.10).

Rotate Left and Rotate Right will turn the selection in 90° increments (FIG 9.11).

FIG 9.9

FIG 9.10

FIG 9.11

Up to now, you could apply any of the controls to either file format your camera is capable of creating, RAW or .jpg. The last four buttons are reserved for RAW images only (FIG 9.12).

FIG 9.12

Selecting the White Balance button will call up the White Balance Adjustment window. In this window you can change the White Balance of the actual shot settings to any white balance setting available in the camera. Should you accidentally shoot a batch of images under Tungsten light (but the camera's white balance was set to Daylight), the entire batch can be changed by simply using this tool and selecting the appropriate White Balance (FIG 9.13).

Take the White Balance further by selecting the Tune button, which calls up a color wheel. Drag the center mark anywhere in the wheel to get effects from sublime to outrageous (FIG 9.14).

FIG 9.13

FIG 9.14

Note that the images are changed only at the thumbnail level and will not be formally applied until you quit DPP or open a different folder and are prompted by the program to do so. Even then, you can revert to the original shot settings at any time in the future.

Click (RAW) is an eyedropper tool that, when placed on any area in the image and clicked, will neutralize that area with whatever color temperature is necessary in an attempt to find neutral gray or white. If you are shooting against a neutral gray background, for example, and some of your pictures are off color because you added a different light with a non-neutral bias or selected the wrong White Balance, this tool may restore proper color just by clicking on a well-lit portion of the background.

To use it, just select the image(s) you want to adjust. Select the Click (RAW) button and place the eyedropper tool on a neutral area. Click again. Done (FIGS 9.15 and 9.16).

Use the Brightness (RAW) feature to make general exposure corrections to selected images. Clicking on it calls up the same correction window you can use in the Edit window, and exposure is variable over a four f-stop range. The beauty of using it in the Main window is that it's easier to make a correction over a large selection of images (FIG 9.17).

Shooting Tip

For those of you who shoot under a variety of color temperatures and who may not have the time to custom white balance every time, here's a tip you might find valuable.

Make certain you have access to either a neutral gray card or a collapsible gray target, both of which can be small enough to keep in your gadget bag. If your job, a wedding perhaps, will take place under a number of lighting conditions, just include your gray target in one, inconsequential, RAW image shot under each of the various lighting conditions. Include enough background so you can tell which lighting condition you were working in. If you need to white balance any of your images after shooting them, just select the appropriate images, select Click (RAW), then click the eyedropper on the gray card shot under the matching conditions. Even major changes in white balance can be easily fixed.

FIG 9.15 Before

FIG 9.16 After

FIG 9.17

If you're happy with what you've done to your images in the Main window, select Batch Process to convert them into real Tiffs or Jpegs. You'll see a new window appear, the Batch Settings window, where you'll make decisions as to where the processed images will go, what kind of file (16 bit Tiff, 8 bit Tiff or Jpeg) they'll become. Additionally, DPP can resize images up or down from their original file sizes. This is especially valuable if your client needs a high quality file for a larger than normal use, a two page magazine spread for example (FIG 9.18).

The Edit Window

By default, the Edit window opens with Thumbnails and Tools selected, so that you'll see the first several of your selected images along the left and the Image Adjustment toolbox at the right. Should you choose to edit individual images, this window alone will probably accomplish 90% of your goals with DPP, so that's where we'll begin (FIG 9.19).

FIG 9.18

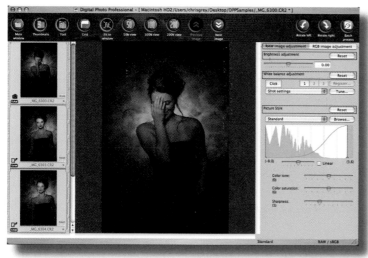

FIG 9.19

You'll notice two bars at the top of the window: RAW Image Adjustment and RGB Image Adjustment. The majority of adjustments will be made on the RAW side, although there are some very interesting tricks to be found in the RGB window.

RAW Image Adjustment

The first image in my queue is a little underexposed on my model's face. I'd been working with a parabolic reflector fitted with a grid spot,

DPP offers adjustments over a four f-stop range, which means you should be able to salvage an image that was over exposed by up to two full f-stops, a feat that's not possible with any software if your original shots were jpegs only, because digital exposure is the most fussy on the high end. With jpegs, an overexposure of only + 1/3 stop will damage the image and the loss of data will not allow detail to be brought back. It can't be "burned in" like overexposed detail in traditional negatives because it simply doesn't exist. Shooting RAW is a partial solution to over and under exposure issues but will take more of your post-production time. Use it wisely.

a honeycomb-like device that fits into the reflector and allows light to be reshaped for a spotlight effect. The grid spot narrows the light beam so that the intensity of the light falls off dramatically at its edges, and my model had moved slightly off her mark. Using the Brightness adjustment (the same control that you'd see in the Main window) allows me to quickly change the exposure value. Note that because the background was lit by another light, and is therefore constant, it will change along with the exposure on the woman. Those of you proficient in Photoshop or other image editing software know that you can create two images from this RAW file; one with a normal background and one with the adjusted background, then blend the two together for an almost perfect match (FIGS 9.20 and 9.21).

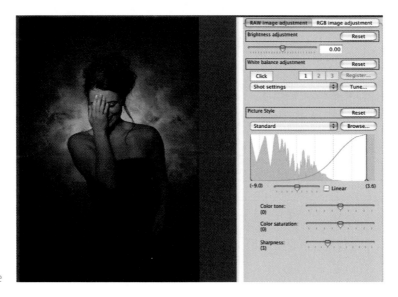

FIG 9.20 Before

The White Balance adjustment will also call up a box similar to that found in the Main window, with one notable exception. You can retain up to three personal white balance settings to be used now or later, as you wish. They can be altered at any time.

Setting a personal white balance is very easy. Simply select the White Balance setting you'd like to use by choosing from the dropdown list (or using the slider under Custom White Balance) (FIG 9.22).

In the Register window, select Custom 1, 2, or 3, then click OK. Your color temperature selection is available anytime until it's changed (FIG 9.23).

FIG 9.21 After

FIG 9.22

FIG 9.23

Although color temperatures can't be set at the White Balance window in the Main window, those set in the Edit window will be available in the Main window after they have been registered.

I'm sure you can see the importance of a control like this. Many wedding photographers shoot everything in RAW format, preferring to take the time to fine-tune each image before processing and printing. Many of those images are made with on-camera flash and sometimes look a little flat. Adding a little extra warmth by changing the color temperature to 5600–6000 K might be beneficial to the final product.

Beauty and glamour photographers frequently want an even greater level of warmth in their images, perhaps all the way up to 10,000 K. Although, as demonstrated elsewhere, you can set the Color Temperature in the camera, shooting RAW will guarantee that you can dial in any color temperature you desire while holding the original shoot data in a protected file (FIGS 9.24 and 9.25).

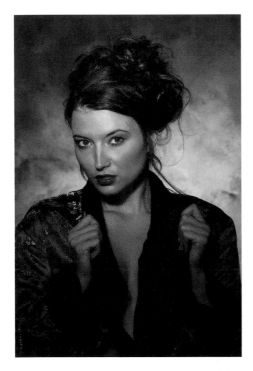

FIG 9.24 8000 K

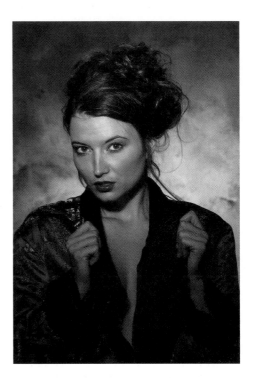

FIG 9.25 10,000 K

If you like the concept of changing an image's color temperature and want to apply it to existing, non-RAW, images, I've outlined a simple yet very versatile Photoshop formula in my book *Photoshop Effects for Portrait Photographers*, also from Focal Press.

PICTURE STYLES
You can, of course, set any Picture Style you wish in the camera. If you shoot jpegs, and you want a look that's different from what you typically shoot that's what you'll have to do, of course. The beauty of RAW and the Edit window is that you have access to all of the Picture Styles, so you can toggle between them to see what looks best, without locking yourself in to a camera-processed style (FIG 9.26).

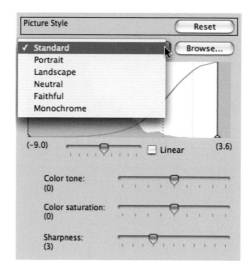

FIG 9.26

Picture Styles are like processing films from different manufacturers in the same chemistry; they all slightly vary in color and look. Whether you use Photoshop for final tweaks or not, the ability to rapidly but consistently alter the Picture Style gives you unprecedented creative freedom over the look of your image. See "Picture Styles" for more information and comparison images.

Adjusting Dynamic Range

What appears to be a traditional histogram is actually a Dynamic Range adjuster. The image in the Edit window originally showed a dynamic range of −9.0 to +3.6. These numbers can be changed by moving the shadow slider (on the left) and the highlight slider (on the right) toward the middle. Moving either slider eliminates some of the shades of light or dark that comprise the image, making transitions from white (no detail) to highlight detail, or black to shadow detail, shorter than what was shot. Although you might wonder why you would ever want to shorten the dynamic range this tool is quite practical; if you're shooting for a critical application and you know the maximum dynamic range of that application is, say, −8.4 to 2.0, you can make those changes as well as necessary Brightness adjustments to get the best possible representation of your image in a shorter dynamic range. If this is not done it's possible that the image will be tonally clipped when it's reproduced (FIG 9.27).

Just below the Dynamic Range window is a nameless graduated slider that you can use to raise or lower the contrast of the image as it appears after you move the sliders or by itself, without any DR adjustment. It's extremely useful for fine-tuning an image with a shortened dynamic range (FIG 9.28).

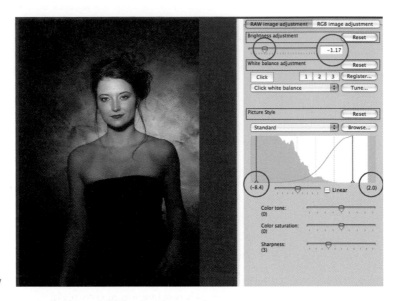

FIG 9.27

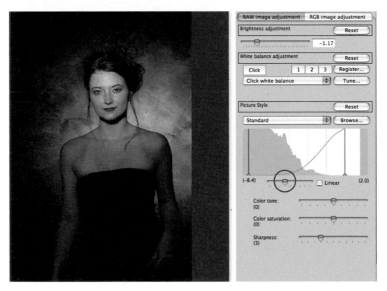

FIG 9.28

Checking the Linear box to the right of the contrast slider will flatten the curve and seems to show an average of represented pixels within the image, actually adjusting the Linear Tone Curve. This is a tool generally used by very advanced users to create their own custom profiles. You've been warned (FIG 9.29).

Below the Dynamic Range graph are two more sliders that are important to any of the Picture Styles; Color Tone and Color Saturation.

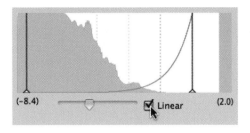

FIG 9.29

Color Tone will skew the overall color of your image in either of two directions. Slide to the left, and the tone takes on more red. Move it to the right and the image gains yellow. This is a useful tool if you need to add to or mellow out colors in a general way.

Color Saturation, like its Photoshop counterpart, will either saturate or desaturate the color strength of your image.

Black and white is back! I mentioned elsewhere that Canon's Monochrome Picture Style is absolutely outstanding, and it truly is, producing neutral tones of great depth and full of visual information, with natural highlights and terrific shadow detail. DPP uses almost identical algorithm as the Picture Styles function in the newer cameras, with a few additional features.

When you select Monochrome, you'll notice changes to the secondary control sliders. The Color Tone and Color Saturation sliders respectively change to Filter Effect and Toning effect (FIG 9.30).

For truly neutral results on either self-printed or lab-generated prints, there are a few things you should know. Many inkjet printers will not print a neutral black and white print even if you send them a neutral file. The standard inks are not designed to do that and results will typically show a slight magenta or green cast. If your printer allows true black and white, you may first have to flush the ink delivery system and change cartridges, a somewhat expensive routine because of wasted ink. Some new printers, like Canon's imagePROGRAF line, can produce beautiful neutral images without skipping a beat (or changing a cartridge). Check and test your equipment before starting a money job.

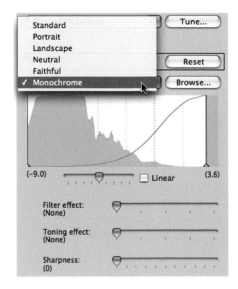

FIG 9.30

Filter Effect

Those of us who shot lots of black and white film will no doubt remember the colored glass filters we used to alter the wavelength of the light that struck the film. In portraiture, women were often photographed with yellow or orange filters because they would lighten skin tones. Men were sometimes photographed with a green filter, which would darken the skin, presumably to give them more character (a look referred to in more than one book as "swarthy").

Nature and architectural photographers would routinely use a red filter to darken blue skies or a green filter to lighten foliage because the filters would lighten colors similar to themselves while darkening their opposites.

Canon's software engineers designed the four most popular black and white filters; yellow, orange, red, and green, into this nifty little slider, and, like all the effects in DPP, the application of each can be viewed in real time. While the difference in my model's skin tone is obvious, be sure to look at the difference in the way the filters affect her lipstick (FIGS 9.31–9.34).

Toning Effect

Just below the Filter slider is Toning Effect. Should you be looking for the classic sepia-tone look of older, silver-based, photographs or just to put some extra zip into a black and white image, you might find what

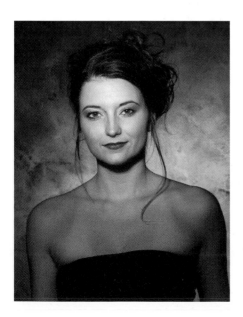

FIG 9.31 Yellow filter

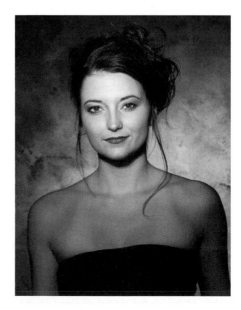

FIG 9.32 Orange filter

FIG 9.33 Red filter

FIG 9.34 Green filter

you need here. Chemical toners were designed to replace the silver in photographic print paper with other metals or with dye, either of which would change the overall color in a print. Toners were originally available in a wide variety of colors and tones but have virtually disappeared from the market since the advent of digital.

Canon's Toning Effect slider will reproduce four colors of toner; sepia, blue, purple, and green. The program also allows you to mix a Filter Effect and a Toning Effect, which can result in some interesting combinations (FIGS 9.35–9.38).

Sharpness

With the exception of Monochrome, all Picture Styles in DPP default to level 3 Sharpness when selected. Sharpness, or the degree of it, is purely a matter of the photographer's taste balanced against the subject matter. Most family portraiture should not be critically sharp, if for no other reason than to spare your subjects the reality of time, while a great deal of advertising's portraiture (and most product photography) needs to be sharp as a tack.

These two comparison images show the range of sharpness available with DPP. In Standard Picture Style, the first shot is set at zero, the second at 10 (FIGS 9.39 and 9.40).

FIG 9.35 Sepia tone

FIG 9.36 Blue tone

FIG 9.37 Purple tone

FIG 9.38 Green tone

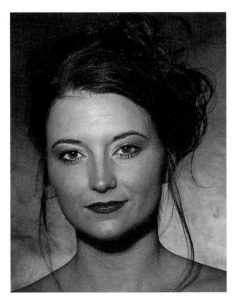

 FIG 9.39 Sharpness zero

FIG 9.40 Sharpness level 10

RGB Image Adjustment

You can continue to fine-tune your image by selecting the RGB Image Adjustment button, found at the top of the Tool window. Here you'll find what looks like a traditional histogram. While it shares some of the functions of a histogram, it's actually a Tone Curve Adjustment and, as such, combines the best of Photoshop's Levels and Curves with some additional features (FIG 9.41).

As with Photoshop's Curves, you create a break point by clicking and dragging certain portions of the graph line, changing the tones, contrast and brilliance of the image. For general corrections, Canon recommends the following basic curves (FIGS 9.42–9.45).

At the top of the chart, you'll see eight boxes; RGB (changeable to Luminance in Preferences), R, G, B, plus four others. Selecting any of the RGB channels allows you to make a Tone Curve correction to just that channel. So, while Luminance mode allows us to make general corrections over the full RGB spectrum, Luminance, along with changes made to the individual Red, Green, or Blue channels, provides more than selective retouching, individual RGB tweaks provide even more creative opportunities. You can place up to eight break points on each of the four lines (FIG 9.46).

FIG 9.41

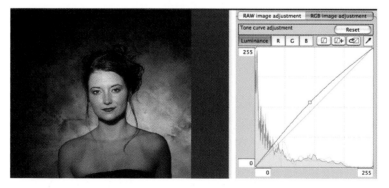

FIG 9.42 Brighter medium tones

If you want to take the easy way out, you can allow DPP to make tone curve decisions for you. DPP will make corrections based on image analysis and create a new tone curve that reflects that analysis. Simply click the first of the next four buttons, Tone Curve Assist – Standard (FIG 9.47), and DPP will do the work for you (FIG 9.48).

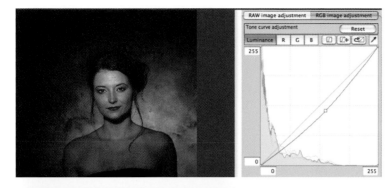

FIG 9.43 Darker medium tones

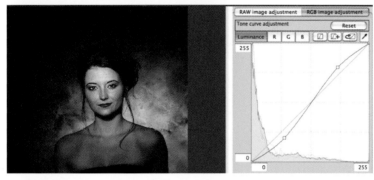

FIG 9.44 For harder tones

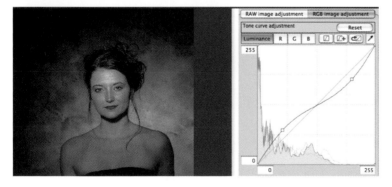

FIG 9.45 For softer tones

If you're working with a more difficult image, move your cursor over to the next button, Tone Curve Assist – High (FIG 9.49). This button allows a major assist that may be able to rescue a severely under exposed image but, like the Standard Assist button, it's a quick fix only. You'll get much better results if you take the time to attack each problem within your image; exposure, color, and white balance, separately (FIG 9.50).

If you've made some previous corrections, color balance or exposure, perhaps, and then made a mistake with the Tone Curve Adjustment, you

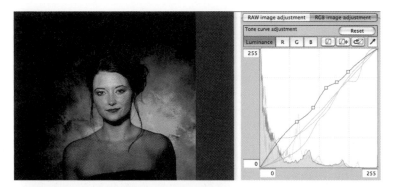

FIG 9.46

FIG 9.47

FIG 9.49

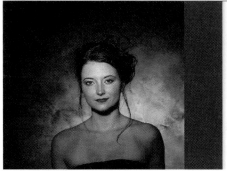

FIG 9.48

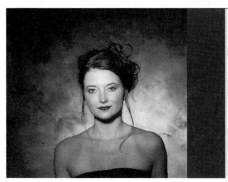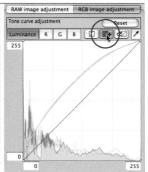

FIG 9.50

can either select Reset or just click on the third button (FIG 9.51). Selecting either will void the tone curve adjustment and return it to default.

FIG 9.51

Finally, just in case you missed this before, Canon's placed another white balance eyedropper (FIG 9.52) right where you need it. Click on a white or gray portion of the image to neutralize the image.

Because most of the items in the drop down menus are duplicated as buttons or selections in the Tool palette I was able to do everything I've shown you so far without using any of those menus. There are a few very

exciting and innovative items hiding in menuland, however, and we need to take a look at them.

RECIPES

You may have noticed some commands in the File and Edit menus that sound a little strange. There are, in fact, seven commands that cryptically reference "recipe." Well, DPP keeps a running tab on all the changes that are made to an image until it's finished and converted to a Tiff of jpeg. The final version of all changes made to an image can be saved and, like a recipe, applied to another image to make a new one that's just as tasty as the first.

It took several minutes to get this particular effect, and I often reset a control because I didn't like what I saw. I radically changed the dynamic range, exposure, contrast, individual RGB channels as well as the entire RGB tone curve. Before converting it to a .tif, I selected Edit>Save Recipe in File, named it, selected a location for it (I created a Recipe Folder), and clicked Save. That's it. Now I can apply this recipe to any photo I wish, now or in the future (FIG 9.53).

FIG 9.52

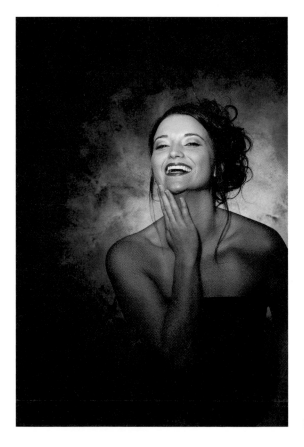

FIG 9.53

Working with Jpegs and Tiffs

Although DPP was developed as a high-end tool for RAW file conversion, it functions quite well, but with limitations, as an editing and image enhancing program for .jpg and .tif files as well. You can only use the RGB Image Adjustment window and palette, but you can make changes to one image, then apply it to others via a recipe. Like working with RAW file data, changes made to Tiffs or Jpegs are only made when selected images are processed. The original image data remains intact.

They may make adjustments to the following items:

Brightness

Click White Balance

Contrast

Color Tone

Color Saturation

Sharpness

Dynamic Range

Automatic Adjustment

Tone Curve

To use the recipe (or any other that's been saved in the created Recipe folder), first select a new photo in the Edit window or in another RAW file folder. Go to Edit>Read and Paste Recipe from File …, and select the proper file and recipe. Go back to Edit>Paste Recipe to Selected Image. The entire conversion process, which perfectly matched the first image, took less than ten seconds. *Note*: Any color differences between these two images is because this image is a screengrab (FIG 9.54).

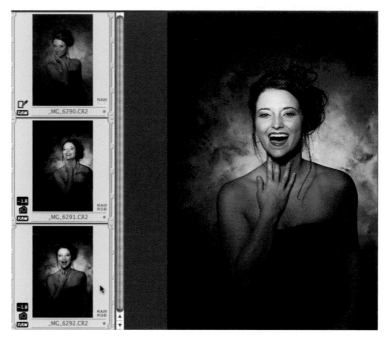

FIG 9.54

DPP can also trim your images on the fly, to any aspect ratio you wish, by using the Trimming tool found under the Tools menu. Calling up that tool will send your selected image to a new window, where you'll see the Aspect Ratio palette. You can choose from a number of presets or select Custom and simply type in the dimensions you need. If you want to crop without a ratio, just select Free and crop as you wish (FIG 9.55).

Unless you return to the last saved settings or revert to the image's shot settings, DPP will produce a trimmed file each time you process that file from now on. You can easily tell if the image has been trimmed by looking for the Trim icon in the Main or Edit window. You'll find it in the upper right corner of the thumbnail (FIG 9.56).

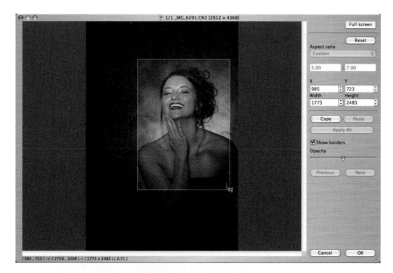

FIG 9.55

FIG 9.56

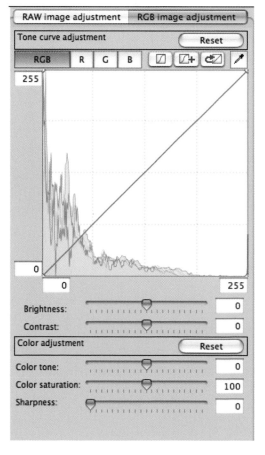

FIG 9.57

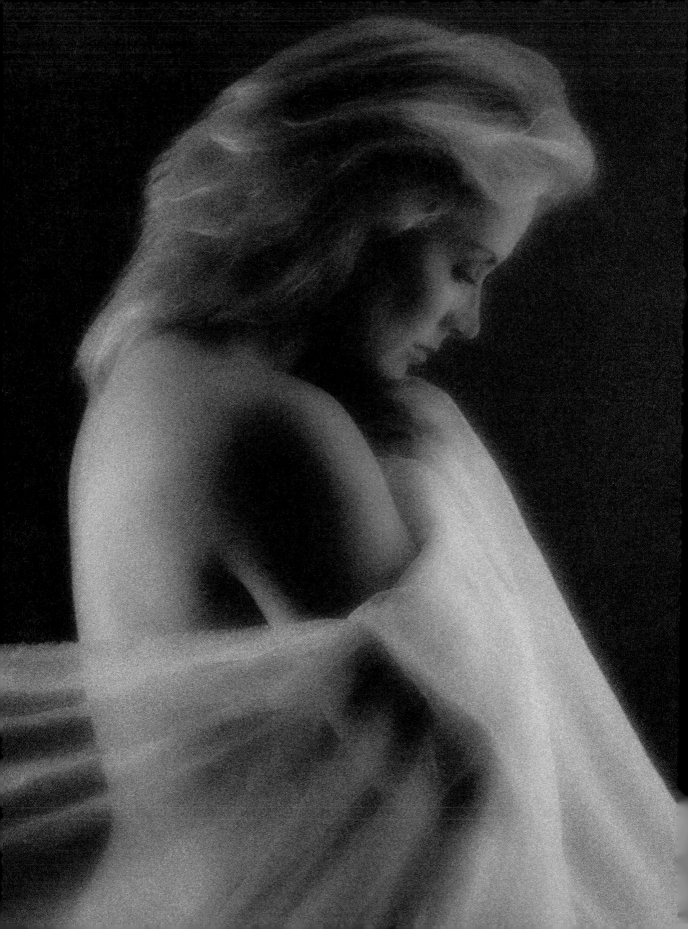

Canon Gallery

Canon Around the World

Take a look at what peers and colleagues can do with their Canon gear, and make note of their tricks and tips for your own work.

With all the wonderful gear at their disposal, it's no wonder that Canon shooters of every level produce consistently remarkable images. From casual snapshots to photojournalism to commissioned advertising, Canon delivers the goods.

There is an acronym, WYSIWYG ("Whizzy-wig"), "What You See Is What You Get," that was the Holy Grail for digital imagers. In the early years of digital, and even today with some camera systems, WYSIWYG is still a mirage on the horizon. But not for Canon. Now you can capture what you see, faithfully, or go beyond it if you wish.

Take a look at some marvellous images, made by enthusiastic Canon photographers from around the world.

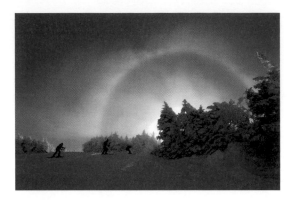

FIG 10.1

David Brownell

SNOW RAINBOW

Shot with a Canon 10D, 20–35 mm f2.8 lens at 20 mm, this rare snow rainbow, caused by the refraction of ice crystals against the sun, was made, coincidentally, at Canon Mountain in Franconia, New Hampshire. David's exposure, 1/1000 at f8, about one stop less than a textbook daylight exposure, accounts for the saturated colors. The camera's preset Daylight color temperature accents the extra ultraviolet light present in a snow scene (FIG 10.1).

FIG 10.2

David Scarbrough

KINDERGARTEN TEACHER MARY SCARBROUGH

David had only the 15 min of "snack time" to get his shot. He bounced two flash units off the ceiling with the STE-1 remote trigger, along with Rear Curtain Sync to fire the flashes at the end of the ½-second exposure, mixing ambient and flash about 50/50. His lens was the EF-S 10–22, at 11 mm, on his 20D (FIG 10.2).

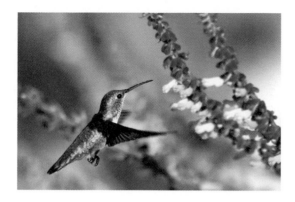

FIG 10.3

Craig Wolf

Hummingbird

According to Craig Wolf, the low noise of his Digital Rebel and the high shutter speeds were what made this shot a success. He'd made a few, quick shots but realized, after reviewing the images, that the shutter speed was too slow to stop the bird's wings. He reset the ISO to 400, which gave him 1/2000 second at f5.6, enough to stop most of the wings' action (www.craigwolf.com) (FIG 10.3).

FIG 10.4

Jim Byron

Marvin

Jim sparked up his ID Mark II and three studio lights (key, key accent, shadow kicker) and a reflector, all set up in advance of his subject's arrival, to create this evocative image. ISO 100, zoom lens at 125 mm, 1/125 at f22 (FIG 10.4).

FIG 10.5

Kristen Farmer

ALEX

As Kristen explains, "We shot this image at the very end of a full day's shoot. The only lighting issue we had was timing the exact moment of a quickly falling sun. We only had moments before it went down too far. We sprayed Alex's hair with a water bottle and used available light and a gold reflector to light her."

Kristen used a 70–200 mm f2.8 zoom on her 1D Mark II, 160 mm, ISO 100, 1/320 at f2.8 (www.greysonhill.com) (FIG 10.5).

FIG 10.6

Allen Birnbach

UNTITLED

It's never a dull moment for commercial photographers. This stunning image, as Allen explains it, is "Part of an ad campaign 'Live the High Definition Life' for DTS, the movie sound company. Shot with three cameras consecutively (when one hit the buffer, we went to the next) to create images for print and motion graphics applications. Shot on an outdoor cyclorama so we could shoot at the maximum frames per second. Over 3000 images were created in one day to complete the project requirements." Canon 1DsMkII, 40 mm, ISO 400 (www.allenbirnbach.com) (FIG 10.6).

FIG 10.7

David Sutton

UNTITLED

The first thing David Sutton did when he got his 1Ds Mark II was to pop out the focusing screen and score a square onto it with an Xacto knife. After years of shooting with Hasselblad, the square format was tied to his visual identity. "The Mark II gives me so much information that I literally throw a third of it away. We offer clients prints up to 30 × 30 and never have a problem. Digital capture saved us almost a week of turnaround time, too." Canon 1Ds Mark II, zoom lens at 28 mm (www.suttonstudios. com) (FIG 10.7).

FIG 10.8

Kreta Chandler

DAHLIA

During an Island vacation, Kreta Chandler wandered into a little flower shop just as the owner's stock was being replenished. One of the buckets of dahlias was placed on the edge of a shaft of sunlight, and Kreta asked permission to photograph it. She used the Standard Picture Style to slightly increase the saturation. "It's my first DSLR," she said. "I love it, but I still have a lot to learn about it." Looks like she's doing OK. Canon 5D. ISO 400, 1/30 at f2.8 (FIG 10.8).

FIG 10.9

Kiet Thai

LEGONG DANCE

This photo was taken during an evening performance of a traditional "Legong" dance in Ubud, Bali. The dancers were illuminated by bright theater lights and, although there was a lot of light, Thai had to use ISO 1600 to get a shutter speed high enough to freeze some motion. He explains, "The movements of the dancers were quick and about half of the images I took were blurred. Thankfully this one came out wonderfully!" Canon Digital Rebel Xt, 18–55 mm kit lens at 55 mm, 1/40 at f5.6 (FIG 10.9).

FIG 10.10

David Shirk

NATIONAL THEATER TAIPEI

There's do doubt Canon shooters are ingenious! David Shirk saw this beautiful reflection in a street puddle after a rainstorm but knew using a tripod would raise his camera too high to get the reflection and the building in the frame. He nested his camera into the crook of his umbrella, just out of the puddle, and used his favorite Custom Function, Mirror Lockup, along with the self-timer to prevent camera shake when the shutter fired. Canon 20D, 18–55 mm kit lens at 18 mm, ISO 200, 30-second exposure at f22 (www.unpluggedphotography.com) (FIG 10.10).

FIG 10.11

Scott Tokar

HOME RUN

Magician Scott Tokar used his Canon 20D and 580 EX flash to work a
little magic into this shot of this young lad's home run. His combination
of twilight, the field lights, and his flash (set to Second-Curtain Sync) got
him a perfect exposure along with a speed trail that followed the ball
after it was struck. Canon 20D, ISO 800, 1/60 at f4.5 (FIG 10.11).

FIG 10.12

Joseph Tichenor

UNTITLED

On location for a transportation advertising agency, and waiting for a particular vehicle, Joey Tichenor killed time by panning his camera with traffic that crossed his vantage point. Note that the reflective signs were frozen in time when the flash fired, but that everything else maintains a motion blur. Canon 1Ds, 16–35 mm zoom at 17 mm, 1/3 second at f14 (www.jtichenorphotography.com) (FIG 10.12).

FIG 10.13

Larry Brownstein

HOLLYWOOD BOULEVARD 108

Larry Brownstein juxtaposed this street performer with a movie poster to make this somewhat unsettling image. The sun had just set behind the buildings, so Larry opened his lens to its maximum aperture, f1.2, so he could continue to shoot with a low ISO. The poster was only a foot or two behind the harmonica player, but the lack of depth of field lends to the eerie feel. Canon 5D, 85 mm f1.2 L, ISO 160, 1/200 at f1.2 (www. larrybrownstein.com) (FIG 10.13).

FIG 10.14

Rizwan Farooqui

ASHA BHOSLE

From Hollywood to Bollywood. Riz Farooqui made this portrait of Bollywood playback singer (over 925 movies!), and Grammy Award nominee, Asha Bhosle using two 580 EX units. Farooqui's key light was on a light stand to camera right and aimed into an umbrella. His second unit, on camera, was modified with a LightSphere. 1D Mark II N, 70–200 mm f2.8 zoom at 185 mm, ISO 400 at f5 (FIG 10.14).

FIG 10.15

Russ Pullen

UNTITLED

London wedding photographer Russ Pullen was sheltered under a bridge with the bride and groom, waiting out a small rain shower. When the sun broke through, lighting the Tower Bridge, Pullen grabbed the couple and brought them out for a shot. Their location was in open shade, so he used flash fill to put a little "pop" in the light. 1D Mark II, 24–70 mm f2.8 zoom at 40 mm, 550 EX flash, ISO 400, 1/1000 at f7.1 (www.russpullen. com) (FIG 10.15).

FIG 10.16

Scott Galloway

INTERIOR

Scott Galloway blended a number of exposures together to create this beautiful interior. "The multiple exposures were taken perfectly level with special care not to bump or move the camera," he said. "F/18 was used for all five exposures at 1/15th, 1/10th, 1/5th, 1/3rd, 1/2. Only three of the exposures were used to make the final image. The 1/15th was used for the sky and ceiling, the 1/3rd was used for the stairs and most of the floor and interior, and one other was used for the wall lights." Canon 5D, 24 mm Tilt/Shift lens, ISO 100, f18 (FIG 10.16).

FIG 10.17

Jeff Morgan

STONE ARCH BRIDGE

Jeff Morgan used his 24 mm Tilt/Shift lens to correct perspective as he looked down on a landmark bridge. Working with 50% overlap, and Auto Exposure Bracket to produce a series of exposures, Morgan stitched together this beautiful High Dynamic Range (HDR) image.

"The highlights in the image come from the −2 stop image; the midtones from the correct exposure; and the shadows from the +2 stop image. It is important to keep the f/stop constant and bracket with the shutter speed so the DOF does not change. To make the images register correctly you need to take all the bracketed images in the same position first before moving the camera. The camera's auto-bracket function works well for this. The middle, or correct, exposure was 4 seconds at f/8.0. I then moved the camera to have a 50% overlap and took the next set of three images and so on," said Morgan. Canon 5D (FIG 10.17).

FIG 10.18

Rick Haithcox

BARNEY BARNWELL

Dallas, North Carolina, photographer Rick Haithcox took great pains to make his image of "local personality and ex-moonshiner" Barney Barnwell look like an effortless grab shot. Rick notes, "The early afternoon sun filtered by pine trees came from camera left. A white reflector was placed to camera right. Black gobo's were placed to keep any hard light off the background door and porch wall. Camera was placed on a tripod and settings were 60th at 5.6 and a Canon cable release switch was used to keep the camera steady. The mirror lock up feature was also used to eliminate any vibrations (Custom Function 12). The color balance was set to manual and was 4600 K, but this image was determined to be best converted to B&W." (FIG 10.18).

FIG 10.19

Cris Mitchell

HOLLYWOOD PORTRAIT

Cris Mitchell, photographer and owner of www.ProPhotoResource.com made this portrait in the style of the old Hollywood masters, George Hurrell and C.S. Bull, using studio strobes equipped with reflectors and grid spots. Mitchell's key light was an 18" Beauty Bowl fitted with a 25° grid. The contrasty light, with its deep shadows, contributes greatly to the period look of this image. Canon 20D, 24–70 mm lens at 40 mm, ISO 100, f5.6 (FIG 10.19).

FIG 10.20

Jorge Fernandez

THE OLD RADIO MAN

He may be just starting in photography, but he's doing everything correctly. After doing a Custom White Balance, and using only the two 60 watt lamps in the room, Jorge Fernandez crouched between a table and sofa and made this evocative image of radio legend Tom Hennesey, who keeps in touch with his friends by cassette tape "broadcasts." Canon 20D, 24–70 mm zoom at 59 mm, ISO 800, 1/80 at f2.8 (FIG 10.20).

FIG 10.21

Jeff Carsten

SUZY THE WONDERPUPPY

For all her speed and determination, Suzy was no match for Jeff Carsten's 20D, even in Program Mode. Carsten's 100–400 mm zoom, at 300 mm, gave him the angle of view of a 480 mm lens, allowing for the camera's 1.6 conversion factor, and AI Servo focus tracked the pup effortlessly as Carsten held the trigger down. ISO 400, 1/800 at f9 (www.southernlightphoto.com) (FIG 10.21).

EGP:

Thanks for saving it.

INDEX